Drawing Animals Made Amazingly Easy

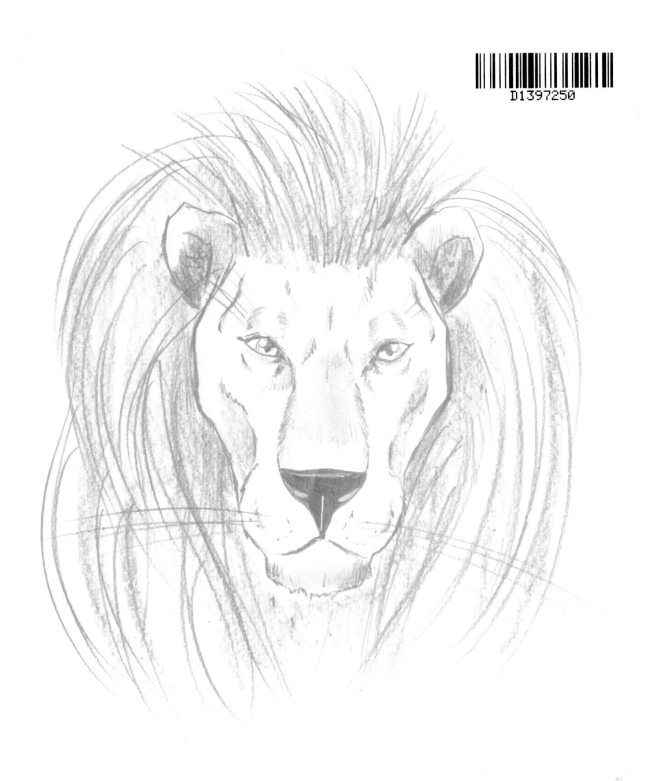

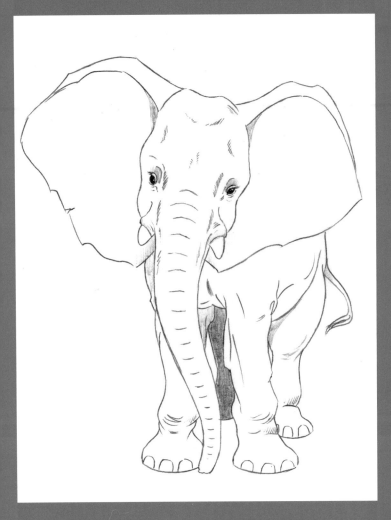
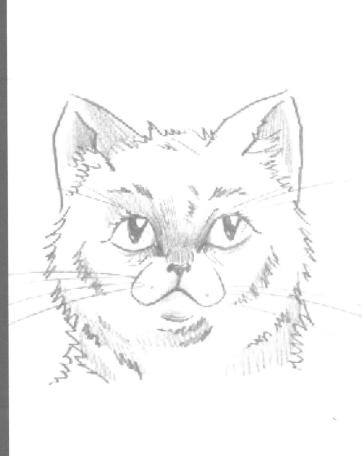
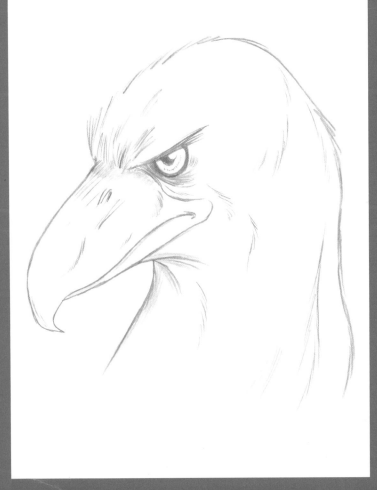
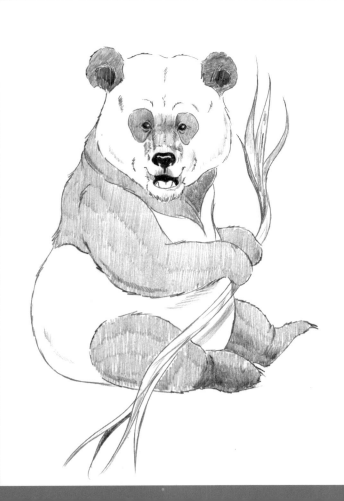

Drawing Animals Made Amazingly Easy

Christopher Hart

Watson-Guptill Publications
New York

To Candace Raney, who has been very supportive of all my endeavors.
To my wife, Maria, for her incredible patience and good cheer.
To my children, Isabella and Francesca, who are generous with their comments.
And to Rusty, who is perhaps the most underpaid model in the world.

Executive Editor: Candace Raney
Design: Mada Design, Inc.
Production Manager: Katherine Happ

First published in 2007 by Watson-Guptill Publications an imprint of the Crown Publishing Group,
a division of Random House, Inc., New York
www.crownpublishing.com
www.watsonguptill.com

Library of Congress Cataloging-in-Publication Data
Hart, Christopher.
Drawing animals made amazingly easy / Christopher Hart.
　　p. cm.
　Includes index.
　ISBN-13: 978-0-8230-1390-6
　ISBN-10: 0-8230-1390-1
　1. Animals in art. 2. Pencil drawing—Technique.　I. Title.
　NC780.H258 2006
　743.6—dc22
　　　　　　　　　2006012454

Printed in the United States of America

6 7 8 9 / 15 14

CONTENTS

INTRODUCTION

■ **DOGS** .8

SEEING ANIMALS AS HUMANS .10

THE DOG HEAD .12

AREAS OF FUR ON THE HEAD .18

"SMILES" AND BARKS .19

SIMPLIFIED BODY STRUCTURE .20

STANDING .24

SITTING .26

PLAYFUL POSE .28

CURLING UP .30

RUNNING .31

OTHER BODY TYPES .32

HANDS AND PAWS .34

FEET AND PAWS .36

CONVEYING VOLUME .38

OVERLAPPING LINES .39

PERSPECTIVE .40

THE EFFECT OF GRAVITY .41

THE WOLF .42

■ **CATS** .**44**

THE HEAD .46

THE "SLEEPING" EYE .51

RENDERING FACIAL DETAILS .52

STANDING .54

SITTING .56

OTHER CAT POSTURES .60

■ **HORSES** .**62**

The Head .64

Simplified Anatomy .70

Body Contours .71

Neck and Chest Muscles .72

The Legs .74

Walking .76

Galloping .78

■ **DEER** .**80**

THE HEAD .82

THE CURVE OF THE NECK .88

VARYING THE HEAD PLACEMENT .89

SIMPLIFIED BODY STRUCTURE ... 90

ALERTNESS ... 92

LEAPING ... 93

RUNNING ... 94

■ **BEARS** .. **96**

THE HEAD .. 98

THE BODY .. 104

WALKING ... 106

ALTERNATE BODY CONSTRUCTION: THE THREE-CIRCLE METHOD .. 108

"STANDING" ... 109

BEAR TYPES .. 110

■ **LIONS** ... **112**

THE LIONESS HEAD ... 114

SIMPLIFIED ANATOMY .. 120

DETAILS OF THE WALK ... 122

RUNNING ... 124

THE MANE .. 125

■ **ELEPHANTS** ... **126**

AFRICAN ELEPHANTS VS. ASIAN ELEPHANTS .. 128

THE HEAD IN PROFILE .. 130

THE BODY IN PROFILE .. 132

THE BODY HEAD-ON ... 134

THE BODY IN 3/4 VIEW ... 136

THE BABY ELEPHANT .. 138

■ **OTHER ANIMALS** .. **140**

CHIMPANZEE .. 142

BALD EAGLE .. 146

PENGUIN ... 150

PIG .. 152

GOAT ... 154

KANGAROO .. 156

GIRAFFE .. 158

INDEX ... 160

INTRODUCTION

Everyone loves to draw animals. And whether hobbyists or illustrators, cartoonists or painters, comic artists or the new generation of computer and video game animators, anyone who wants to draw animals with authority needs to be well acquainted with their anatomy.

But what makes this book so different is how it relates animal anatomy to human anatomy—something with which you already have a working familiarity. You probably think drawing animals is confusing because animal joints are configured so differently from human joints, right? Well, not so fast. Animal joints actually are positioned very similarly to human joints. (That's why I'll often refer to an animal's forelegs as its "arms" and its hind legs as its "legs.") Once you get this, drawing animals will be much easier. Think about it. What if every time you looked at a dog, a deer, a lion, or a bear, you could instantly tell where the elbow or the shoulder or the knee or the hip was? Wouldn't that take the mystery out of animal anatomy? After you've read this book, you'll never look at an animal in the same light. How animals walk and how they move will make sense to you in a new way.

In addition, most drawing books only show you highly detailed skeletal and muscular charts of animals in a standing side view, as if this provides you with enough information about anatomy. But skeletal and muscular charts are much too complex, and leave you with lots of unanswered questions. For example, which bones and muscles should you emphasize when drawing an animal? What do the bones look like in a front view or when the animal walks? Anatomical charts are useless unless you're planning to be a veterinarian. This book simplifies animal skeletons specifically for artists, showing only the muscles that are visible near the surface, under the skin. Who cares about muscles that are so deeply embedded that they never show through to the surface? Artists should draw what they can see—not what would be visible only on an X-ray.

We'll also deal with movement and rendering. Animals are not static creatures; they bend, twist, jump, and run. So, you'll learn how to draw them in their natural poses. You'll also learn how to enhance the aesthetics of your drawings by creating lines that are naturally pleasing to the eye, and how to draw eyes, fur, and contours in ways that highlight an animal's natural beauty.

The focus will be on the most popular animal breeds and species. For example, instead of focusing on the greyhound (which was the animal used in one of the first animal-anatomy books and, therefore, became the go-to animal-anatomy model), this book will present the more dog common breeds, like the Labrador. The same goes for wildlife: You'll get lions and tigers, not ocelots.

Animals have always been a favorite subject of mine, a subject for which I have a real fondness. I hope the lessons here will be useful to you and will change your thinking about how to draw animals. Some concepts may take time to sink in, and there's no need to commit everything to memory all at once. Use this book as a reference, turning to it as often as you need—as a reminder. The three keys to drawing and improving are these: Keep practicing, keep learning, and enjoy!

DOGS

I'm beginning with dogs for several reasons. First, everyone is very familiar with them. We all almost have a built-in reference file of dogs in our minds. So, if you're drawing a dog, you can easily edit yourself if what you've done looks wrong. Second, the exuberant personalities of dogs make them great subjects. Their energy and character jump out at us—and seem to jump off the page. And third, dog anatomy easily translates to that of other animals. Once you've acquired a working familiarity with dog anatomy, you can easily apply it to cats, horses, deer, lions, and even elephants or pigs.

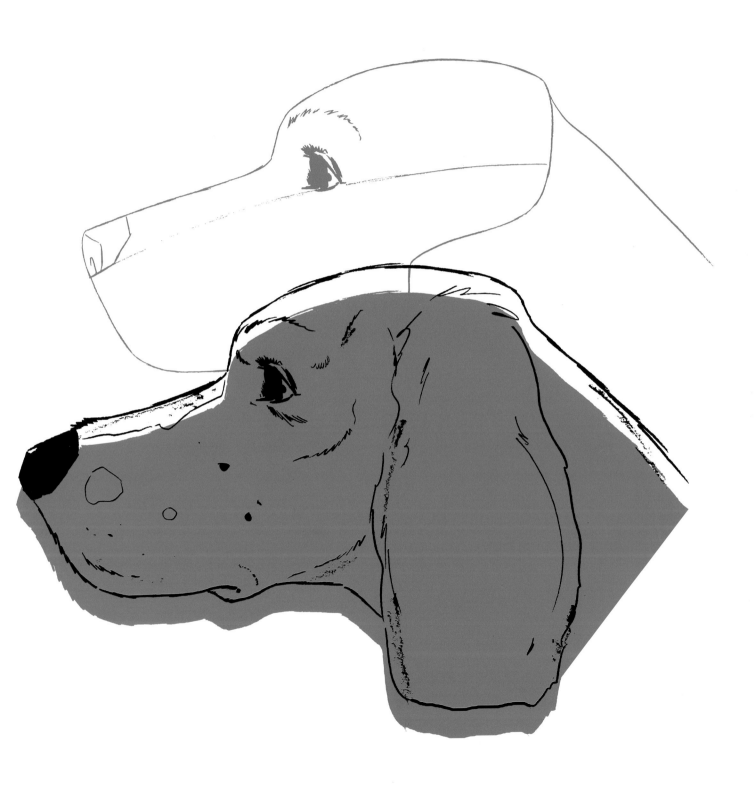

SEEING ANIMALS AS HUMANS

Just how does one get comfortable with animal anatomy when animal skeletons seem so different from our own? The answer is simple: You look for the similarities—and there are more than a few—between animal and human skeletons. Think of an animal as a strangely built human. Once you do this, the mechanics of animal anatomy begin to make sense. Memorization becomes unnecessary, and instead, you can concentrate on the artistry of your drawings. I've used a dog/human comparison here to make this point, but this concept applies to all the animals in this book.

Throughout the book, I'll often use human anatomy terms to call out the corresponding spots on animals. These may not be the true anatomical terms for the animals, but that doesn't matter for our purposes. What matters is making the connection between human and animal anatomy.

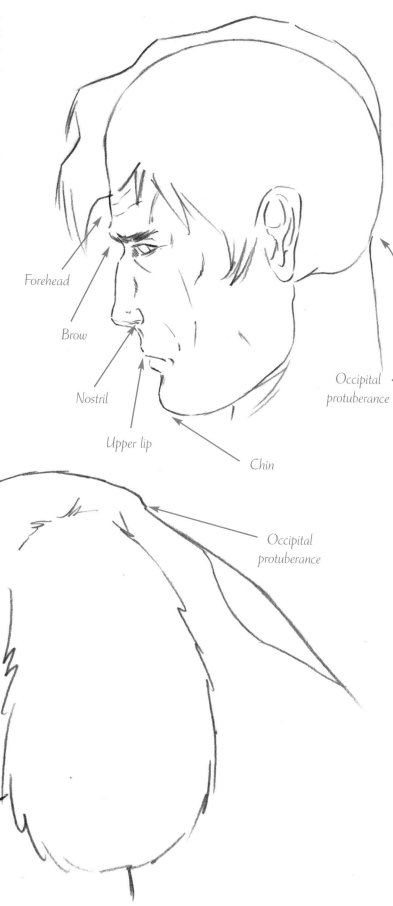

Forehead

Brow

Nostril

Upper lip

Chin

Occipital protuberance

Forehead

Brow

Occipital protuberance

Nostril

Upper lip

Chin

Placing a dog and a person in a similar posture, clearly shows how closely dog and human anatomy resemble each other. It becomes easier to make the correlation. You can clearly see where the "elbows," "knees," "heels," "hands," "shoulders," and so on, are located. And note that this isn't an unrealistic dog pose; dogs, bears, and other animals do rear up—striking a more humanlike stance—from time to time.

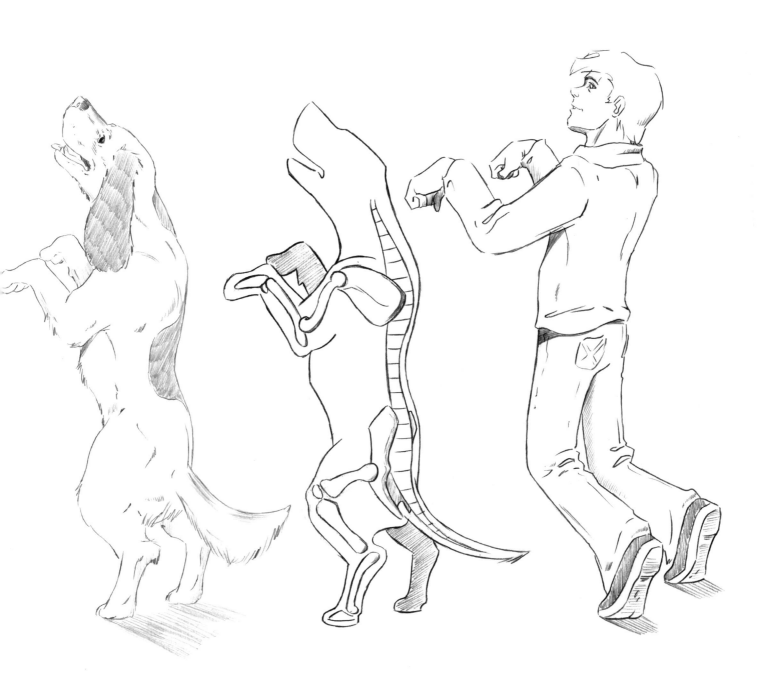

THE DOG HEAD

I'm a serious believer in diving right in. And I also believe that learning is enhanced only when creativity is increased. So, before I make any more comparisons of human and animal anatomy, let's start with something fun and draw a few dog heads to warm up and get our creative juices flowing. Not only are dog heads relatively easy to draw, they are very expressive. You'll find that many of the other animals we will learn to draw throughout the book, especially bears, also share the dog's basic head shape.

Profile

Usually, in my art-instruction books, I start with the front view of the head, but with animals that have long muzzles, it's better to start with the profile. For one

thing, the shapes are more interesting, and for another, you don't have to worry about drawing the muzzle in perspective (looking like it's coming toward you), which would require foreshortening and can be tricky.

For this example, I've drawn a springer spaniel, which is a typical, popular medium-size family dog. Many other dog breeds, such as setters and retrievers, have the same basic head structure, so this is a good construction to get under your belt.

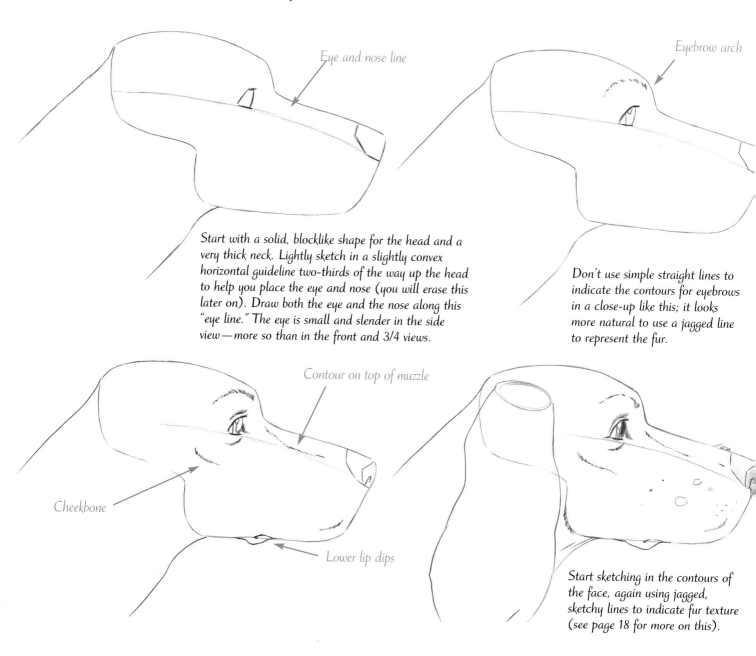

Eye and nose line

Eyebrow arch

Start with a solid, blocklike shape for the head and a very thick neck. Lightly sketch in a slightly convex horizontal guideline two-thirds of the way up the head to help you place the eye and nose (you will erase this later on). Draw both the eye and the nose along this "eye line." The eye is small and slender in the side view—more so than in the front and 3/4 views.

Don't use simple straight lines to indicate the contours for eyebrows in a close-up like this; it looks more natural to use a jagged line to represent the fur.

Contour on top of muzzle

Cheekbone

Lower lip dips

Start sketching in the contours of the face, again using jagged, sketchy lines to indicate fur texture (see page 18 for more on this).

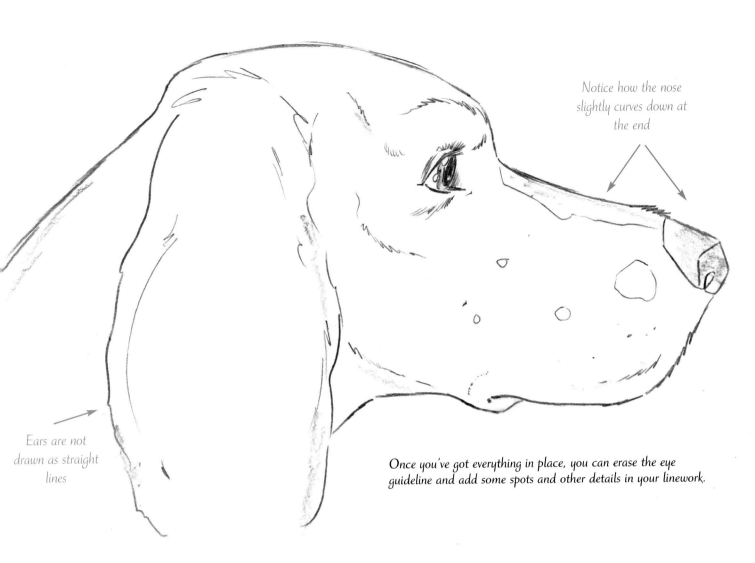

Notice how the nose slightly curves down at the end

Ears are not drawn as straight lines

Once you've got everything in place, you can erase the eye guideline and add some spots and other details in your linework.

The Dog's Eye in Profile

In profile, the outer line of the iris curves toward the front of the eyeball, making the iris appear skinny. The shine needs to be placed so that it looks like it is invading the pupil and that the eyelid is cutting it off. The eyelid must be dark—almost as if the dog were wearing eyeliner.

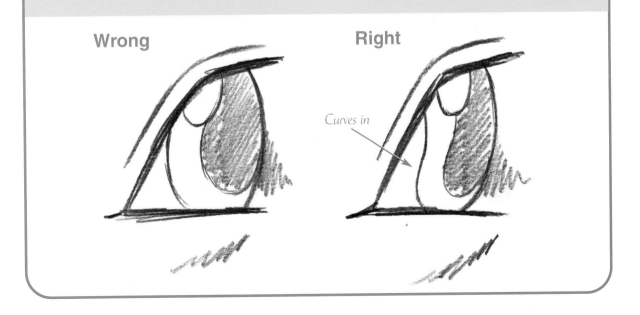

Wrong

Right

Curves in

Front View

Obviously, things are going to change when you go from the profile to the front view. The outline of the face, for example, will appear rounder and less angular than it will in profile. Although a prominent muzzle is easy to draw in profile, it is more difficult to show in the front view. In the front view, the muzzle appears compressed, and this has a tendency to flatten the look of the face. And if the muzzle starts to look flat, you'll lose the distinctive quality that makes a dog look like a dog. You can use the principles of perspective to your advantage by accentuating the muzzle in such a way that it appears to be getting larger as it gets closer to you, just like distant train tracks seem to get gradually larger the closer they get to you. So, in the example here, the muzzle isn't indicated by two parallel lines, but by two lines that widen outward as they approach the viewer. This eliminates the flattening effect in the front view while also maintaining the muzzle's prominence.

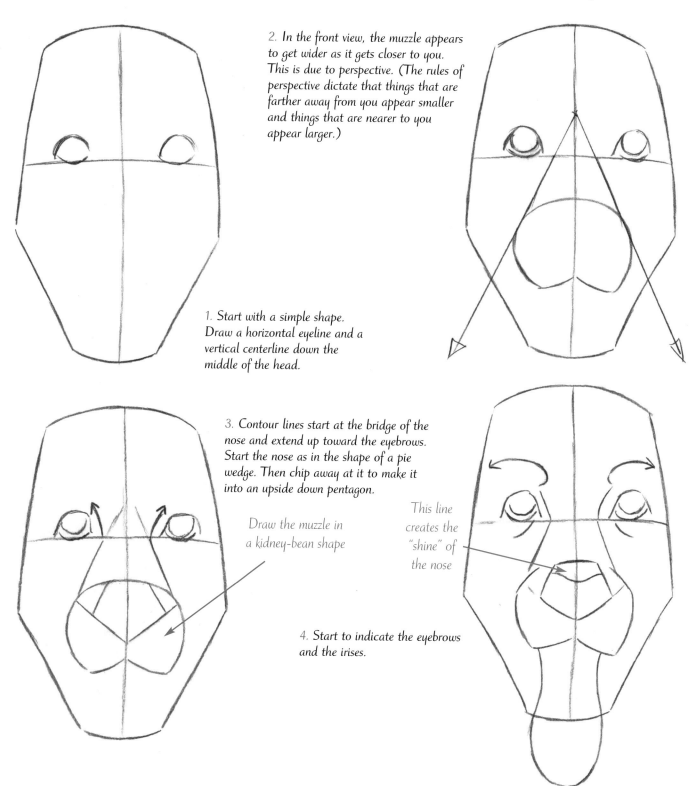

2. In the front view, the muzzle appears to get wider as it gets closer to you. This is due to perspective. (The rules of perspective dictate that things that are farther away from you appear smaller and things that are nearer to you appear larger.)

1. Start with a simple shape. Draw a horizontal eyeline and a vertical centerline down the middle of the head.

3. Contour lines start at the bridge of the nose and extend up toward the eyebrows. Start the nose as in the shape of a pie wedge. Then chip away at it to make it into an upside down pentagon.

Draw the muzzle in a kidney-bean shape

This line creates the "shine" of the nose

4. Start to indicate the eyebrows and the irises.

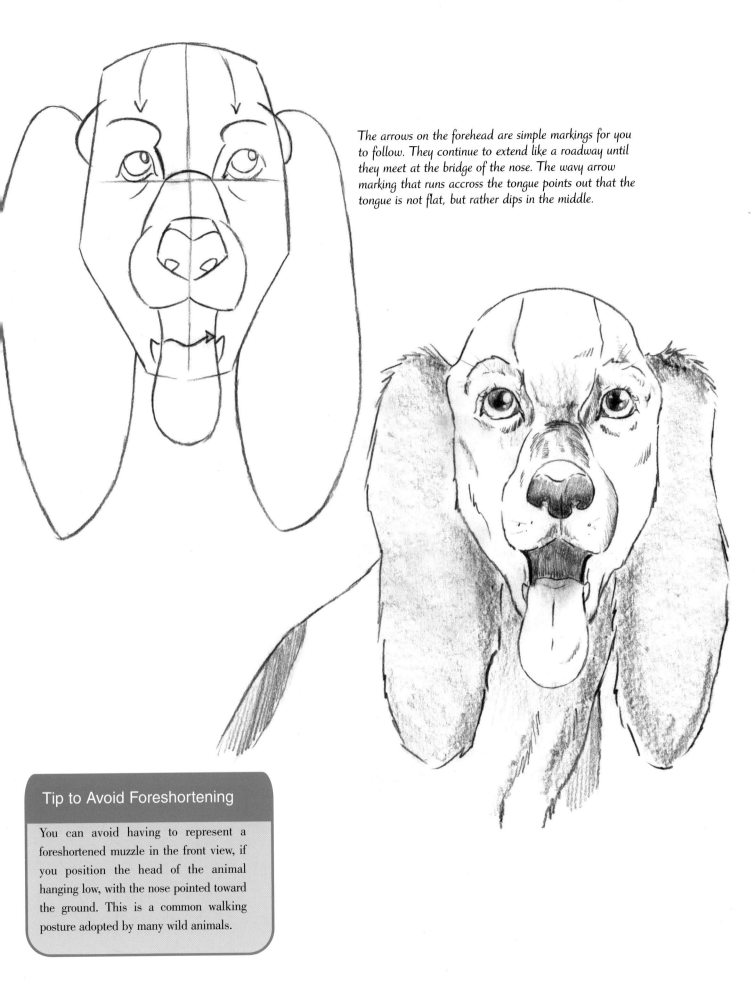

The arrows on the forehead are simple markings for you to follow. They continue to extend like a roadway until they meet at the bridge of the nose. The wavy arrow marking that runs accross the tongue points out that the tongue is not flat, but rather dips in the middle.

Tip to Avoid Foreshortening

You can avoid having to represent a foreshortened muzzle in the front view, if you position the head of the animal hanging low, with the nose pointed toward the ground. This is a common walking posture adopted by many wild animals.

3/4 View

This is a pleasing angle. It's softer than a profile, which tends to chisel the angles of the face abruptly. In the 3/4 angle, you see not only similar shapes as in the profile, but also a decent amount of the top of the head, which adds another surface in the drawing. Some of the far eye is visible, as is a bit of the far side of the nose and muzzle. This makes the head look rounder and more three-dimensional, without the issues of perspective and foreshortening that you get in the front view. It's a more natural-looking angle.

The main challenge in drawing the 3/4 view is maintaining the integrity of the head shape. Don't let the head get too wide because you mistakenly believe that you're drawing more surface in the 3/4 view. Confine yourself to your basic starting form. Rather than thinking of it as *drawing* a 3/4 view, think of it as *chipping away* at a block of stone with a chisel. You're not *adding the features onto* the initial head shape to make a 3/4 view; you're *carving the features into* the form. Don't expand the construction as you go along.

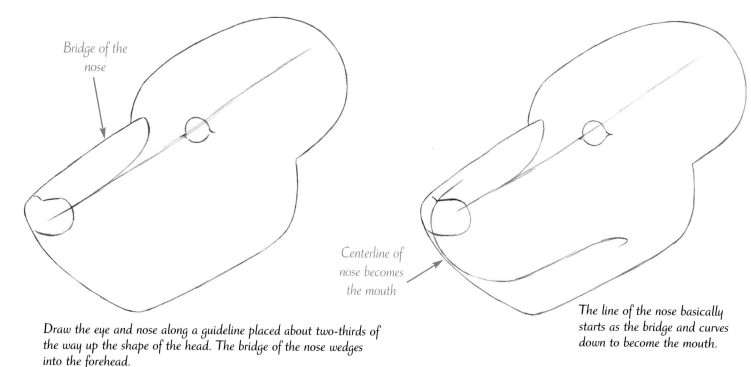

Bridge of the nose

Centerline of nose becomes the mouth

Draw the eye and nose along a guideline placed about two-thirds of the way up the shape of the head. The bridge of the nose wedges into the forehead.

The line of the nose basically starts as the bridge and curves down to become the mouth.

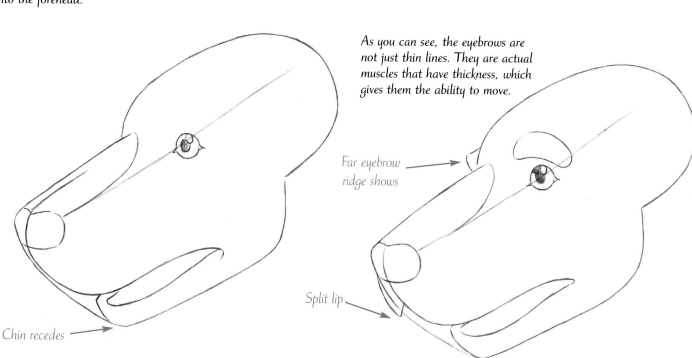

As you can see, the eyebrows are not just thin lines. They are actual muscles that have thickness, which gives them the ability to move.

Far eyebrow ridge shows

Chin recedes

Split lip

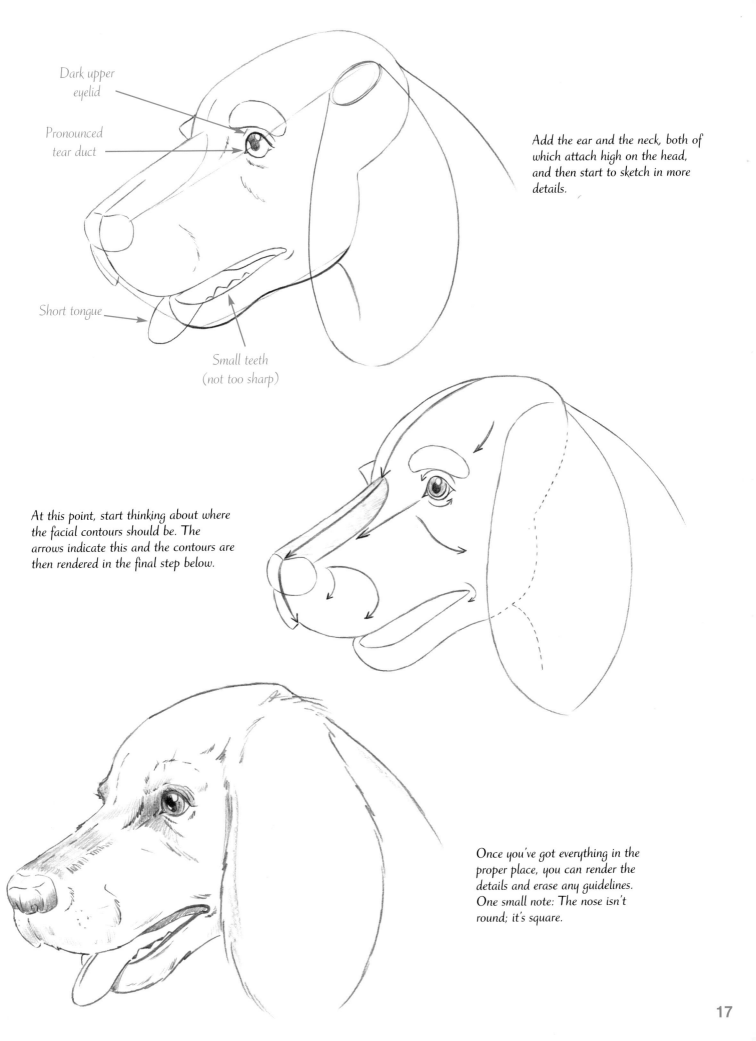

Dark upper
eyelid

Pronounced
tear duct

Short tongue

Small teeth
(not too sharp)

Add the ear and the neck, both of
which attach high on the head,
and then start to sketch in more
details.

At this point, start thinking about where
the facial contours should be. The
arrows indicate this and the contours are
then rendered in the final step below.

Once you've got everything in the
proper place, you can render the
details and erase any guidelines.
One small note: The nose isn't
round; it's square.

AREAS OF FUR ON THE HEAD

Nothing looks as good on a finished animal drawing as a few well-placed, sketchy ruffles of fur. They add life. This goes for dogs and for other furry animals, as well. But if you don't put these areas of fur in the correct places, the drawing may take on an awkward look. This drawing shows where the ruffles occur on the dog's head. Leave ruffles off of the other parts; that's where things remain smooth.

Not all dogs will have all of these ruffles showing at all times—that would make them pretty scraggly. You have to pick and choose which areas to emphasize according to your subject and your taste.

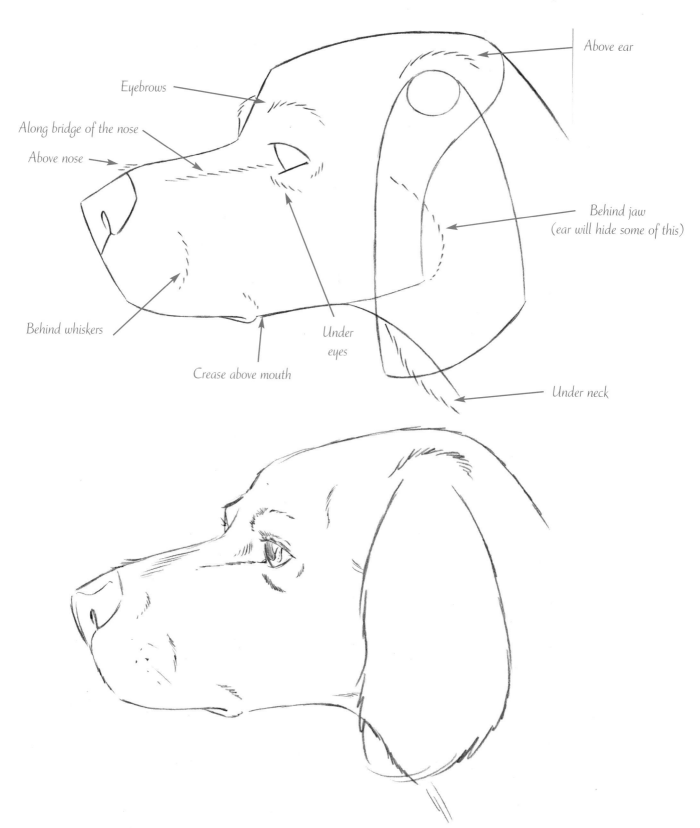

Above ear

Eyebrows

Along bridge of the nose

Above nose

Behind jaw
(ear will hide some of this)

Behind whiskers

Under
eyes

Crease above mouth

Under neck

"SMILES" AND BARKS

"Smiling" and barking are two common canine actions that you should master. First the dog "smile." We've all seen it. And yet a dog doesn't really lift its lips and smile like a human. So how is it that we can tell when a dog is smiling? The sparkle in its eyes? The wag of its tail? The tongue hanging out? Sure, all of those things are indicators. But I think the mouth does, in fact, smile. It's just a subtle smile. And it's not the same as a human smile. In fact, were you to draw a human smile on a dog, you would instantly turn the drawing into a cartoon. Instead, the dog's smile starts off with the upper lip mimicking a vague human smile with the lips traveling slightly upward toward the back of the head.

Then, they take a sudden, sharp dip at the end. It's more of an open-mouth, expectant look than a smile. In this way, the teeth can show, and it won't look menacing. Bright, wide eyes are also essential to complete the look.

Now, on to the bark. Here's a little tip to keep in your back pocket when you might need it: When a dog barks, yawns, or howls, the mouth shortens. That's right, it shortens. Simply shortening the mouth makes it look like the dog is barking. Elongating the mouth makes it look like the dog is smiling. Also, note that the tongue never hangs out of the mouth when a dog barks. The tongue hanging out is an expression of happiness or a function of cooling off.

The "Smile"

The "Bark"

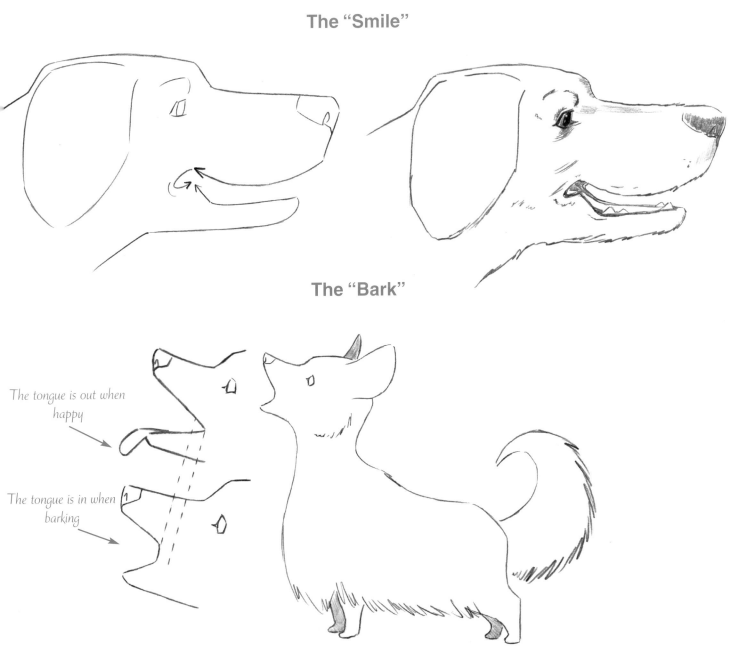

The tongue is out when happy

The tongue is in when barking

19

SIMPLIFIED BODY STRUCTURE

Having a familiarity with the basic body structure of whatever animal you're drawing is useful. An understanding of the main parts of the skeleton and the sections of the legs and torso will help your drawing greatly. Here's a brief overview.

Simplified Anatomy

It helps to have some point of reference as to where the bones are. It you have no idea where they go, it's hard to have any confidence that you're drawing the limbs and joints in the correct configuration. Hey, I'm not trying to make you an anatomist—that's why this is all *simplified*. Once you get a firm understanding of the basics, you'll actually have more creative freedom to express yourself. Without this knowledge, you'd spend too much time trying to figure out why your drawing "just doesn't look right," instead of concentrating on artistic touches.

Here's what I'd like you to notice in this Irish terrier example. First, take a look at the direction and angle of the bones, because those angles dictate the angles of the limbs, pelvis, and shoulder blades. Notice that the spine widens at the shoulder blade and at the pelvis, causing the back to rise at those two places. Therefore, the back of an animal is never straight but rather slopes gently up and down because of the varying thickness of the spine.

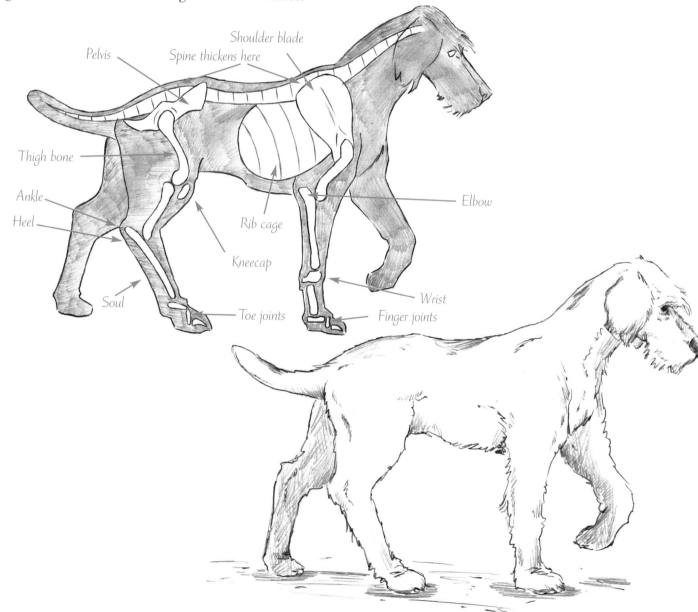

Pelvis · Spine thickens here · Shoulder blade · Thigh bone · Ankle · Heel · Rib cage · Kneecap · Soul · Toe joints · Finger joints · Wrist · Elbow

Where Things Are When a Dog Walks

The dog's walk is representative of how many animals walk. Understand how dogs walk and why their joints bend the way they do, and you'll understand how all mammals walk. The humorous human mimics the dog's pose, showing precisely how a human would have to walk in order to move like a dog. The purpose of this is to show you where the elbow, knee, heel, toes, hands, fingers, and so on, are on the dog. Simply look at the human, identify the body part, look at the dog, and identify the same body part. You'll start to get a gut understanding of the anatomy.

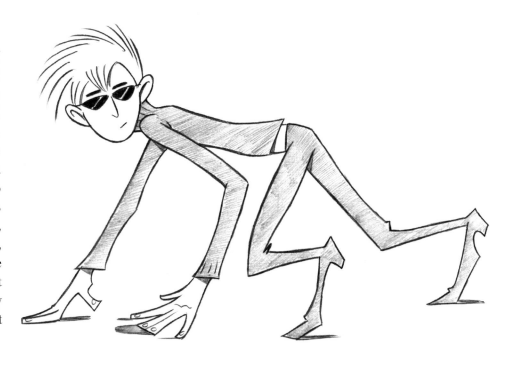

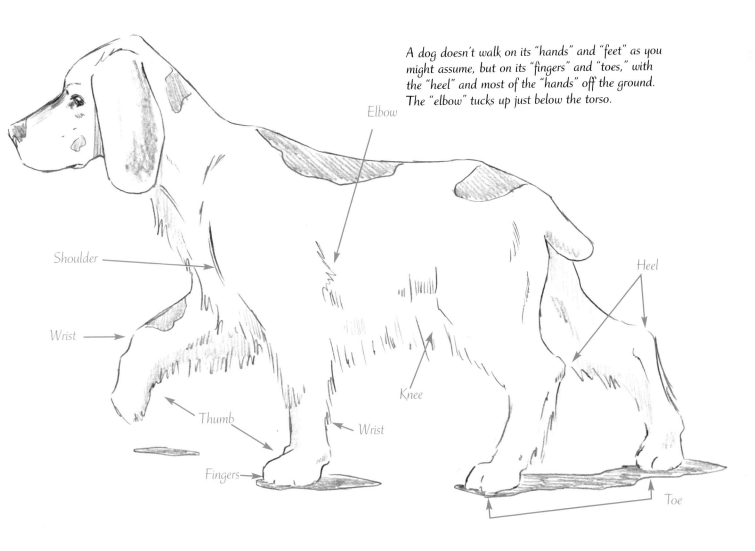

A dog doesn't walk on its "hands" and "feet" as you might assume, but on its "fingers" and "toes," with the "heel" and most of the "hands" off the ground. The "elbow" tucks up just below the torso.

Elbow

Shoulder

Wrist

Thumb

Fingers

Wrist

Knee

Heel

Toe

The Knee

We're used to thinking of the knee as being low on the body. But really, the equivalent of the knee on most mammals is much closer to the torso. Humans are the exception to this rule. Horses, lions, bears, pigs, goats, deer, and so many others have knees in roughly the same, high place; weird animals, like you and me, have them low, near our ankles.

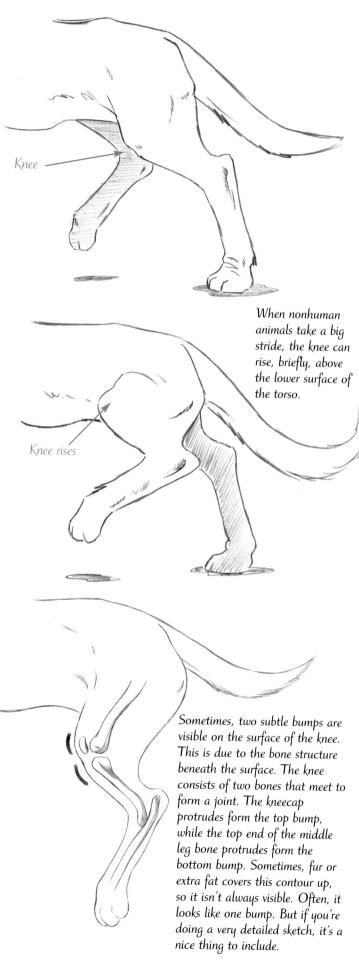

Knee

When nonhuman animals take a big stride, the knee can rise, briefly, above the lower surface of the torso.

Knee rises

Sometimes, two subtle bumps are visible on the surface of the knee. This is due to the bone structure beneath the surface. The knee consists of two bones that meet to form a joint. The kneecap protrudes form the top bump, while the top end of the middle leg bone protrudes form the bottom bump. Sometimes, fur or extra fat covers this contour up, so it isn't always visible. Often, it looks like one bump. But if you're doing a very detailed sketch, it's a nice thing to include.

The Difference between Front and Back Legs

When relaxed, back legs tend to angle forward from the heel to the toes, while front legs tend to fall straight down.

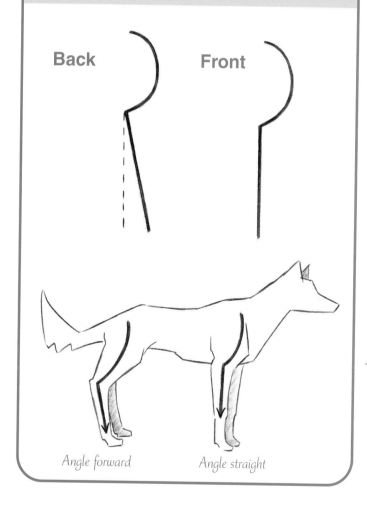

Back **Front**

Angle forward *Angle straight*

22

The Torso

Since body structure isn't just about bones, but also about shapes, let's leave skeletons behind for a while and take a look at the main section of the body—the torso. Here it is, made amazingly easy: Think of the torso as having three sections. I could make it more complicated, but then I'd have to rename this book.

Of course, you must draw the torso so that it looks like a single unit. But the torso should also have a rhythm to it, or it will look like one large undifferentiated blob.

This is where the three sections come in. Remember, animals are muscular, since they are built to work hard. They have body contours as a result of those muscles. The shoulders create the first hill of the torso, the back creates the valley in the center, and the pelvis (and hindquarters) form the lower hill. Just remember the three torso sections and how they flow together. You will see as we move to other mammals how this concept translates to them as well.

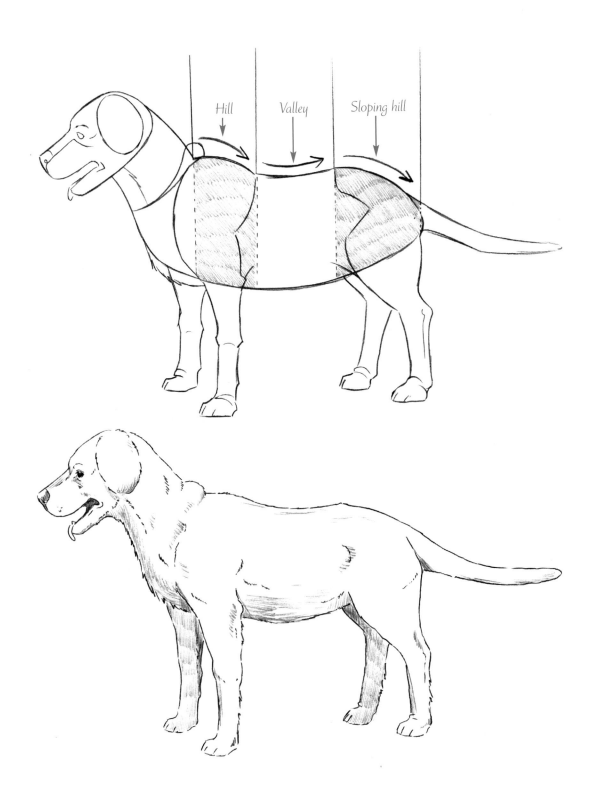

Hill Valley Sloping hill

STANDING

On the previous page, I broke the body down into three sections. But sometimes, especially with smaller dogs (and other small animals), you can simplify the body structure even further, modifying the three sections so that the middle section is smaller and much less prominent or even breaking the body down into only two sections. You would then draw these two main sections as large circles to give the body volume.

To modify the three-section body structure for a smaller dog, draw a reduced midsection sandwiched by two large circles. Note that the front circle protrudes past the neck a little, giving volume to the chest.

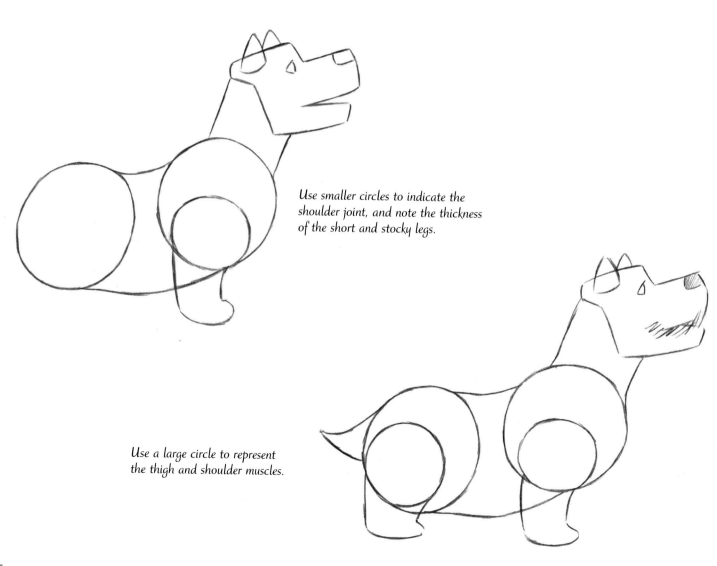

Use smaller circles to indicate the shoulder joint, and note the thickness of the short and stocky legs.

Use a large circle to represent the thigh and shoulder muscles.

Once you have the legs on the near
side of the body in place, you can
add the far legs. Don't hide the far
legs—they give the figure dimension.

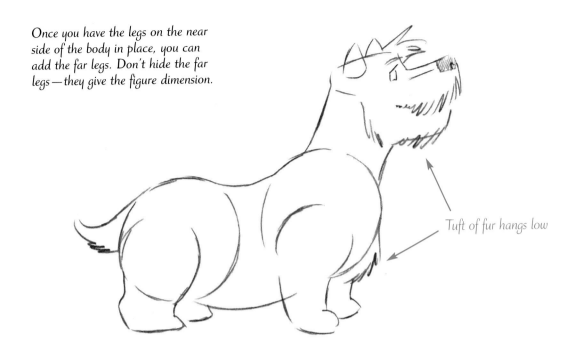

Tuft of fur hangs low

Don't be fooled into thinking that smaller dogs are
any less hardy than larger ones. One look at the
chest and neck of a small terrier like this will dispense
with that notion. And sometimes, the smaller a dog
is, the more spunk it has. I love these little bundles of
personality. But then again, if I were to list all of my
favorite breeds, I'm afraid I'd run out of pages.

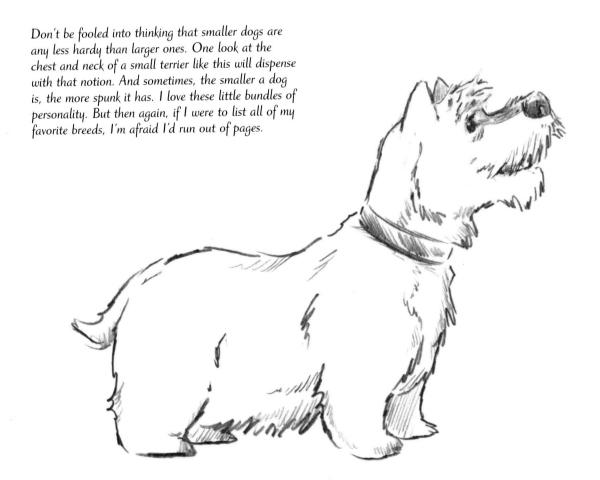

SITTING

Anatomy and body structure get trickier for sitting poses, in which the body is compressed and overlaps itself. The lower legs are all but hidden under the thighs, and beginning artists often have no clue what's going on anatomically. They fake it, drawing sort of a ball for the thigh. And you know what? It looks like they've faked it.

But once you know the real mechanics of the underlying form, you can draw a sitting pose with more authority—regardless of what type of animal it is. Although parts of the anatomy are hidden, you will know where and how the bones are configured, and this knowledge will always translate into a more convincing drawing.

Seated Anatomy

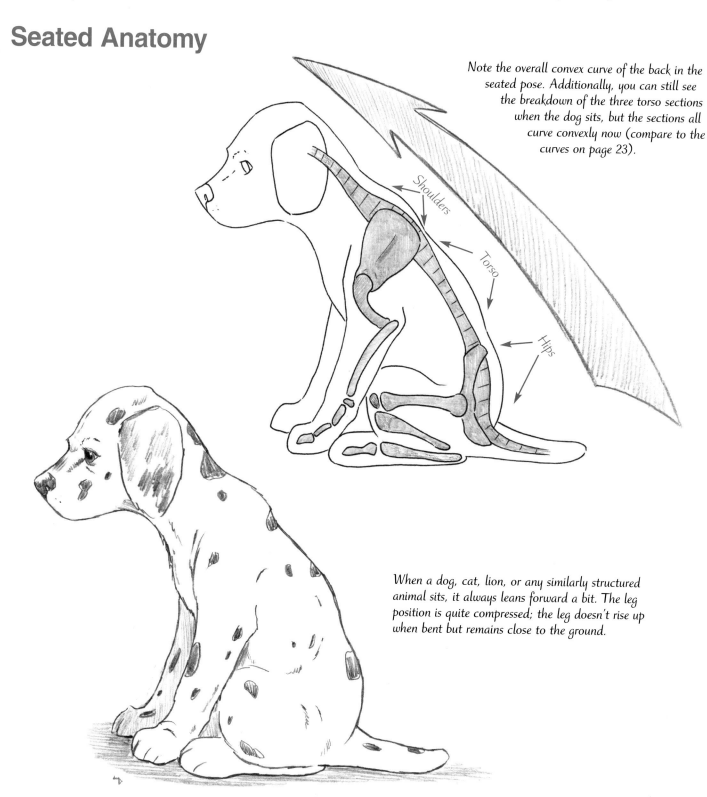

Note the overall convex curve of the back in the seated pose. Additionally, you can still see the breakdown of the three torso sections when the dog sits, but the sections all curve convexly now (compare to the curves on page 23).

Shoulders

Torso

Hips

When a dog, cat, lion, or any similarly structured animal sits, it always leans forward a bit. The leg position is quite compressed; the leg doesn't rise up when bent but remains close to the ground.

The Seated Pose Step by Step

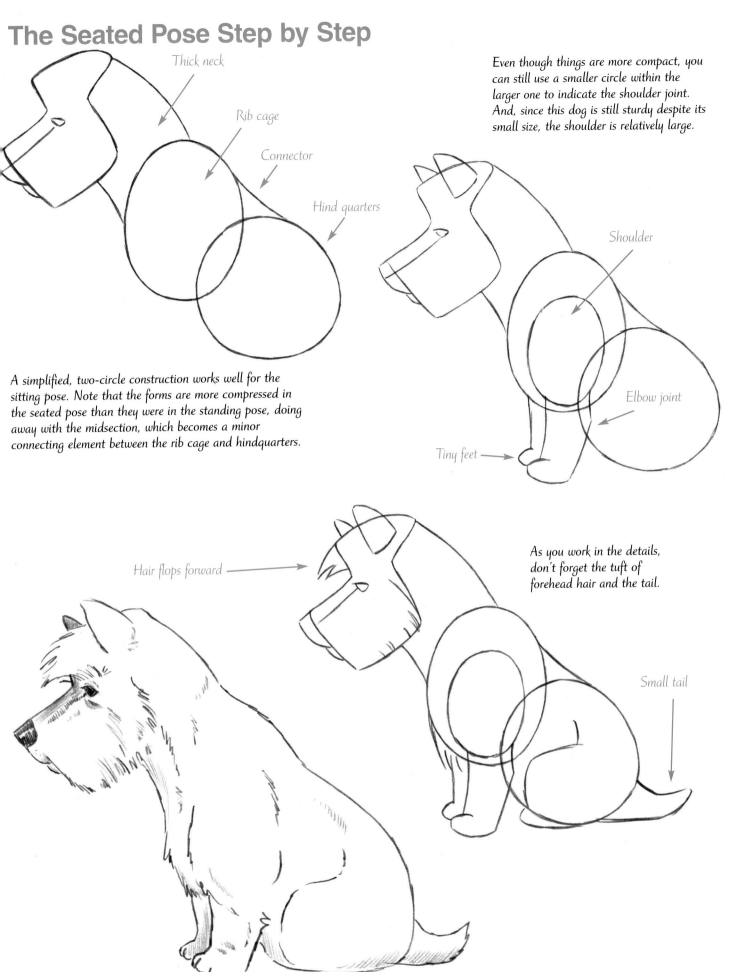

Thick neck

Rib cage

Connector

Hind quarters

Even though things are more compact, you can still use a smaller circle within the larger one to indicate the shoulder joint. And, since this dog is still sturdy despite its small size, the shoulder is relatively large.

Shoulder

Elbow joint

Tiny feet

A simplified, two-circle construction works well for the sitting pose. Note that the forms are more compressed in the seated pose than they were in the standing pose, doing away with the midsection, which becomes a minor connecting element between the rib cage and hindquarters.

Hair flops forward

As you work in the details, don't forget the tuft of forehead hair and the tail.

Small tail

PLAYFUL POSE

When a dog lowers its forelegs and torso in a bowing motion, it means only one thing: Come play with me!

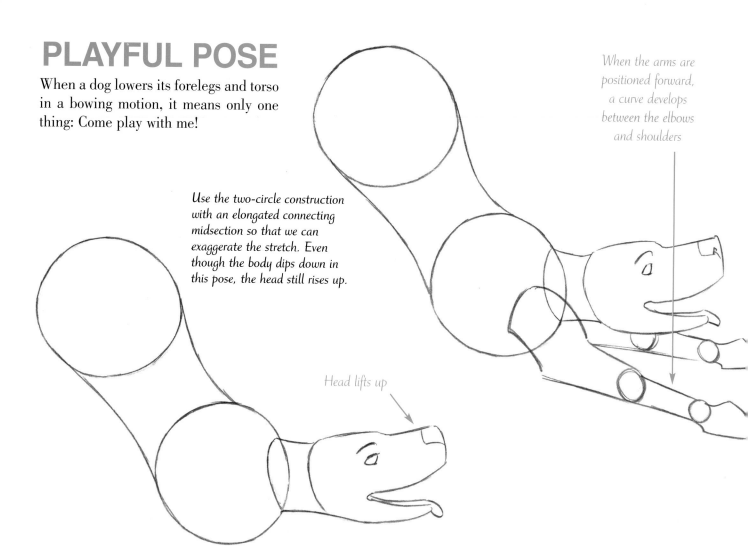

When the arms are positioned forward, a curve develops between the elbows and shoulders

Use the two-circle construction with an elongated connecting midsection so that we can exaggerate the stretch. Even though the body dips down in this pose, the head still rises up.

Head lifts up

Directional Flow

Body language is communication. The entire body sends a message by taking on a single, directional flow. And fluidity is the key to representing this flow convincingly. The play bow is a particularly good pose to illustrate this concept because it is naturally curvy. Take a look at the fluid lines, indicated by the arrows.

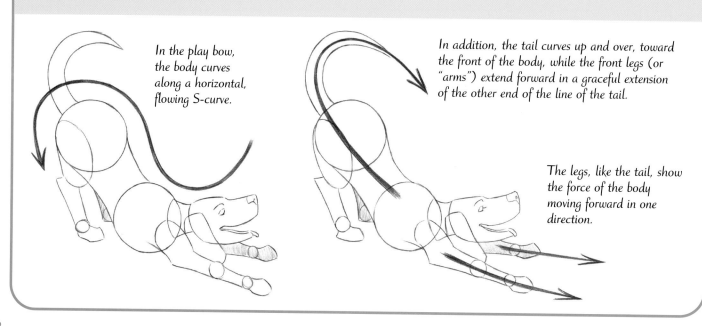

In the play bow, the body curves along a horizontal, flowing S-curve.

In addition, the tail curves up and over, toward the front of the body, while the front legs (or "arms") extend forward in a graceful extension of the other end of the line of the tail.

The legs, like the tail, show the force of the body moving forward in one direction.

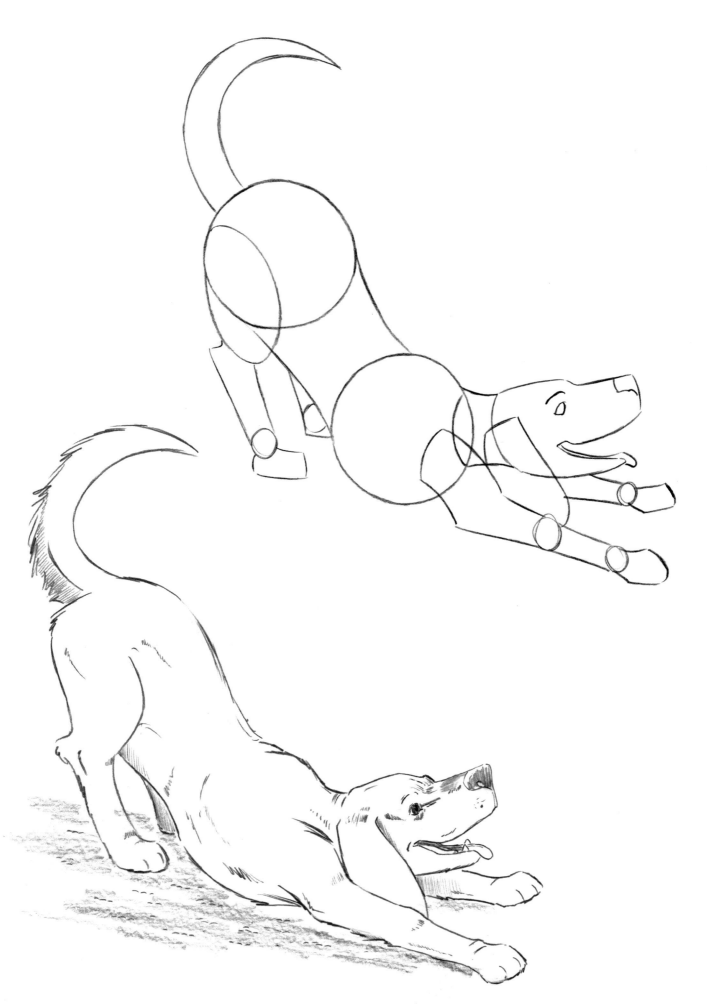

CURLING UP

When a dog curls up, it really curls up. The tail wraps around the entire body, coming full circle past the nose. Where should you start with a pose like this? Obviously, it's important to get the positioning right, because it's very dear, and the body language plays an integral part in making it work. Start by setting up the overall, curled-up shape; then fit everything else inside. You're establishing the framework first.

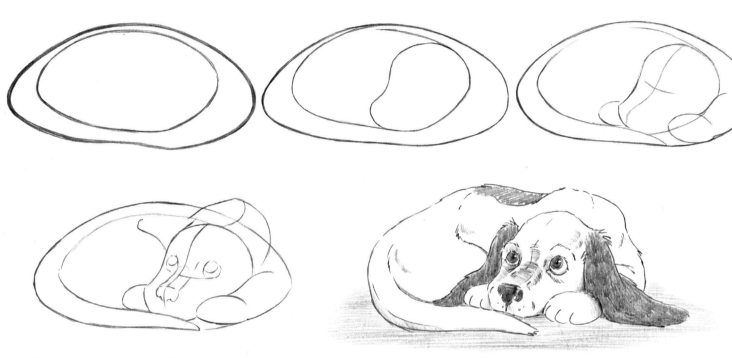

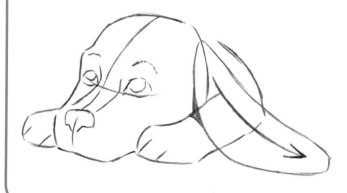

I've used a beagle puppy to illustrate this pose. I like to have my puppies look up. It gives them an innocent look.

A Note about Floppy Ears

The more floppy the dog's ear is, the looser it is. In this example, the ear is resting on the foreleg, which means we need to show the underlying form of the foreleg underneath the floppy ear.

Wrong

This floppy ear doesn't reflect the underlying shape of the arm beneath it.

Right

This floppy ear wraps around the form beneath it.

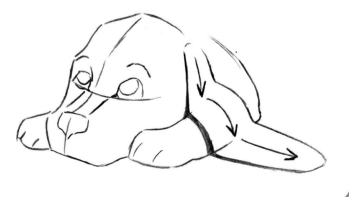

RUNNING

There are different types of animal "runs." Dogs chasing squirrels or Frisbees in the park may run with reckless abandon, tongues hanging out the sides of their mouths. Animals in the wild, such as the wolf, may run in a manner that's quite controlled, simply cruising but ready to jump into high gear at a moment's notice. The leg positioning is similar regardless, with all four legs off the ground at the same time and gathered close together under the center of the body at some point in the running motion. (For more information on how four-legged animals walk, see *Walking* on page 76 in the horse section.)

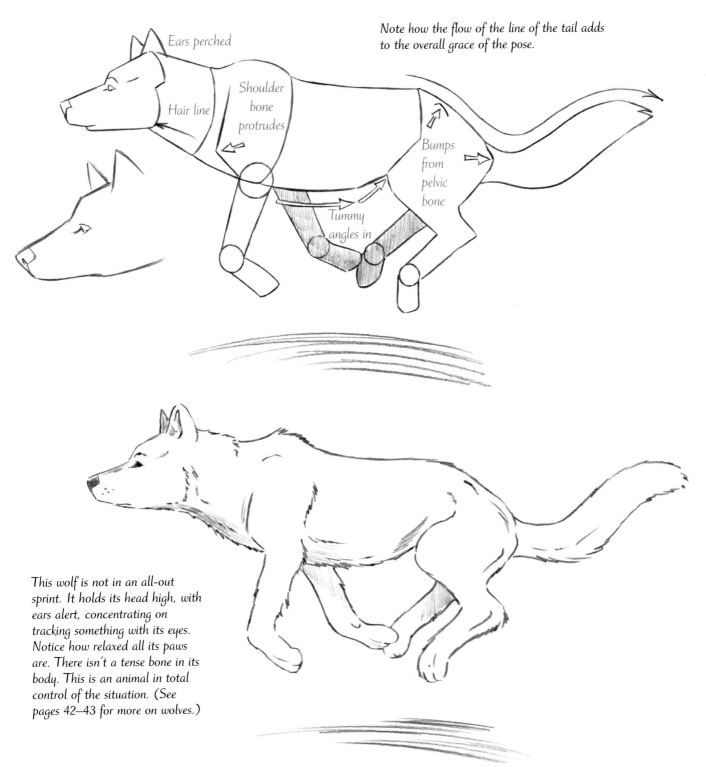

Ears perched

Note how the flow of the line of the tail adds to the overall grace of the pose.

Hair line

Shoulder bone protrudes

Bumps from pelvic bone

Tummy angles in

This wolf is not in an all-out sprint. It holds its head high, with ears alert, concentrating on tracking something with its eyes. Notice how relaxed all its paws are. There isn't a tense bone in its body. This is an animal in total control of the situation. (See pages 42–43 for more on wolves.)

OTHER BODY TYPES

Before we move on to the details of the hand and feet, I want to note the variety of dog body types out there. Not all dogs look like Labradors and spaniels, so take a look.

Low and Elongated

Dachshunds are a perfect example of this body type. Besides being famous for its hot doglike body, the dachshund has tiny paws, pronounced black nails, and stubby feet. It also has one of the sweetest, gentlest faces in the dog world. When a dog this long and awkward tries standing up, it's especially endearing. Corgis and basset hounds also fall into this body-type category.

Bent legs angle inward when the dog "stands." The heels also angle inward sharply.

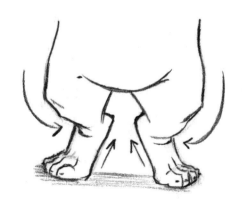

Lean and Elegant

Being sleek and majestic, greyhounds fall into the lean and elegant category. A noble dog, the greyhound carries itself with an aristocratic air, which you can see in the way the neck rises at a 90-degree angle from the body, rather than leaning forward as it does on most dogs. Although not quite as lean as the greyhound, the Doberman pinscher is another thin, graceful dog in which this technique can be used.

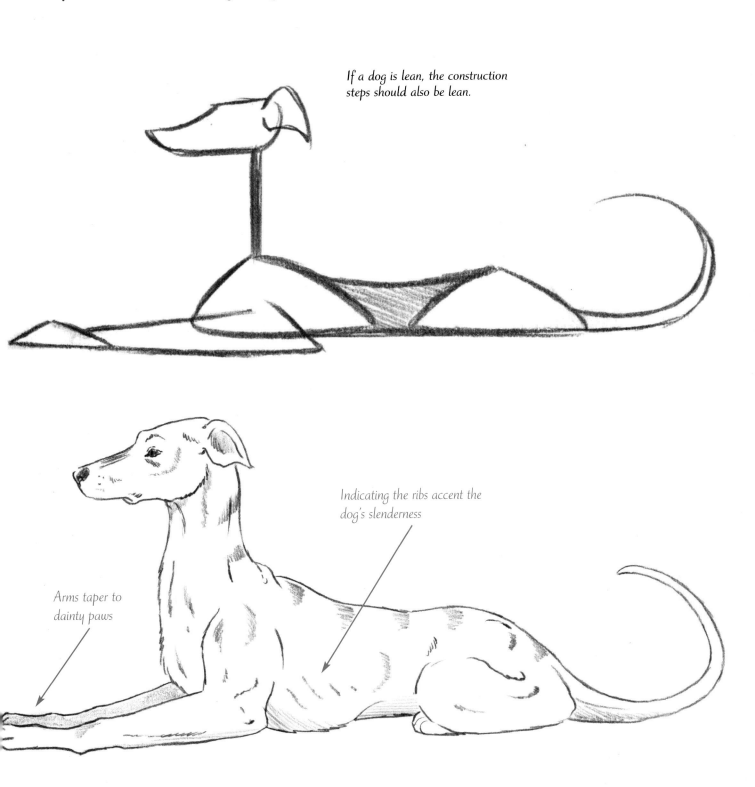

If a dog is lean, the construction steps should also be lean.

Indicating the ribs accent the dog's slenderness

Arms taper to dainty paws

HANDS AND PAWS

Dogs don't really have *hands*. They have *paws*. But human hand anatomy is surprisingly similar to dog paw anatomy—and to paw anatomy in many other animals that have vestigial thumbs.

Left (Outer View)

The "thumb" (the dew claw) isn't visible in this view, but I've indicated the height at which it falls just to give you an idea of all the landmarks. The "wrist" joint is just barely higher on the dog "arm" than the thumb. And note: Animals with this type of paw construction walk on their "fingers," not their "palms." Most of the dog's palm is off the ground when they walk. Hey, it wouldn't work for me, but then again, I'm not a dog.

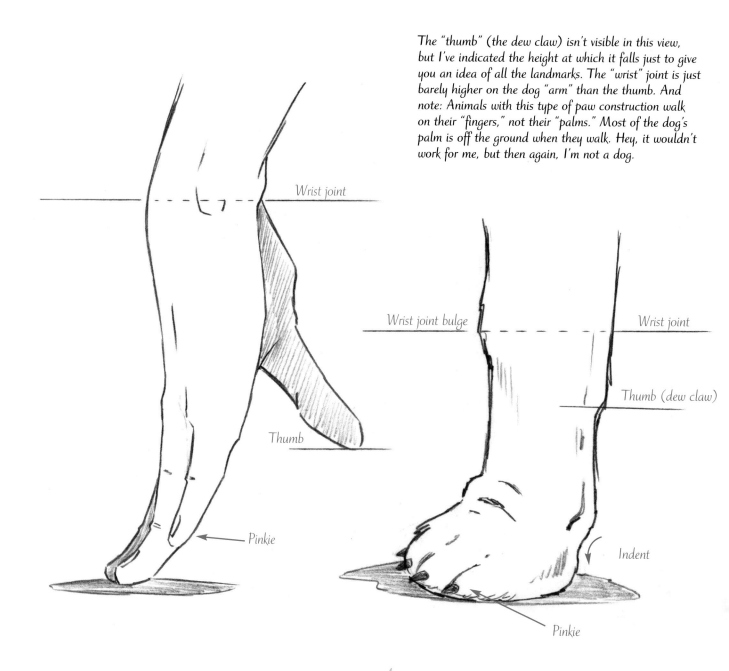

Wrist joint

Wrist joint bulge

Wrist joint

Thumb (dew claw)

Thumb

Pinkie

Indent

Pinkie

Right (Inner View)

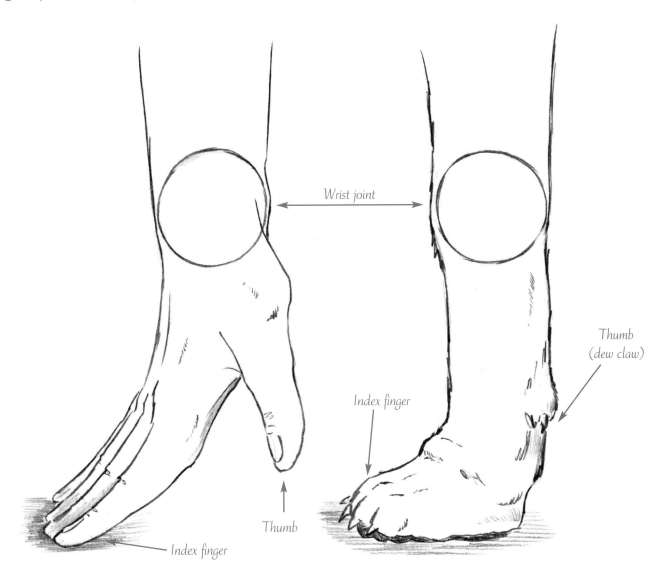

Wrist joint

Thumb
(dew claw)

Index finger

Thumb

Index finger

FEET AND PAWS

Believe it or not, but animals *do not* walk on the soles of their feet! They only walk on their toes. Let's go in for a close-up of this concept.

Basic Comparison

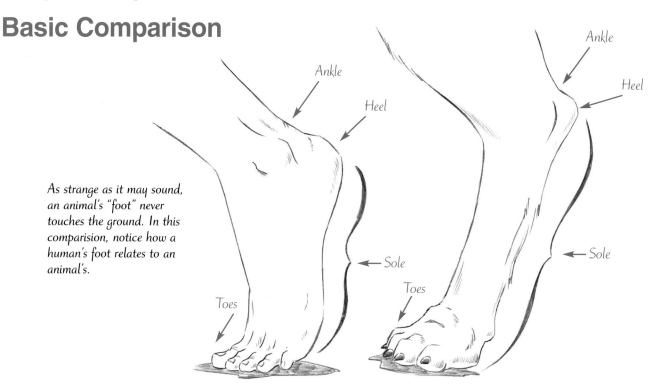

As strange as it may sound, an animal's "foot" never touches the ground. In this comparision, notice how a human's foot relates to an animal's.

Ankle

Heel

Ankle

Heel

Sole

Sole

Toes

Toes

Relaxed "Hands" and "Feet" Walking

When relaxed, a dog's paws are always floppy. That's one of the main distinctions I've noticed between animals and humans: Humans use their hands in a very precise manner, whereas animals use their "hands" in a loose and imprecise way.

The idea of relaxed front and rear paws is especially important when dogs—or any other animals with similar "hands" and "feet"—walk. Take a look at the Great Dane to the right. This relaxed-paw quality is something that animators use and know well. It's a principle known as *drag*, and you can see it if you watch any wildlife special on

TV. When animals walk, the paws drag behind in a floppy, relaxed manner. This is very different from the way humans walk. Yes, the joints in human hands are often loose during walking, but they never "drag" behind to quite the extent that you see on animals.

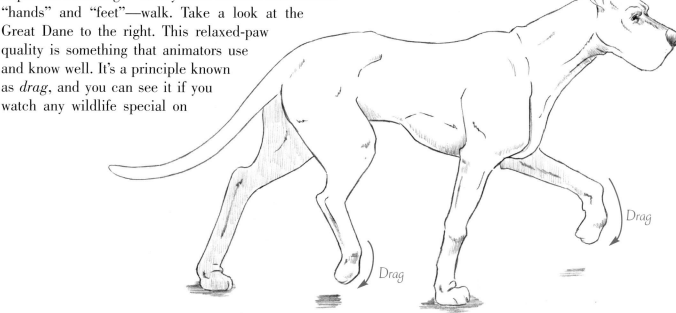

Drag

Drag

36

Doggy Paws

A dog's paws really relax when it sleeps.

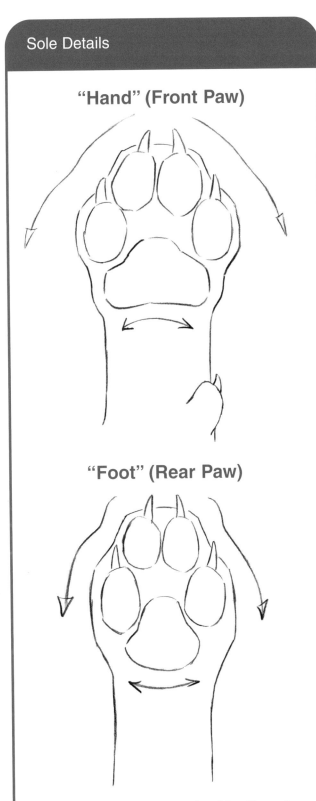

Sole Details

"Hand" (Front Paw)

"Foot" (Rear Paw)

On the front paws, the central pad is wider and curves down. The central pad on the rear paw is more narrow and curves upward. Also, the front paws are wider overall than the rear paws.

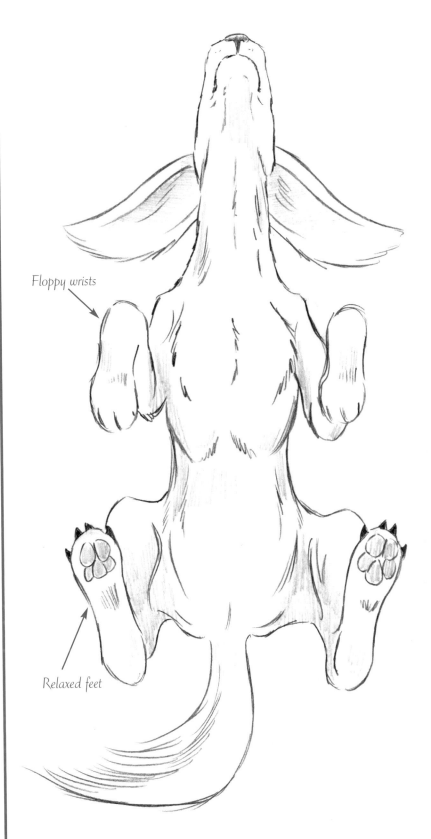

Floppy wrists

Relaxed feet

Whether we're talking about dogs or great apes, animals can't control their "hands" with the precision necessary to do intricate tasks. So, make sure you highlight the looseness of an animal's wrists and ankles to give them that imprecise feeling.

CONVEYING VOLUME

It's very important to create a sense that the animal is round, not flat. You do this by using curved *guidelines*, which artists often use to help them visualize things in the initial drawing. The curved dotted lines in the drawing below are the guidelines. I've sketched them in as dotted lines to make them stand out, but if you use these guidelines, sketch them in lightly as *solid* lines, not dotted ones, and erase them later when finishing the drawing. The bolder arrows are the lines that will show up on the final drawing (without the arrowheads, of course). They follow the same, curved direction as the dotted guidelines.

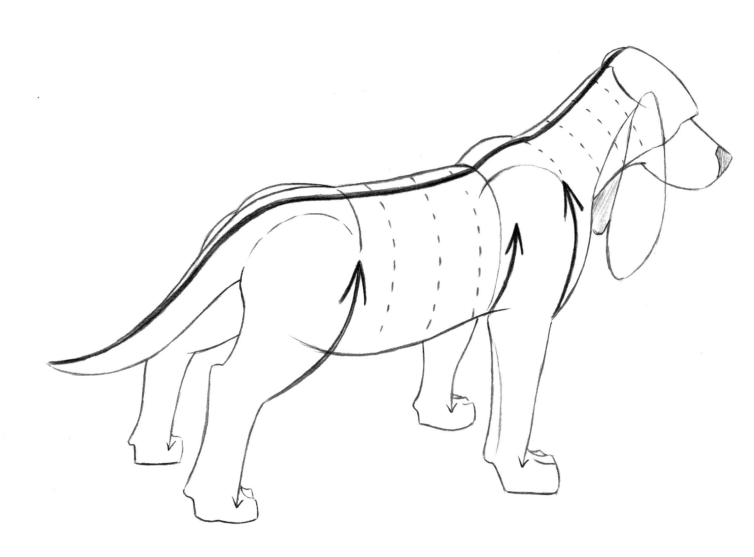

Note how the final, solid lines follow the curve of the dotted guidelines. Because of this, the form successfully conveys a feeling of roundness and volume. The lines also successfully divide the body into distinct sections; without these sections, the body would become an undifferentiated mass, without depth or definition.

OVERLAPPING LINES

When separate objects or when parts of the same object overlap, with parts of one object placed in front of another, the illusion of depth is created. To represent this effect in a drawing, you must have the lines of the closer object overlappng the lines of the more distant object, even if just by a little. This is vital in all drawings, regardless of the subject. I cannot emphasize this enough.

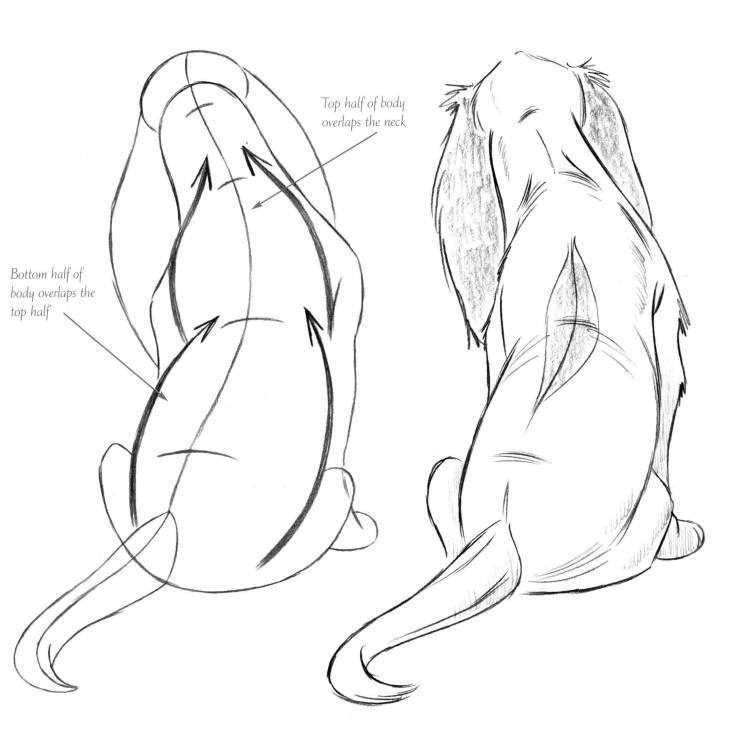

Top half of body overlaps the neck

Bottom half of body overlaps the top half

Notice how the lower set of arrows overlaps the upper set. Just this small amount of overlap is enough to create a sense of depth.

PERSPECTIVE

Unless an animal is facing you in an exact front pose or a precise side view, you'll see the effects of perspective on the animal. Briefly again, the rules of perspective state that things that are nearer to you appear larger than things that are farther away.

So, if you're drawing a four-legged animal in perspective, you must adjust the foot alignment to reflect this concept. Just like train tracks receding into the distance, the paws should be aligned along two intersecting sets of imaginary lines, called *vanishing lines*, which extend to *vanishing points*. (Note: Of course, train tracks are parallel and only *appear* to come together far off in the distance, but it's the appearance that's important here.)

To create vanishing lines, draw a horizon line over the figure. Place a vanishing point to the left and

another vanishing point to the right. Sometimes a vanishing point is placed off the page, as is right-hand vanishing point in this example. Align the vanishing lines with the dog's paws, as you see below. This will allow you acheive the correct leg placement in perspective. When this happens, the legs on the near side of the body will be a little lower on the page than the legs on the far side of the body.

When the legs are placed parallel to one another in a regular standing pose, the paws will create a rectangle shape as they fall on the vanishing line intersection points. When this happens, you know you've got the feet aligned correctly. This is just a quick concept to remember with all animals. You don't need to get your ruler out, but just keep it in mind, and use this page as a refresher when the opportunity comes up.

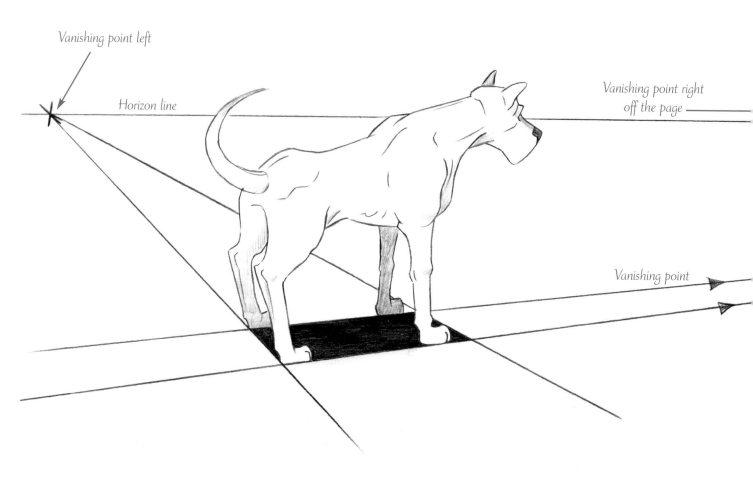

THE EFFECT OF GRAVITY

Gravity affects everything. It affected Newton. Without it, do you think he would have invented all those wonderful cookies? Moving right along. . . .

The legs hold up the back section of the dog. The "arms" hold up the front section. But the middle of the back—especially on long dogs—has no leg support at all, so it would look weird if it were perfectly straight and stiff as a board. The back has to sag a little in the middle as gravity pulls down on it. A long, low breed like the basset hound provides a good illustration of this.

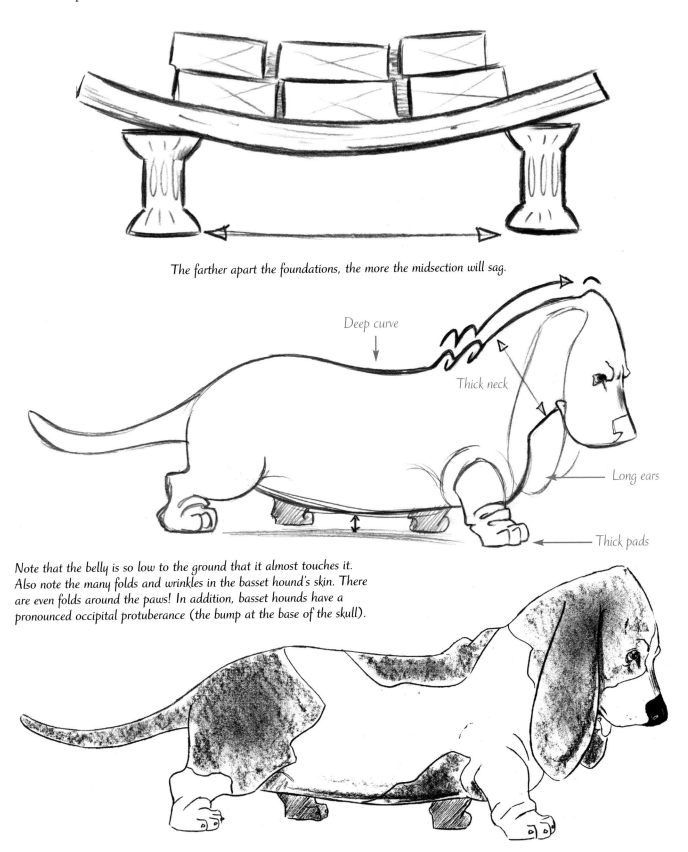

The farther apart the foundations, the more the midsection will sag.

Deep curve

Thick neck

Long ears

Thick pads

Note that the belly is so low to the ground that it almost touches it. Also note the many folds and wrinkles in the basset hound's skin. There are even folds around the paws! In addition, basset hounds have a pronounced occipital protuberance (the bump at the base of the skull).

THE WOLF

Dog and wolf DNA is so similar that some scientists believe these two animals, for all practical purposes, to be the same. Nonetheless, all debate aside, they certainly are close in appearance. But there are definite visual clues that, when appearing altogether, indicate—unmistakably—a wolf.

Wolves are more feral and ragged looking, with a slinkier gait. There's also something a little mysterious about them, almost darkly charismatic and elegant. When drawing a wolf, it's best to use a light touch, for although they're strong and can be fierce, they're much more agile and lighter boned than a dog of equal size.

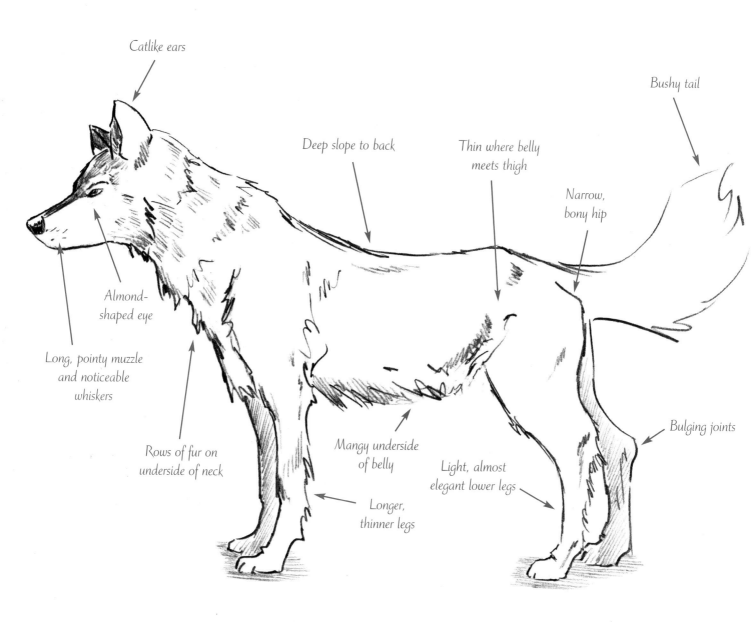

Catlike ears

Bushy tail

Deep slope to back

Thin where belly meets thigh

Narrow, bony hip

Almond-shaped eye

Long, pointy muzzle and noticeable whiskers

Bulging joints

Rows of fur on underside of neck

Mangy underside of belly

Light, almost elegant lower legs

Longer, thinner legs

Facial Details

While similar to dogs, wolves do have some subtle differences. You can follow the basic dog head construction (*see* pages 12–17), but you will need to tweak some of the details. For example, wolf eyes have a haunted yet alert look, as though they can pierce through miles of snowy trees to see their prey.

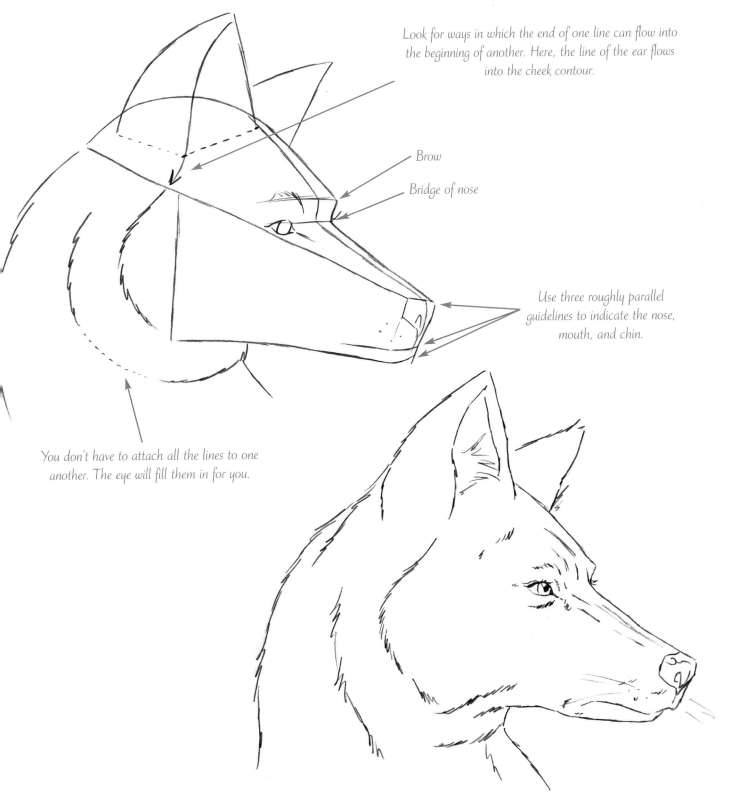

Look for ways in which the end of one line can flow into the beginning of another. Here, the line of the ear flows into the cheek contour.

Brow

Bridge of nose

Use three roughly parallel guidelines to indicate the nose, mouth, and chin.

You don't have to attach all the lines to one another. The eye will fill them in for you.

CATS

ere's a contradiction for you: Cats are pretty easy to draw, in a challenging kind of way. Here's what I mean. The foundation of the cat face, for example, is a combination of instantly recognizable elements: the circular head, the tiny nose, the puffy muzzle, those pointy ears, and the long whiskers. But there are subtleties to drawing a cat, and if you hope to draw felines with any flair, you'll have to master these, as well.

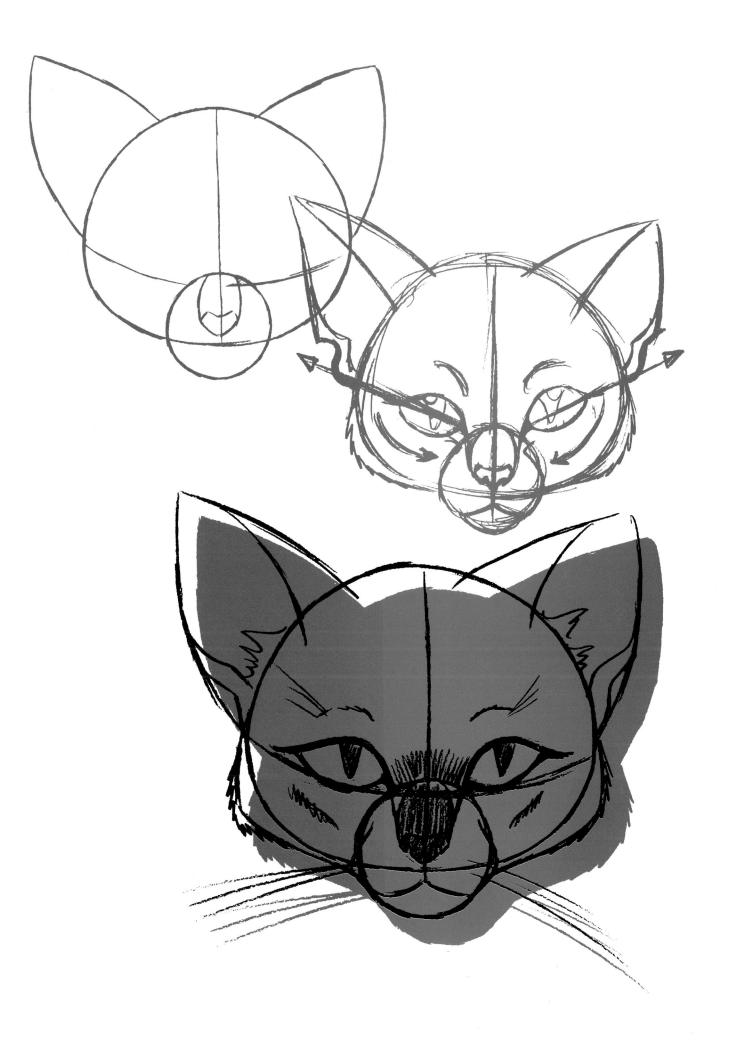

THE HEAD

What can make cat features a bit tricky to draw are the details, particularly those in the muzzle/eye area, which basically serves as one fused component. The reason for this is the fact that the bridge of the nose suddenly expands when it reaches the eyes, widening out and placing a lot of distance between the eyes. In addition, the nose is small and delicate but falls on a large, bushy muzzle that, in turn, sits on a chin that's pronounced yet delicate. And, don't forget the delicate mouth. All of this is concentrated in the center of the cat's face.

Front View

With the dog, I started with the profile, because the dog's long muzzle makes the profile the more interesting view. But cats have less pronounced muzzles, so the cat profile is not as dynamic; therefore, let's start with the front view.

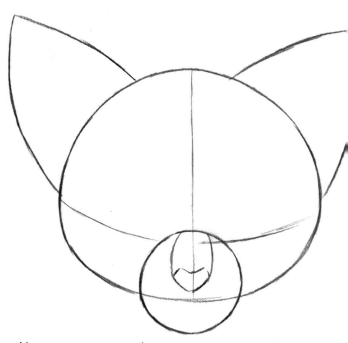

You can start your initial construction with two circles: a large one for the skull and a smaller one for the muzzle area. Place the eye line low on the head. The bottom of the nose should fall roughly in the center of the smaller circle.

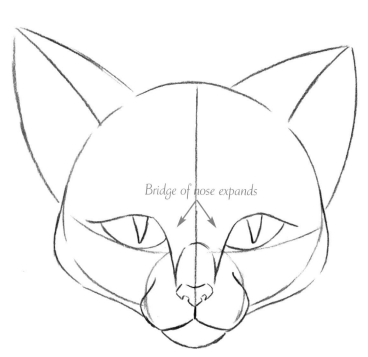

Bridge of nose expands

Place the bottom of the eyes on the eye guideline.

Four things give the eyes that classic catlike look: the almond shape, the narrow pupils, the thick outlines, and the upward slant.

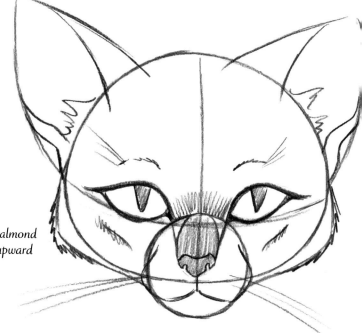

It might be tempting to think of cats as miniature lions, but they're not even close in terms of facial construction. They're really their own type of animal. (Compare with pages 116–117.)

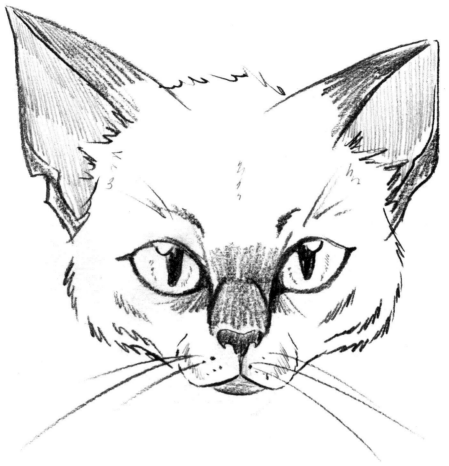

The Angle of the Eyes

Tilt the eyes up at the ends to give them the classic "catlike" appearance. The arrows under the eyes indicate the contours of the cheeks, which are represented by the ruffles of fur.

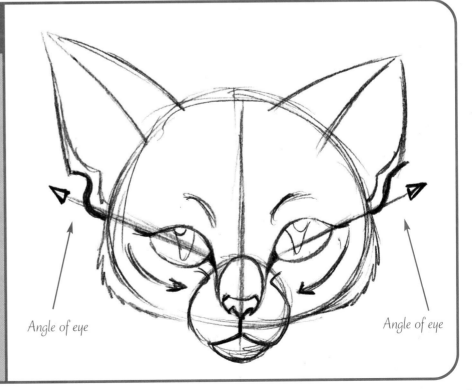

Angle of eye

Angle of eye

3/4 View

The 3/4 view shows why the vertical center guideline is so useful. Drawing the center line down the head can give you a feeling of depth, as it continues over the bridge of the nose where the line extends beyond skull.

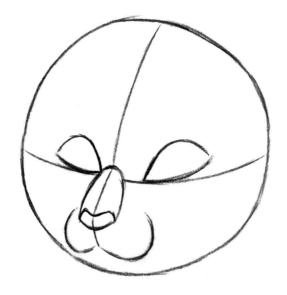

Start with a simple sphere for the head.

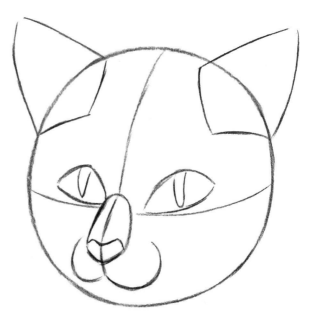

Notice how the ears wedge inside of the head; they don't just sit on top of it.

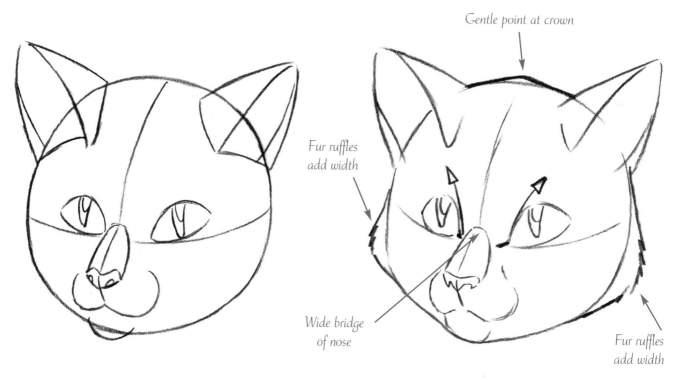

Gentle point at crown

Fur ruffles add width

Wide bridge of nose

Fur ruffles add width

Add a delicate chin so that it sticks a little out of the outline of the head.

Notice how the bridge of the nose widens into the countour lines on both sides of the inner eyes.

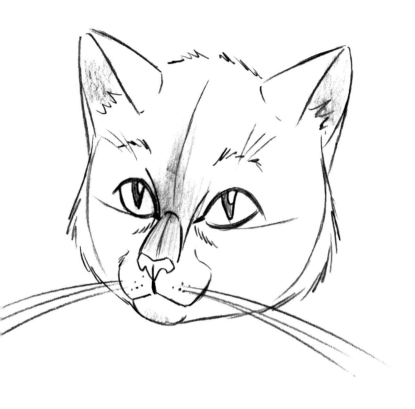

Look at how the center line helps to keep the angles of the muzzle clear.

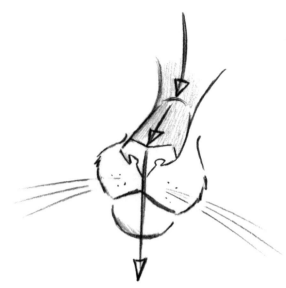

The Cat Nose

The cat's nose is an odd shape to draw from scratch. Begin with a basic shape and slowly chip away at it.

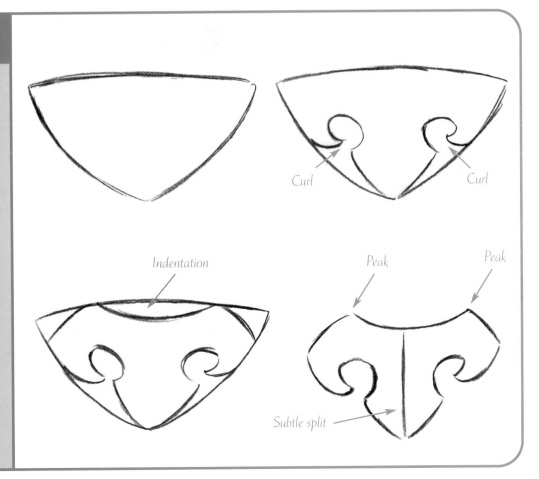

Curl *Curl*

Indentation *Peak* *Peak*

Subtle split

49

Profile

The cat has a particularly short nose, which makes its profile one of the simplest to draw in the animal kingdom. The planes of the head are easy to follow. The only part that might prove deceptive is how thick the neck is at the base of the skull. The cat has small, delicate features. A thick neck suggests a powerful, muscular animal. Although it seems contradictory to put the two elements on the same creature, it's not in this case.

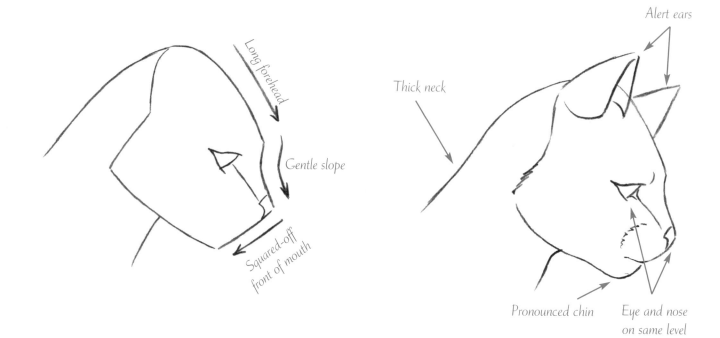

Long forehead

Gentle slope

Squared-off front of mouth

Alert ears

Thick neck

Pronounced chin

Eye and nose on same level

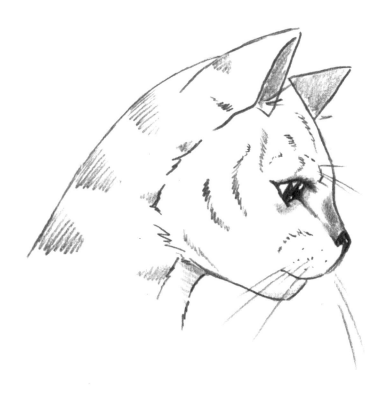

Note the cat's posture when relaxed: The neck curves forward, and the head tilts slightly downward.

THE "SLEEPING" EYE

There's nothing more delicious than a catnap. Cats spend a lot of time sleeping, so it's important to know how to draw a closed (*i.e.*, sleeping) cat eye. Cats also close their eyes when purring, when relaxing, and when they're pleased. When cats sleep, their lids seem to close as if they weigh a thousand pounds. It's important to get the correct eye position—a cross between a shut eye and a squint.

Wrong

Too thin. The closed eye is never just a single line.

Right

Always show some thickness, as if you could almost see some eyeball between the eyelids—but not quite. Note that the eye isn't a simple arching line: It dips down sharply toward the nose and then flares up at the end toward the ear.

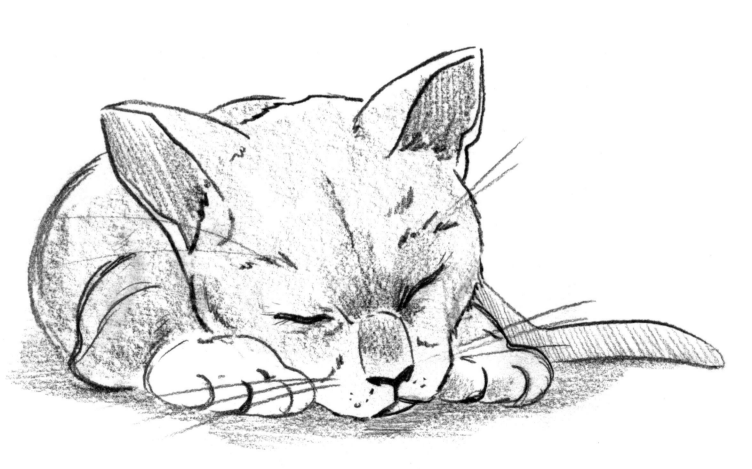

RENDERING FACIAL DETAILS

Contours

The cat's head is basically spherical, so it is important to add contour lines to the interior of the head shape in order to define it. Add only the amount necessary to do the job, however. With other animals, you can add contour lines liberally, as accents. But since you're using contour lines on the cat to establish the very structure of the head shape, adding additional lines would only detract from the foundation you're trying to establish.

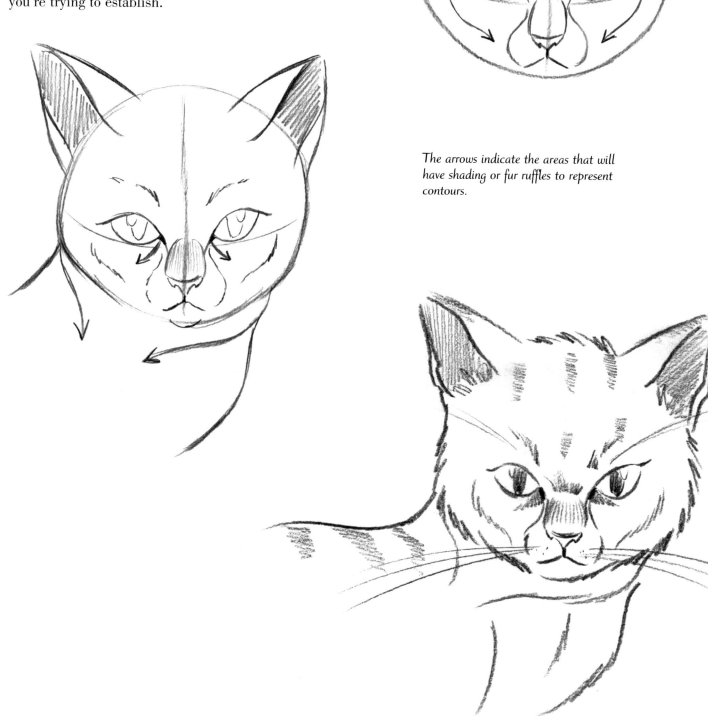

The arrows indicate the areas that will have shading or fur ruffles to represent contours.

Line Quality

Some cats are just balls of fuzzy fur with four legs. They look like they stuck their paws in an electric socket. You can't draw these fuzzy guys with a sleek, straight line, because it would look wrong. Of course, you should make your initial, rough sketch with a regular line. But when tracing over your drawing to finish it, use a textured, zigzag line. The fuzzier you want your cat to be, the more zigzagged the line should be.

Whisker Placement

Cats have particularly long whiskers. The three places you should add them to your drawings are—in order from longest to shortest—on the muzzle, the eyebrows, and the inner part of the ears.

Straight

Interrupted

Choppy (Light)

Choppy (Bold)

Note that when the lines are broken, they are broken diagonally. This conveys the texture of fur.

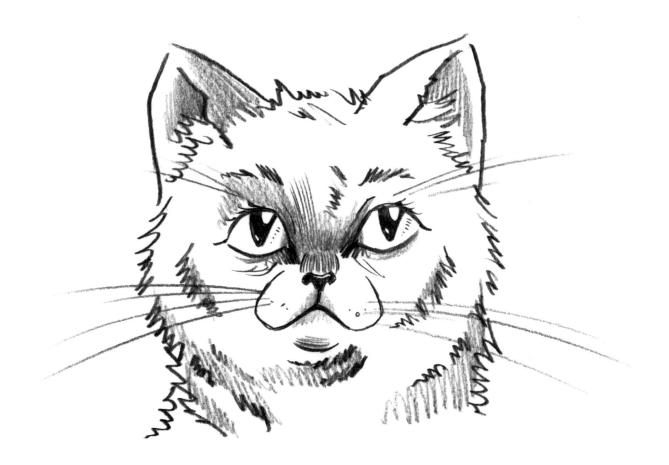

STANDING

Cats are bottom heavy. The rump is much thicker than the chest. The back legs are usually bent at the knees, and the trunk of the body is carried fairly low to the ground. By looking at the back half of a cat, you would never guess it's the world-class athlete it actually is. The front half of the cat, however, is a different story. The head is small and aerodynamic, the neck is strong looking, and the chest and shoulders are pronounced. The arms are strong and tapered, with the small feet indicative of speed.

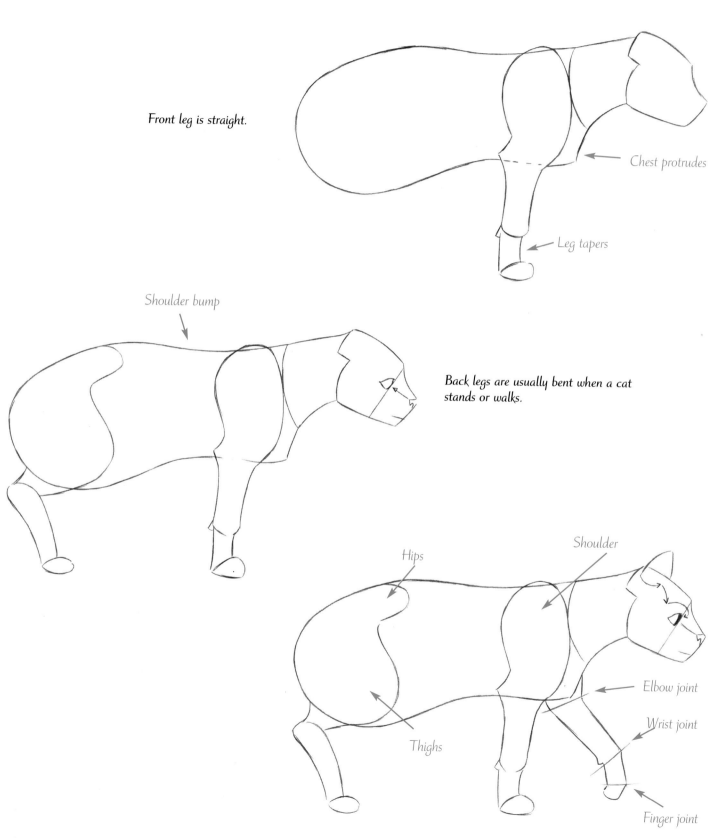

Front leg is straight.

Chest protrudes

Leg tapers

Shoulder bump

Back legs are usually bent when a cat stands or walks.

Hips

Shoulder

Thighs

Elbow joint

Wrist joint

Finger joint

54

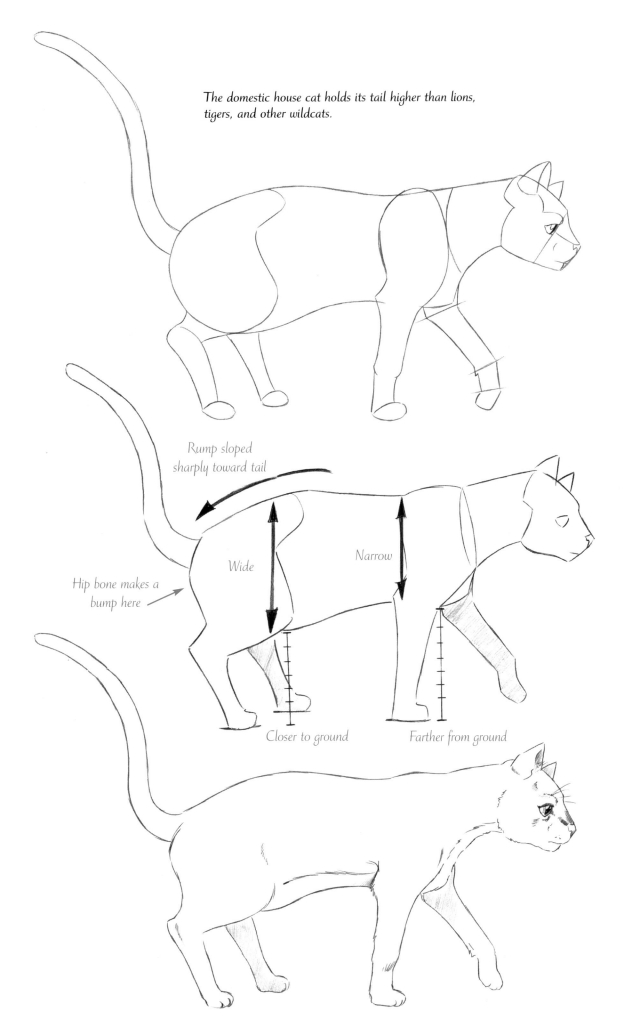

The domestic house cat holds its tail higher than lions, tigers, and other wildcats.

Rump sloped sharply toward tail

Wide

Narrow

Hip bone makes a bump here

Closer to ground

Farther from ground

SITTING

Cats have a particularly tidy look about them when they sit. They tuck their arms in close to their bodies. The body bunches up and can be drawn with two circles. It's a pleasing look and easy to draw. Unlike dogs, horses, and lions, cats have very round bodies, with only soft curves and bends.

Side View

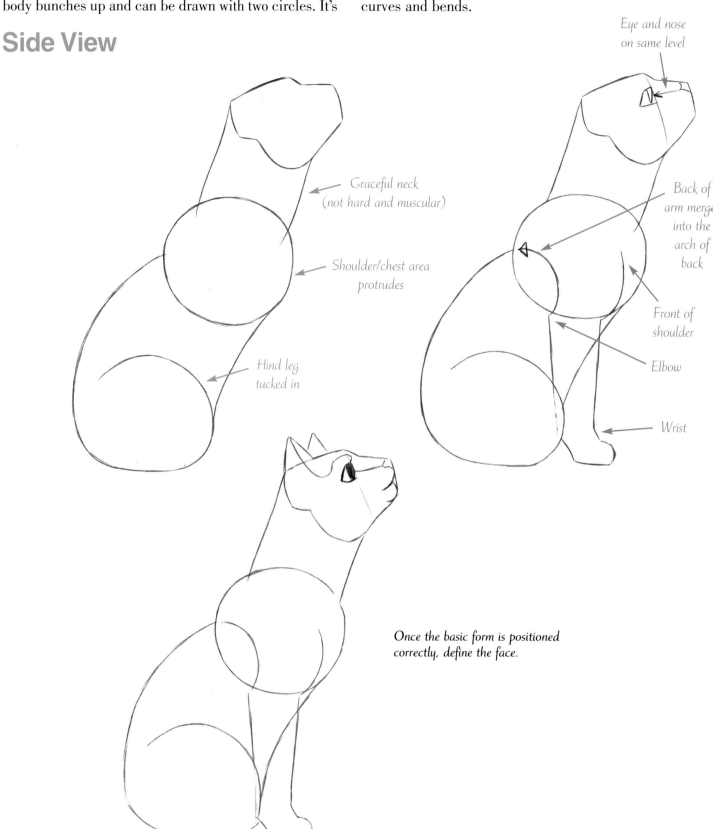

Graceful neck
(not hard and muscular)

Shoulder/chest area
protrudes

Hind leg
tucked in

Eye and nose
on same level

Back of
arm merges
into the
arch of
back

Front of
shoulder

Elbow

Wrist

*Once the basic form is positioned
correctly, define the face.*

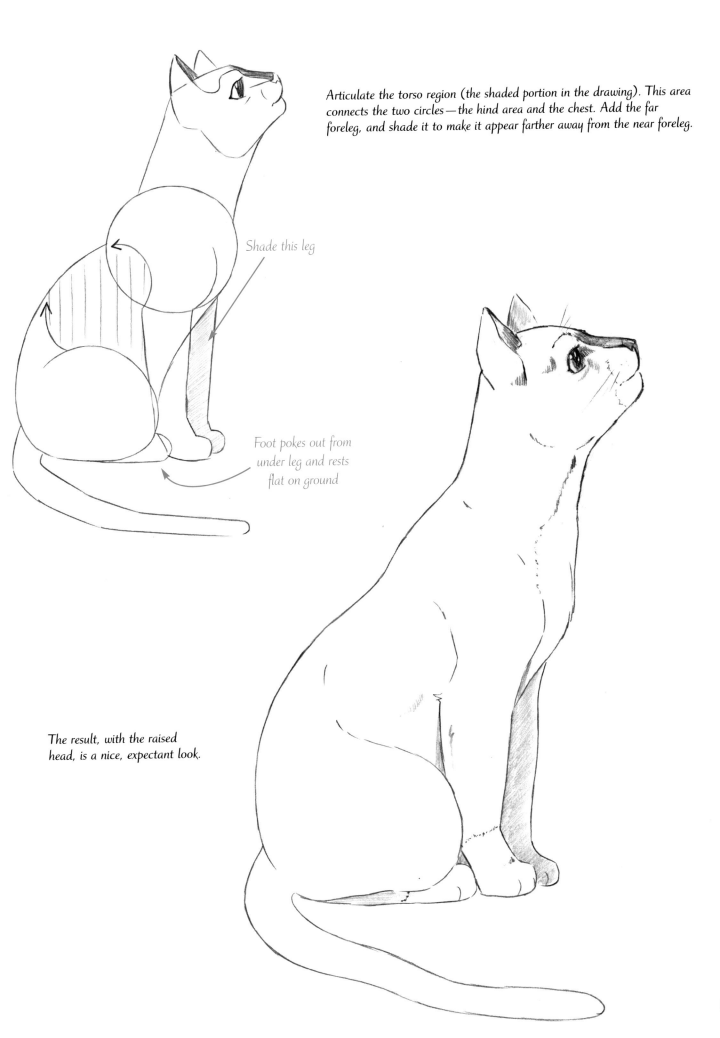

Articulate the torso region (the shaded portion in the drawing). This area connects the two circles—the hind area and the chest. Add the far foreleg, and shade it to make it appear farther away from the near foreleg.

Shade this leg

Foot pokes out from under leg and rests flat on ground

The result, with the raised head, is a nice, expectant look.

The Arched Back

When a cat sits, its back always arches outward (convexly). For the back to dip down toward the ground, the cat must be supporting itself on all four legs. But whether the cat is standing or sitting, there will always be a noticeable rise in the shoulder area.

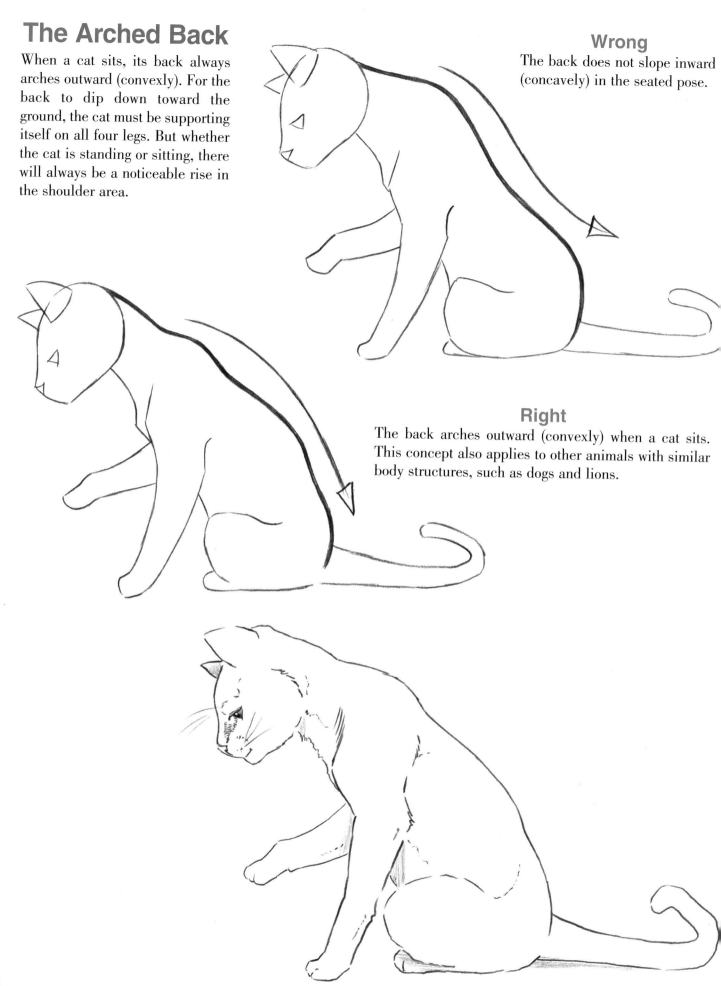

Wrong
The back does not slope inward (concavely) in the seated pose.

Right
The back arches outward (convexly) when a cat sits. This concept also applies to other animals with similar body structures, such as dogs and lions.

Front View

In the front view, the construction of the seated pose is very different from that of the seated pose in the side view. But happily, it's even easier to draw. The most notable thing is that the chest and its fur overlap the tops of the arms (forelegs). Therefore, the front legs are greatly simplified. You don't even need to draw the elbows, which can be a somewhat complicated affair on animals.

In the front view, however, it becomes necessary to articulate the individual "fingers" of the paws. They should look very round and harmless, with the claws retracted.

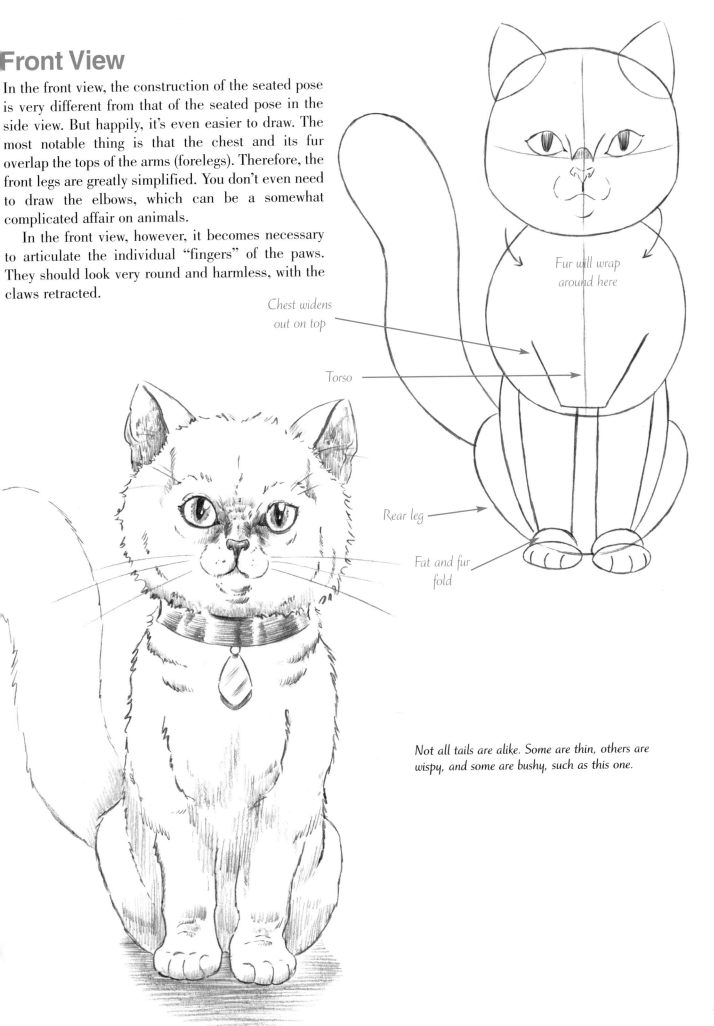

Fur will wrap around here

Chest widens out on top

Torso

Rear leg

Fat and fur fold

Not all tails are alike. Some are thin, others are wispy, and some are bushy, such as this one.

OTHER CAT POSTURES

Reclining and Relaxing

When cats relax and recline, they often lie on their side. This pose might seem uncomfortable to you and me, but a cat can hold it for an extended period. It might look easy to prop your back off the ground like this, but I could only do it if I had a personal trainer yelling in my face.

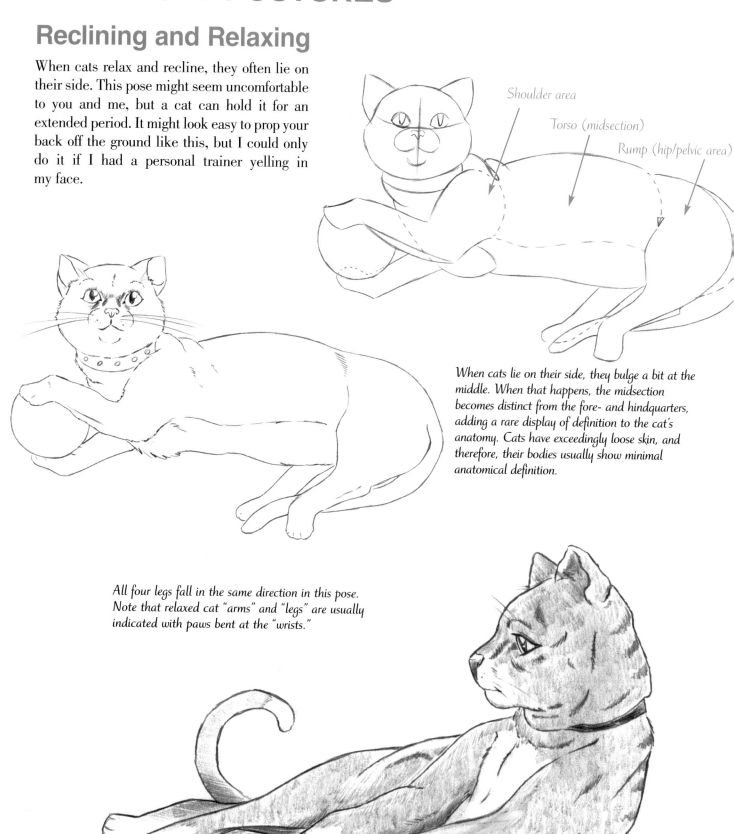

Shoulder area

Torso (midsection)

Rump (hip/pelvic area)

When cats lie on their side, they bulge a bit at the middle. When that happens, the midsection becomes distinct from the fore- and hindquarters, adding a rare display of definition to the cat's anatomy. Cats have exceedingly loose skin, and therefore, their bodies usually show minimal anatomical definition.

All four legs fall in the same direction in this pose. Note that relaxed cat "arms" and "legs" are usually indicated with paws bent at the "wrists."

Concentrating

Cats have a fierce and unwavering ability to focus. They can target their gaze on a moving object like a heat-seeking missile. Note the eye contact of this cat on the mouse. When a cat is lurking and ready to strike, its eyes widen and its eyeline concentrates on the shortest line of sight to the object it is tracking. It never looks at the object sideways or over its shoulder.

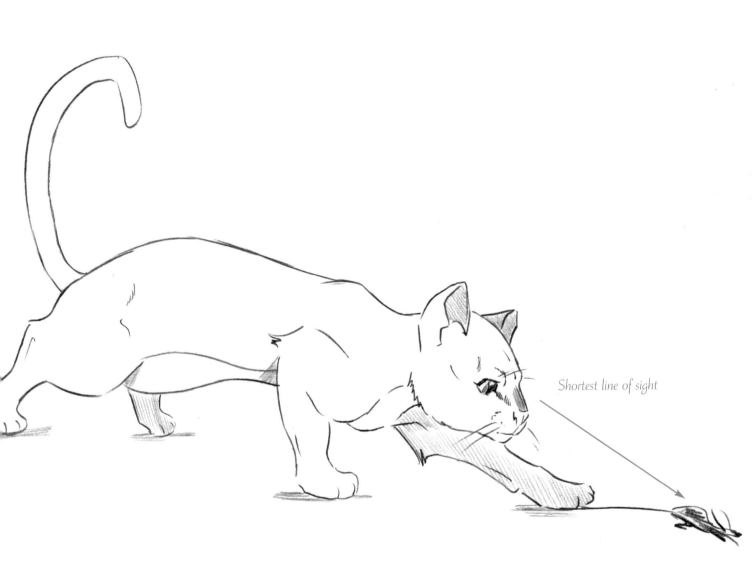

Shortest line of sight

HORSES

The horse is among the most popular animals to draw. It's also challenging for many beginning artists. Though I used to feel the same way, I now find the horse one of the easier animals to illustrate. Once I learned and understood horse anatomy, and it really made sense to me, could I construct the horse body as easily as if I were playing with a set of blocks. Don't worry, you can, too.

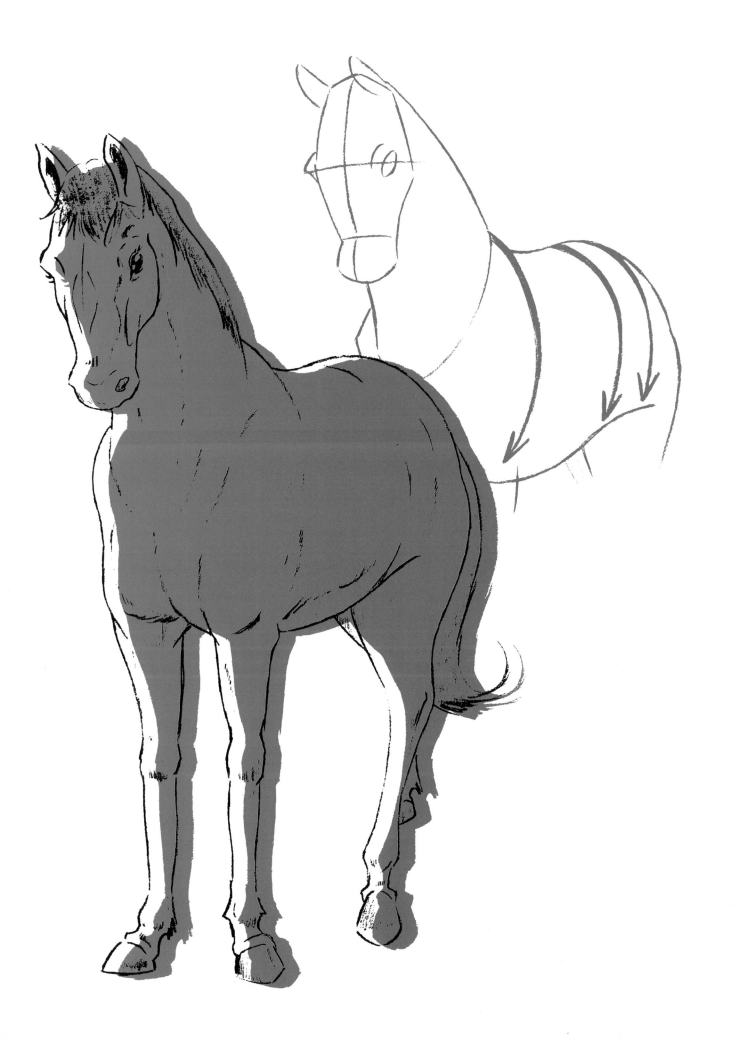

THE HEAD

With horses, nothing is hiding their anatomy. It's all out there for everyone to see—with no fur or fat covering it up and making it a mystery. This gives artists a distinct advantage. Once you know where everything goes, anatomically, you can see the evidence of it on the animal just by looking at it.

The common mistake people make when drawing the horse is beginning with too complex a shape. But you can draw the overall shape of the horse's head with just a few lines. And, once that's in place, the rest is just a matter of "carving" and shaping.

Profile

Like the dog, the horse has an elongated head with a pronounced muzzle that is often easier to capture in the side view, so we'll start with that.

Start with what is, basically, a tapered rectangle. The eye is an almond shape and is angled vertically.

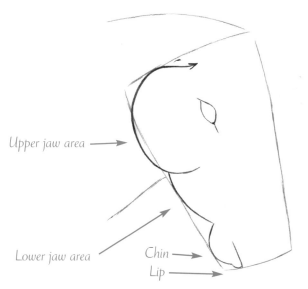

Upper jaw area

Lower jaw area

Chin

Lip

"Carve" contours into the underside of the head and jaw. We do this because this is where much of the "action" is on the horse's head.

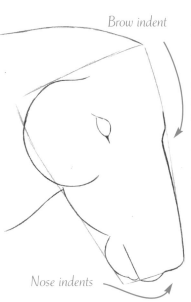

Brow indent

Nose indents

Next, delineate the brow. Then, start to tweak the nostril and mouth area. Note that the horse has a visible overbite that must be indicated. Now, after barely starting, you're already seeing your drawing start to take shape. By drawing *into* the initial rectangular shape, rather than drawing *outward* from it, you're much less likely to go wrong with the proportions.

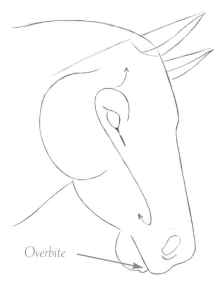

Overbite

Note that the nostril isn't a circle but an irregular oval. The contours around the eye circle back around toward the nose. A small bone above the eye turns back toward the ear and blends back into the head, causing a deep indentation right above the eye that's visible on all horses. The arrows in the sketch indicate these things.

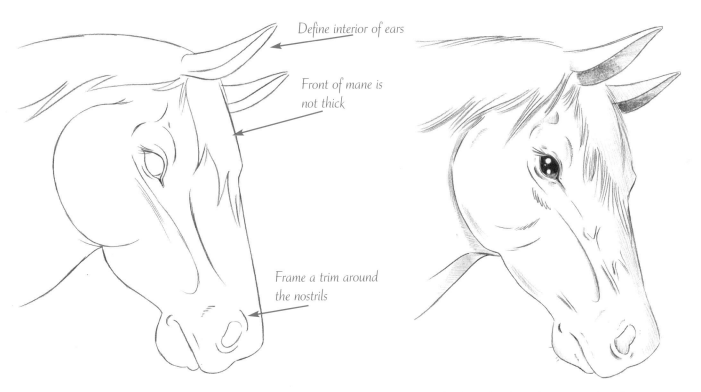

Define interior of ears

Front of mane is not thick

Frame a trim around the nostrils

Follow the labels to add some details.

Add some finishing details to the mare and to the eye.

The Other Side

Some artists favor one side of the head for the profile over the other. But it's important to be able to draw your subject facing all directions. You don't want to draw a group of animals all facing to the right simply because you can't draw any other position.

You will notice that the profile below is slightly different from the one in the step-by-step sequence in that this horse tilts its head a bit toward us, so we can see some of the far eye. From this angle you can see that the long part of the horse's nose isn't exactly straight. There's actually a very subtle curve where the bone of the skull ends and the cartilage begins. (*See* pages 68–69 for a similiar view.)

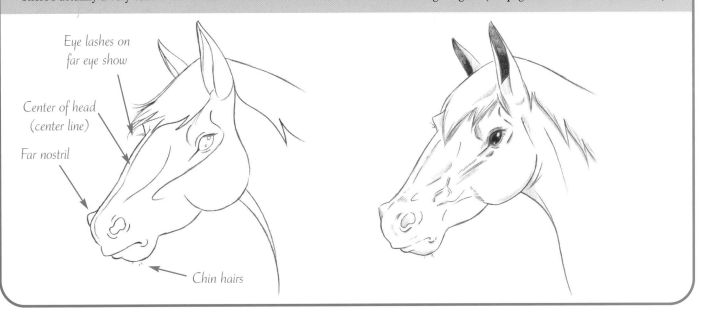

Eye lashes on far eye show

Center of head (center line)

Far nostril

Chin hairs

Front View

In the front view, you can see how long and thin the horse's head actually is. This angle is tailor-made for a precise step-by-step approach. Of course, you can always draw things more loosely if you'd like, but if you want a sure-fire method to learn the front view, try the shapes and proportions here.

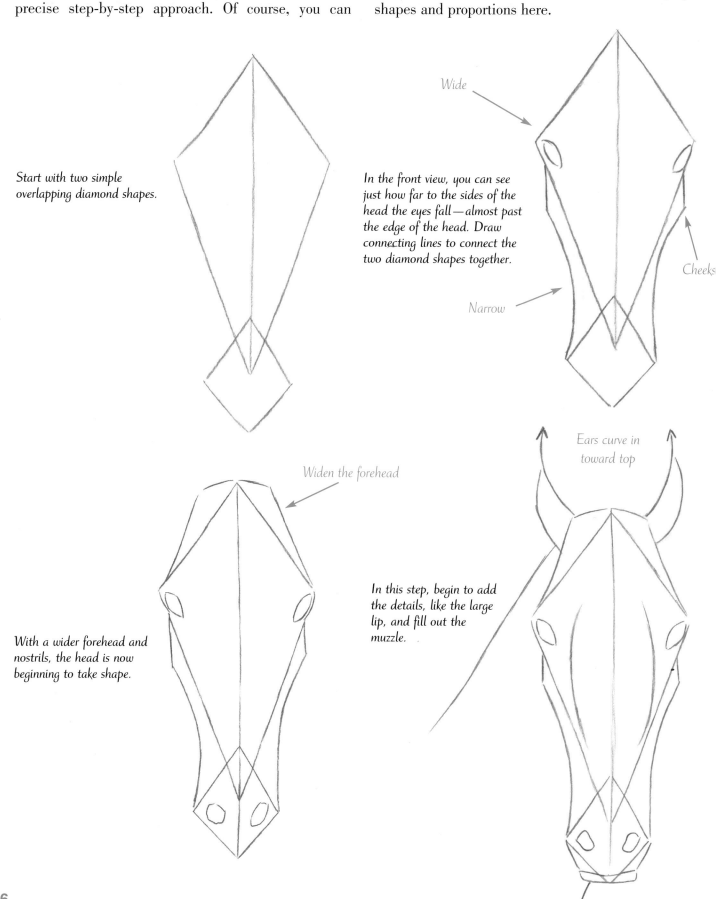

Start with two simple overlapping diamond shapes.

Wide

In the front view, you can see just how far to the sides of the head the eyes fall—almost past the edge of the head. Draw connecting lines to connect the two diamond shapes together.

Narrow

Cheeks

Widen the forehead

With a wider forehead and nostrils, the head is now beginning to take shape.

Ears curve in toward top

In this step, begin to add the details, like the large lip, and fill out the muzzle.

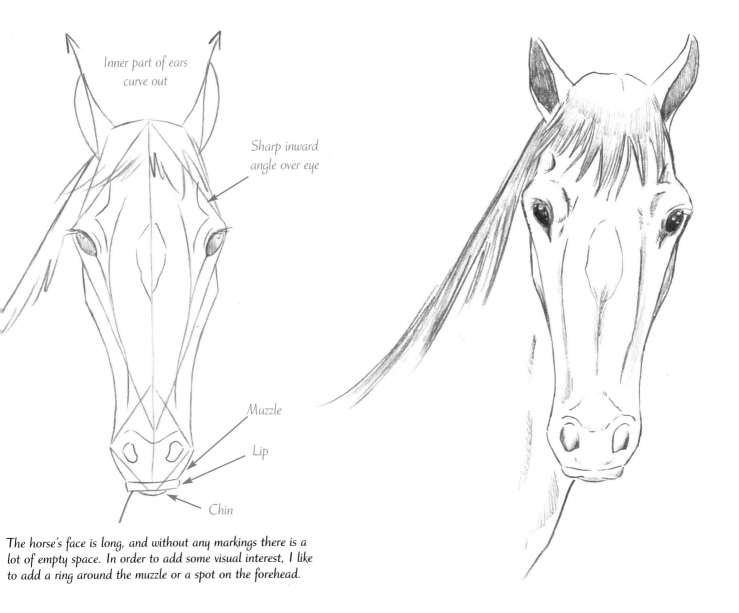

Inner part of ears curve out

Sharp inward angle over eye

Muzzle

Lip

Chin

The horse's face is long, and without any markings there is a lot of empty space. In order to add some visual interest, I like to add a ring around the muzzle or a spot on the forehead.

The Horse Eye

A horse's eye does not have any white space. It is just a huge, black, shiny pupil. Add several shine spots to make the eye look moist and glistening.

Unlike human eyelashes, horse eyelashes are drawn down and away from the face, not up toward the eyebrow area. This is true for elephant eyelashes, too.

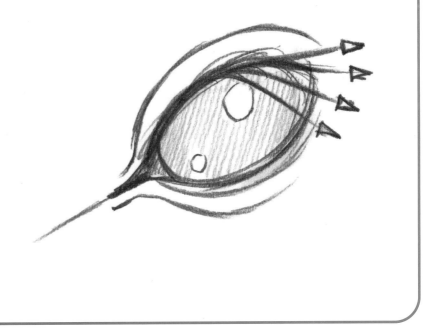

3/4 View

This is a striking head angle for the horse, primarily because it highlights the sweeping way in which the neck curves as it attaches to the head.

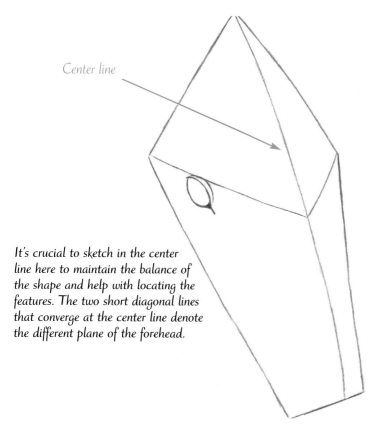

Center line

It's crucial to sketch in the center line here to maintain the balance of the shape and help with locating the features. The two short diagonal lines that converge at the center line denote the different plane of the forehead.

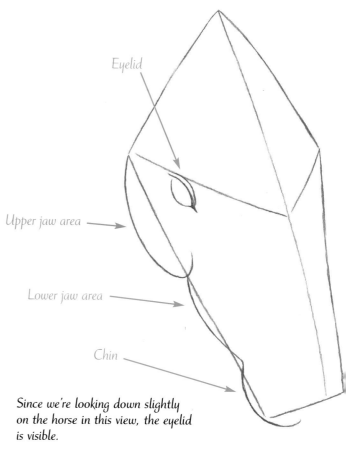

Eyelid

Upper jaw area

Lower jaw area

Chin

Since we're looking down slightly on the horse in this view, the eyelid is visible.

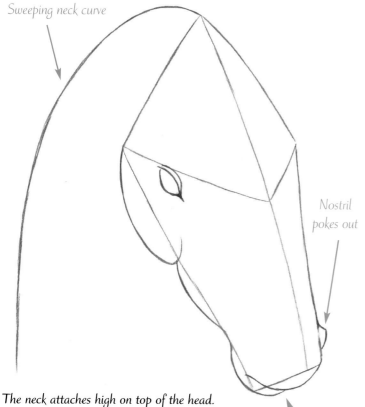

Sweeping neck curve

Nostril pokes out

The neck attaches high on top of the head.

Overbite

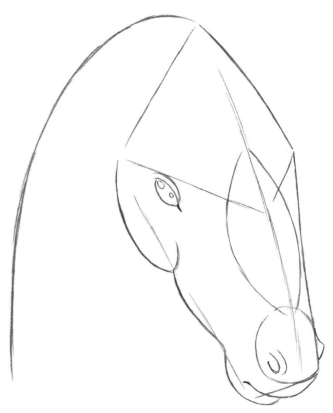

The stretched oval in the middle of the horse's face is a good guideline for the interior contour lines of the bridge of the nose, which will be visible in the final drawing.

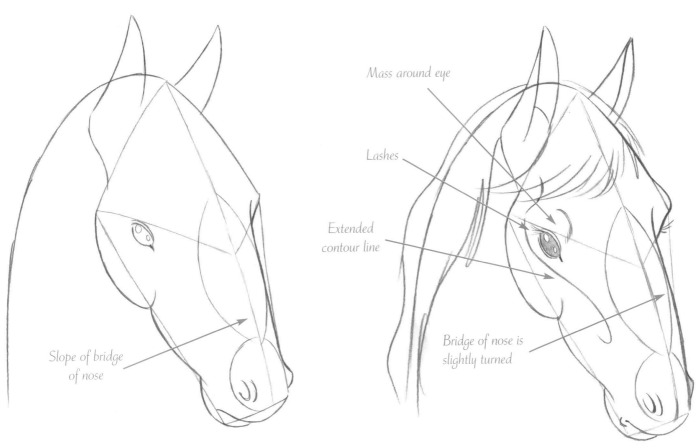

Mass around eye

Lashes

Extended
contour line

Slope of bridge
of nose

Bridge of nose is
slightly turned

The ear attaches to the area near the upper
portion (the base) of the jaw.

Now that the drawng looks like a horse, we begin to
add the details to turn the basic construction into a
drawing. Define the contours, add details, and refine
the lines with subtle curves.

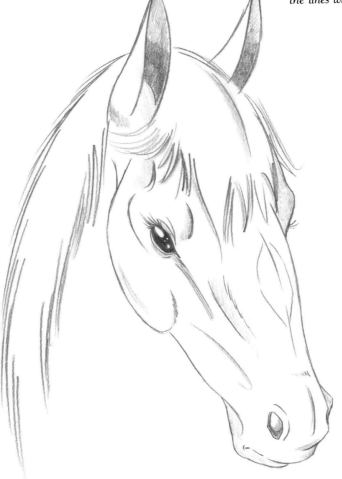

SIMPLIFIED ANATOMY

Horse anatomy should remind you a great deal of the dog anatomy we covered previously. As you start to notice the similarities across the range of species in this book, you'll develop the intuitive understanding necessary to draw animals without having to constantly stop and refer to anatomy books.

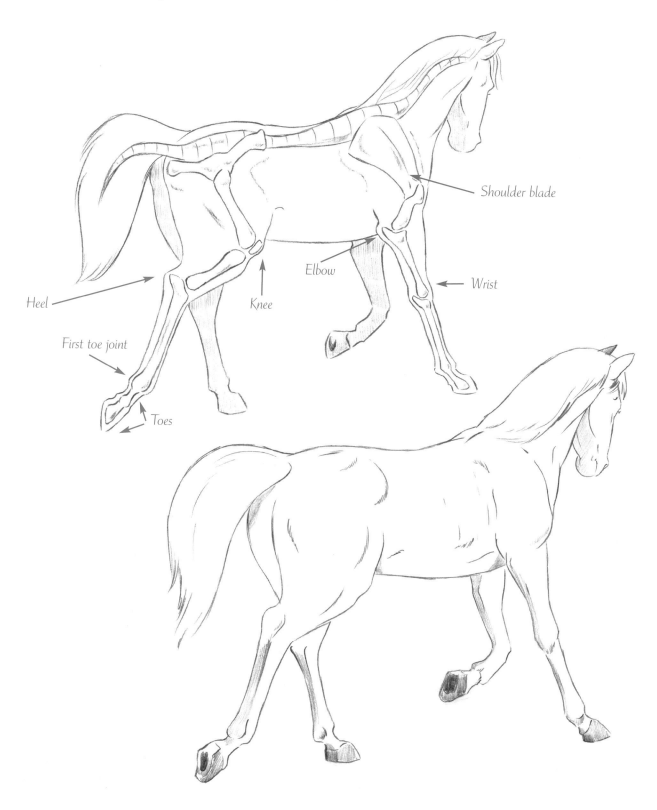

Shoulder blade

Elbow

Wrist

Heel

Knee

First toe joint

Toes

BODY CONTOURS

To represent the contours of the horse's body, it helps to look at the lines of the muscles—what I call the "line flows." These line flows indicate the way the muscles show through to the surface of the animal, creating the contours we see. They're affected by the way the horse moves, bends, twists, and carries itself—and by gravity.

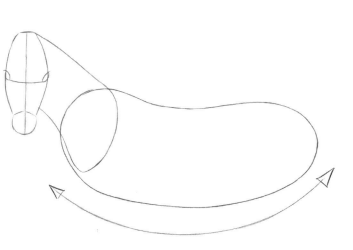

The long torso results in considerable sway in the horse's belly.

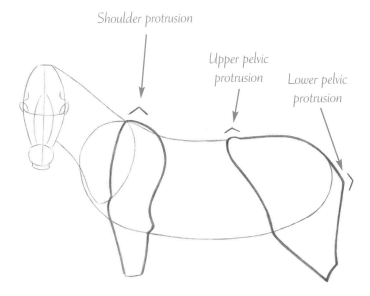

Shoulder protrusion

Upper pelvic protrusion

Lower pelvic protrusion

Underlying bones and muscles, as shown above, create the contours seen on the surface.

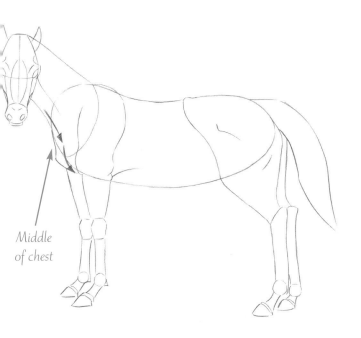

Middle of chest

The lines of the neck flow into the chest. The line of the neck continues down to become the center line of the chest.

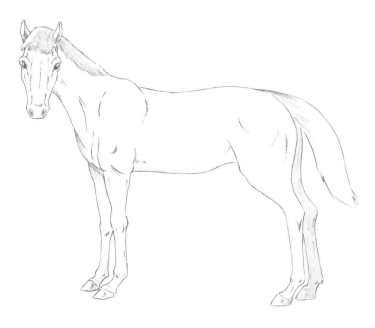

For the final drawing, break up some of the connected lines you drew in the previous step. The viewer's eye will connect the dots without us having to do it for them.

NECK AND CHEST MUSCLES

The horse's neck is thick and impressively muscular. The contours resulting from these muscles run down the length of the neck and are apparent to the eye. They also add to the grace of the neck, so use them to your advantage by letting them flow from the neck to the chest. When one line connects seamlessly to another, the result is always pleasing to the eye. Horses also have thick and clearly defined chest muscles, especially at the point at which the neck and chest meet. When you draw the horse at any angle in which the neck and chest are visible, you must also indicate the chest muscles; they give the horse its stature.

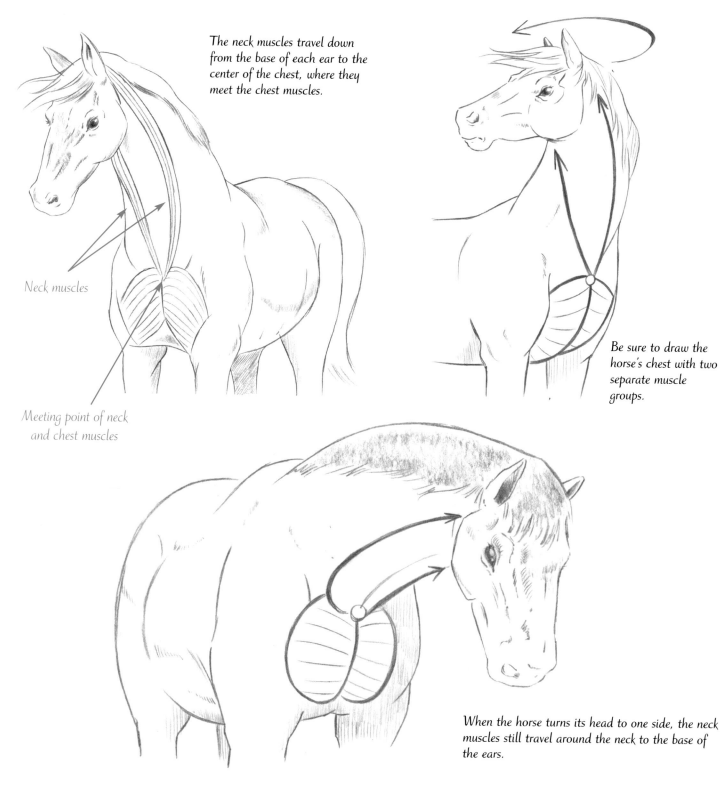

The neck muscles travel down from the base of each ear to the center of the chest, where they meet the chest muscles.

Neck muscles

Meeting point of neck and chest muscles

Be sure to draw the horse's chest with two separate muscle groups.

When the horse turns its head to one side, the neck muscles still travel around the neck to the base of the ears.

The Neck and Chest in Relation to the Whole Body

It's helpful to view the neck and chest as part of the whole system. So, here's a nice 3/4 view of the entire body. Note how prominent the chest is. Were you to leave out the defining features of the chest muscles, your horse would lose a lot of its "horseness."

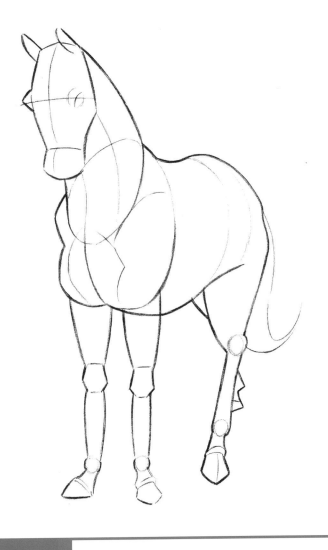

A Note about Volume

Sketching in several progressive and arching contour lines around the body can help you give the torso the illusion of roundness and solidity. The arrows in the illustration show you where to place these contours.

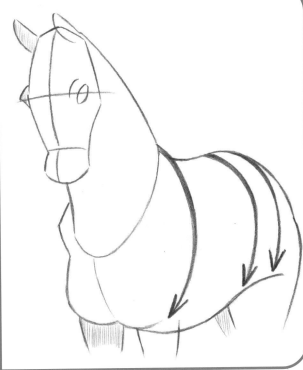

73

THE LEGS

To draw a horse's legs convincingly, pay attention to the direction of the leg bones. In the examples below, I've used arrows to indicate—in a simplified way—the angles of the different sections of the legs. This should help you begin to understand which way the limbs should be configured, no matter what kind of stance or posture the horse assumes. Drawing arrows, or any simple stick shapes, as simplified legs, is a helpful way to begin any sketch. If you mess up, these guidelines are easy to erase and adjust. Better to start this way than to render a beautiful foreleg, only to realize later that you laid out some of the joints incorrectly and must redraw the entire limb. Once the sticks are in place and look right, draw the legs around them and erase the sticks.

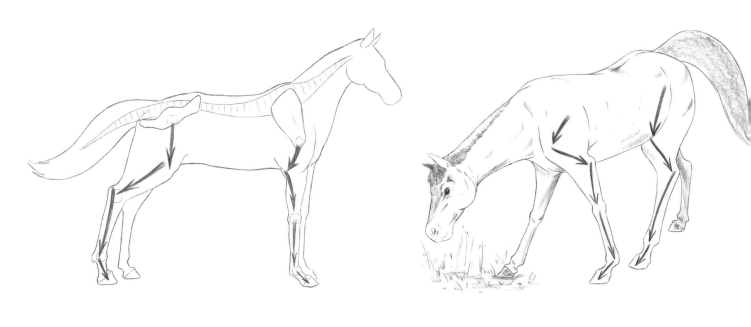

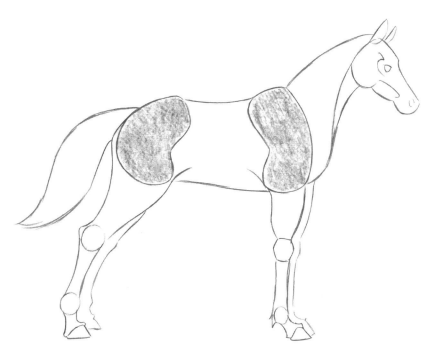

Fore- and Hindquarters

Part of the legs amd the horse's fore- and hindquarters are large, muscular areas composed of many individual muscle groups. But you can draw them as two general masses (the gray areas to the left) without sacrificing any of the animal's power and grace.

The Horse's Heel

The lower hind legs of a horse—like those of most ungulates (hoofed animals)—are very skinny. This is due to the fact that top of the "heel" bone is higher off the ground on the horse than it is on most nonhoofed mammals. Compare it to that of the elephant, bear, and human. The horse's heel is the highest.

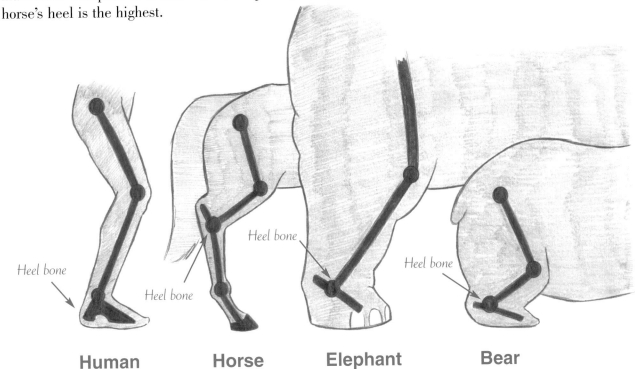

Heel bone

Heel bone

Heel bone

Heel bone

Human **Horse** **Elephant** **Bear**

The Hoof

As mentioned above, and unlike the dog and cat (or bear and elephant on pages 96 and 126), the horse is a hoofed animal. It doesn't have "hands" and "feet" with "fingers" and "toes"; its "fingers" and "toes" are "fused together" in the hoof, rather than made up of individual bones. And do you know what a hoof really is? One gigantic, hard-as-rocks nail.

The most important thing to note here is the angle at which the hoof meets the leg: It's always at a diagonal. If the hoof you've drawn looks like a block or is a little off, chances are you haven't drawn it at the correct angle. Show the most hoof in the front, and from there, angle back, on a diagonal, toward the rear—where the hoof narrows.

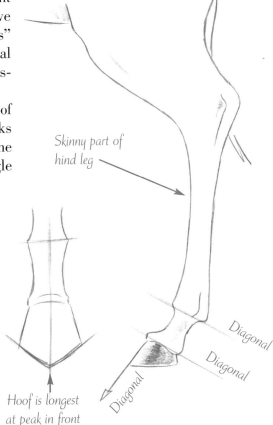

Skinny part of hind leg

Diagonal

Diagonal

Diagonal

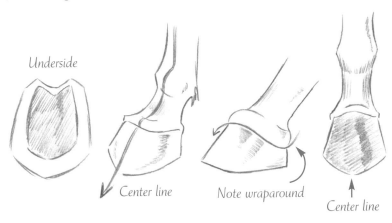

Underside

Center line

Note wraparound

Center line

Hoof is longest at peak in front

WALKING

This sounds obvious, yet it's remarkably easy to overlook: When a four-legged animal walks, it must have at least one leg from each side of its body on the ground at all times. If, at any point in the walk, it were to have, say, its left front *and* left rear legs off the ground at the same time, it would topple over! When the back leg lands, the front leg on the same side rises. When the front leg hits the ground, the rear leg on the same side rises, and so on. If you keep it that simple, you'll avoid confusion and create clear, convincing poses.

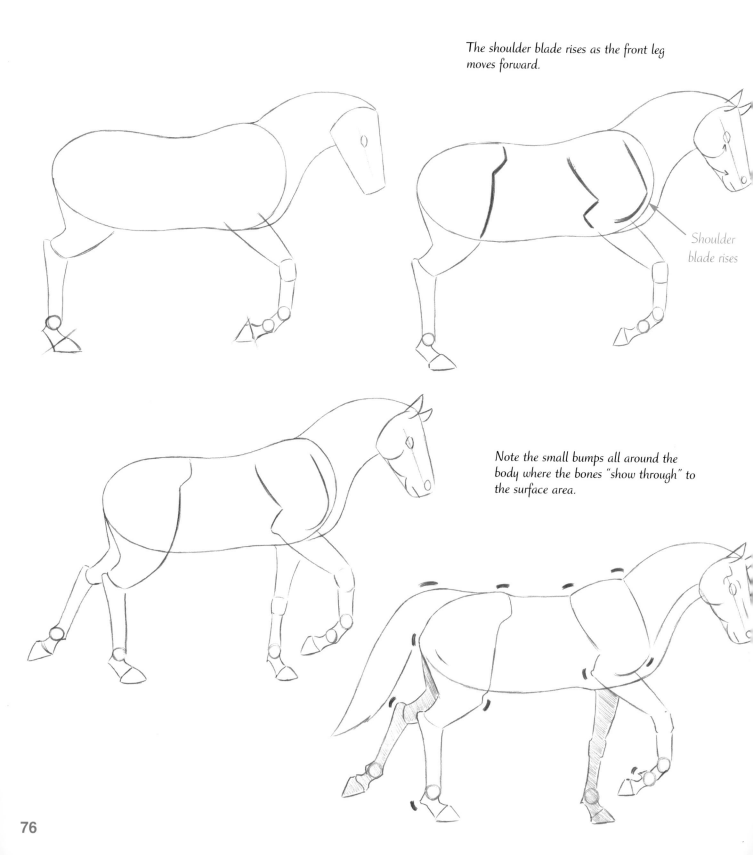

The shoulder blade rises as the front leg moves forward.

Shoulder blade rises

Note the small bumps all around the body where the bones "show through" to the surface area.

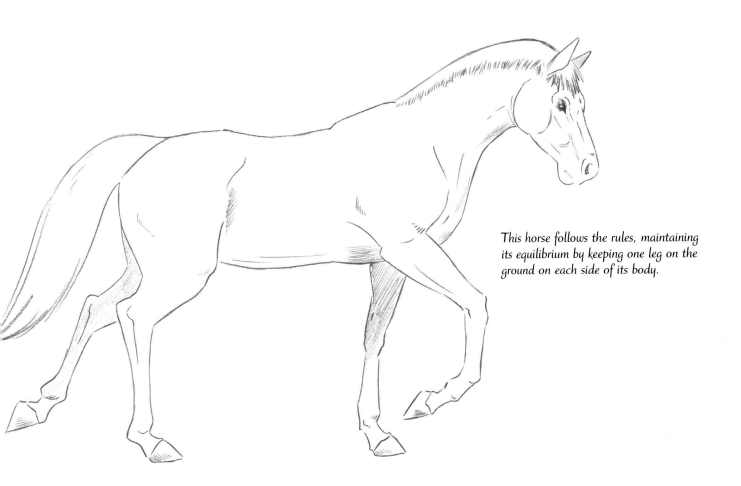

This horse follows the rules, maintaining its equilibrium by keeping one leg on the ground on each side of its body.

As the horse takes another step, the feet that were off the ground come down, while the ones that were on the ground rise.

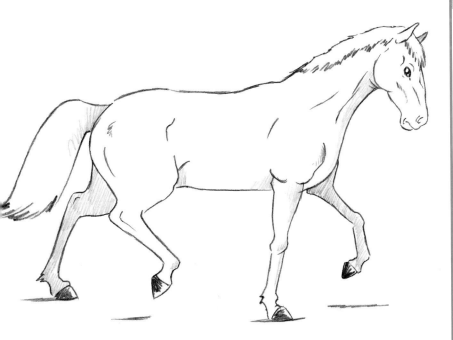

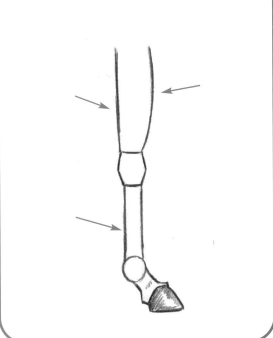

A Note about Horse Leg Muscles

In the top section of the horse foreleg, the muscles are rounder in the front and straighter in the back. In the lower section, both the front and back are straight.

GALLOPING

Here's where the horse puts the pedal to the metal. When galloping, all of its "feet" are off the ground at the same time. Once again, when comparing animals to humans, we find the same hold true for us. At some point, both of our legs are off the ground when running Notice the placement of legs underneath the horse.

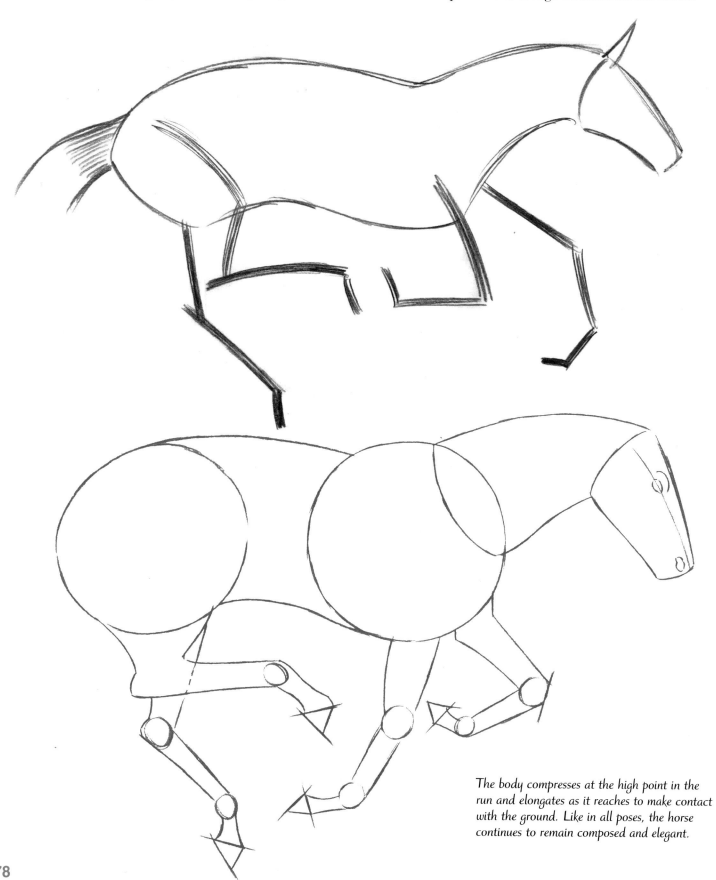

The body compresses at the high point in the run and elongates as it reaches to make contact with the ground. Like in all poses, the horse continues to remain composed and elegant.

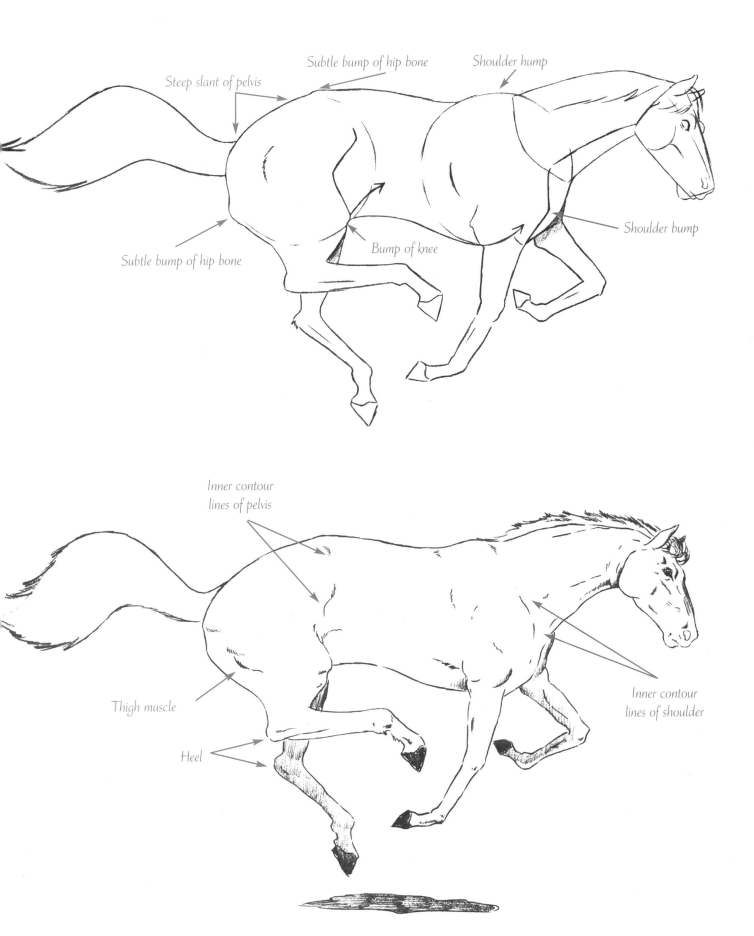

Steep slant of pelvis

Subtle bump of hip bone

Shoulder hump

Subtle bump of hip bone

Bump of knee

Shoulder bump

Inner contour lines of pelvis

Thigh muscle

Heel

Inner contour lines of shoulder

DEER

What a beautiful animal the deer is. On any given fall or spring day, there are up to eight of these guys in my backyard. They're all over New England—bucks, does, fawns. I know we suburban homeowners are supposed to think of them as pests, but to me they're nothing short of exquisite—a sight to admire. When they see you, they engage you visually, staring straight into your eyes. The remarkable thing is that they will hold your gaze as long as you continue to hold theirs. They exhibit both an elegant, gracious gait and considerable size and power. To me, their grace is most evident when they run and leap; it's almost like ballet. They are also incredible jumpers, able to leap four and a half feet in the air from a complete standstill.

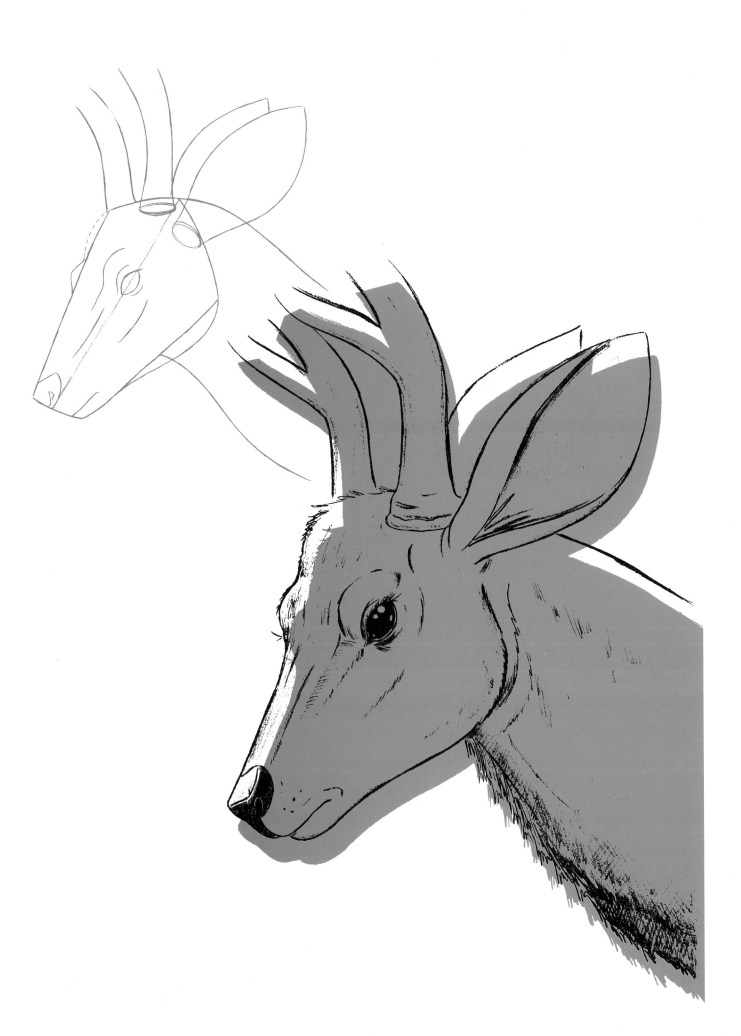

THE HEAD

At first glance, the deer's head looks easy to draw. Unlike the horse, it doesn't have a massive jaw or a cup-shaped, receding chin. But there are subtleties that require your attention if you're to create an aesthetically pleasing deer, rather than a simply recognizable one.

The deer possesses an odd ensemble of features that, taken one at a time, seem awkward—and yet, seen as a whole, are quite pleasing to the eye. The deer's nose is large and square, not a delicate little feature. The eyes bulge outward to an extreme degree—so much so that it takes a while to get comfortable with them, since their placement may seem wrong to you at first. The ears are oversized. The forehead is high and bony. The chin is almost nonexistent. Doesn't sound like the ingredients for one of nature's most elegant creatures, does it? And yet, it is.

Profile

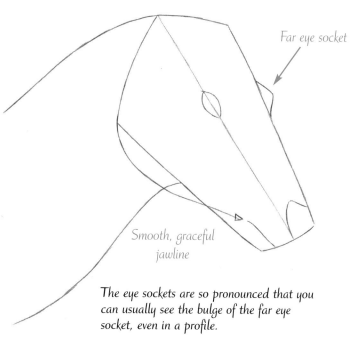

Underside of neck follows a gentle S-curve

The outline of the deer's head is simple and streamlined from the side.

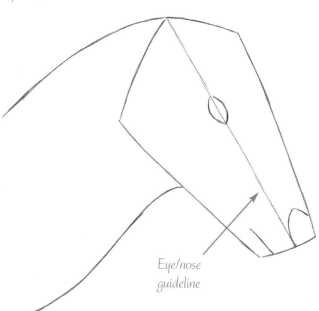

Eye/nose guideline

The center of the eye and bottom of the nose fall on the same line. Sketching in a guideline can help you position them correctly.

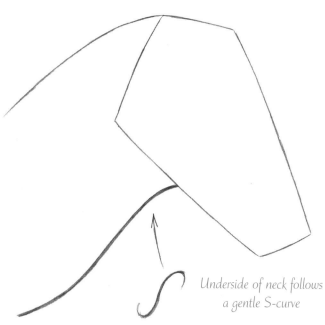

Far eye socket

Smooth, graceful jawline

The eye sockets are so pronounced that you can usually see the bulge of the far eye socket, even in a profile.

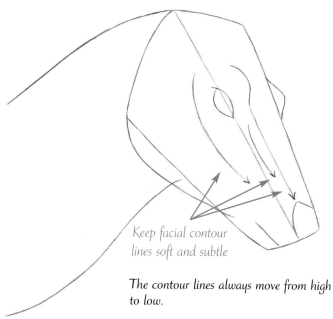

Keep facial contour lines soft and subtle

The contour lines always move from high to low.

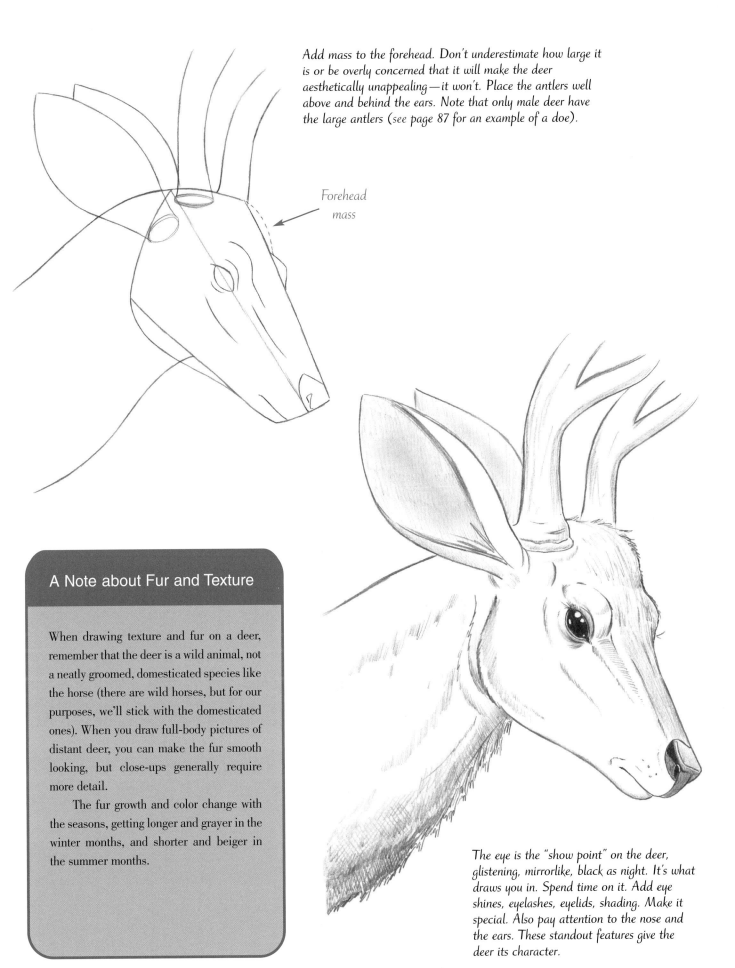

Add mass to the forehead. Don't underestimate how large it is or be overly concerned that it will make the deer aesthetically unappealing—it won't. Place the antlers well above and behind the ears. Note that only male deer have the large antlers (see page 87 for an example of a doe).

Forehead mass

A Note about Fur and Texture

When drawing texture and fur on a deer, remember that the deer is a wild animal, not a neatly groomed, domesticated species like the horse (there are wild horses, but for our purposes, we'll stick with the domesticated ones). When you draw full-body pictures of distant deer, you can make the fur smooth looking, but close-ups generally require more detail.

The fur growth and color change with the seasons, getting longer and grayer in the winter months, and shorter and beiger in the summer months.

The eye is the "show point" on the deer, glistening, mirrorlike, black as night. It's what draws you in. Spend time on it. Add eye shines, eyelashes, eyelids, shading. Make it special. Also pay attention to the nose and the ears. These standout features give the deer its character.

Front View

Okay, pencils out! We're going to break this down to make sure you can follow along without missing any of the beats. This should give you a good grasp of the form and the aesthetics.

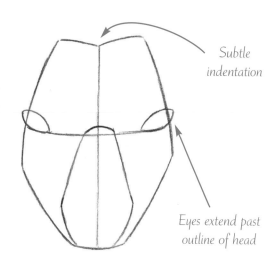

Subtle indentation

Eyes extend past outline of head

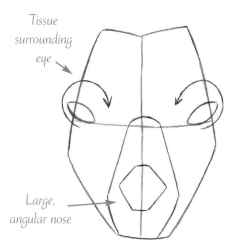

Tissue surrounding eye

Large, angular nose

1. Place the almond-shaped eyes so that they overlap the outline of the head, breaking the border. Deer eyes face 45 degrees to the side, unlike human, dog, and bear eyes, which face straight ahead. The bridge of the nose begins where the guidelines intersect. They widen as they travel down the face, toward us, becoming the muzzle.

2. Once you have the eyes in place, draw lines around them to indicate the surrounding muscle and tissue. Also sketch in a six-sided shape that will eventually become the nose.

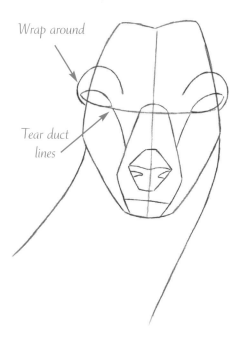

Wrap around

Tear duct lines

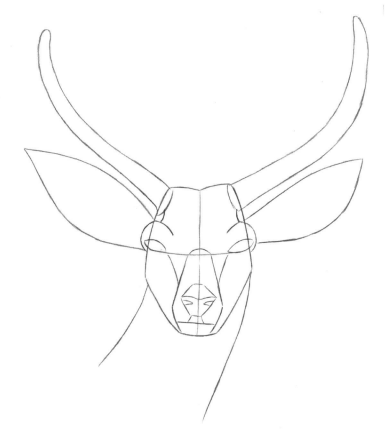

3. To represent the extended muzzle in the front view, draw contour lines that extend from the tear ducts of the eyes to the snout. Note that the neck is as wide as the head.

4. The bottom edge of the ears should be parallel to the ground and never dip below this line. The ears may move upward, but never lower than parallel to the ground. Note, also, that the ears are very large and fall under the antlers. Also, it's important to extend the black tip of the nose down to the top lip.

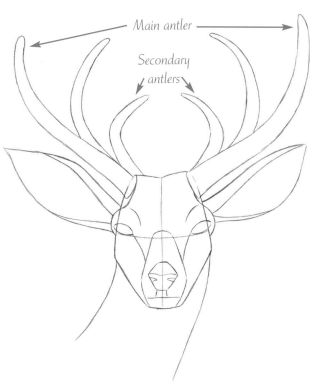

Main antler

Secondary antlers

Eye Socket Detail

Draw the skin that wraps around the eye with a flowing, graceful line.

5. The antlers are bone, with fur-covered skin and nerves. Antlers grow faster than any other bones in any other animal. They come directly out of the skull, which is why the forehead is so deep; it serves as its foundation.

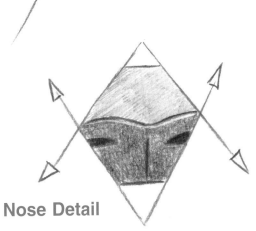

Nose Detail

When the sun shines down from directly above the deer, it hits the top of the nose and makes the top of the surface slightly brighter than the front of the nose. Indicate this by using different tones of shading (lighter for the top and darker for the front). The interior of the nostrils receives no light at all, so make those areas darkest.

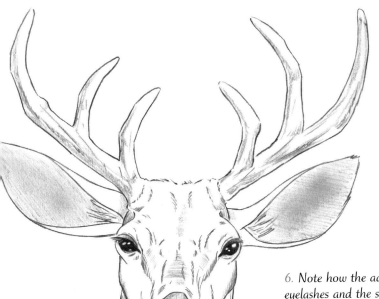

6. Note how the addition of small accents, such as the long eyelashes and the small tufts of inner ear hair, adds to the beauty and realism of the image. The muzzle contour lines help convey the effects of perspective on the face, guiding the eye from the eyes to the nose. And note the better effect achieved by using textured contour lines, rather than simple, straight lines.

Okay
with simple lines

Better
with textured lines

3/4 View

The 3/4 view shows the width of the forehead, which serves as the base for the antlers on bucks. This pose requires a delicate balance. On the one hand, the buck must look formidable; he's a protector. On the other hand, he's still a deer, not a buffalo; his main defense is running, not fighting. So he's not bruiser. Make him look strong but still lithe. I've come within twenty feet of many does—but I would never do that with a buck.

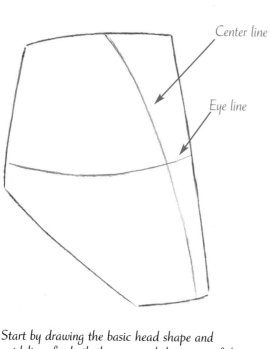

Start by drawing the basic head shape and guidelines for both the eyes and the center of the head.

Center line

Eye line

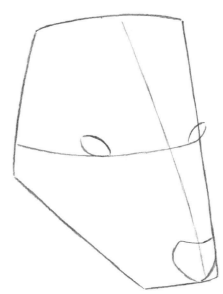

Since this is a 3/4 view, the near eye is slightly larger than the far one, and more of the nose falls on the near side of the center line than on the far side.

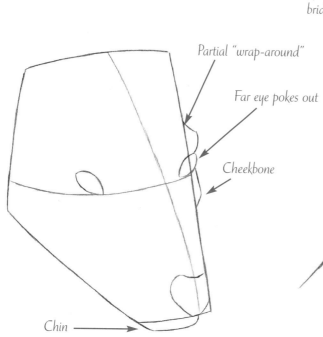

Partial "wrap-around"

Far eye pokes out

Cheekbone

Chin

Start to indicate the contours on the far side of the head by sketching in the eye socket and the cheekbone. In the 3/4 view, the far eye "wrap-around" is not always visible. Sometimes the far eye pokes out.

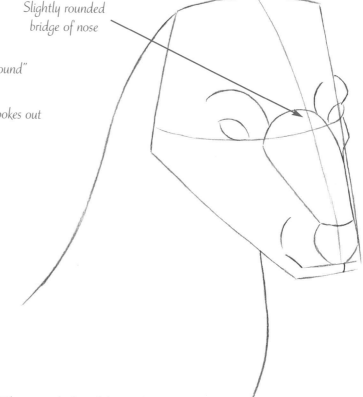

Slightly rounded bridge of nose

The extra-thick neck lets us know the buck is the one in charge. Added thickness is created by widening the lower line of the neck. The top line, where the neck connects to the top of the head, always remains the same.

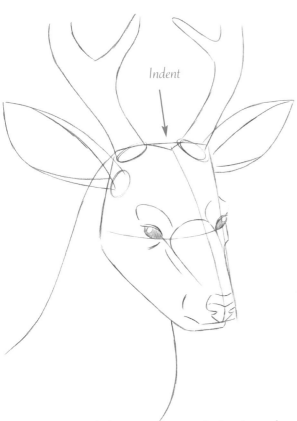

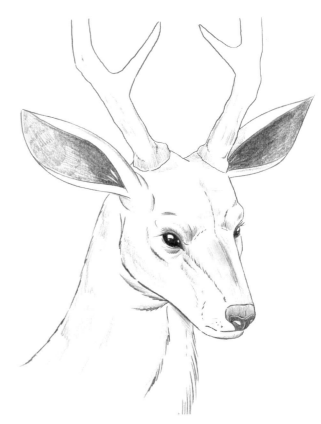

Note the clear body language. Keeping the head erect but the nose pointed down exudes a masculine aura. The antlers are each firmly planted on separate bumps on the forehead, and the forehead indents at the center line.

The typical doe expression is one of watchful waiting. But the buck's stare is different. You can't tell whether he's watching you because he's ready to run or because he's ready to defend. If you're the one he's staring at, it can be a little unnerving.

The Doe

The female deer, or doe, doesn't have pronounced antlers and is slightly smaller than the male deer, with a narrower neck. Frankly, the doe looks more feminine, so use a subtle aesthetic to bring a feminine quality to your drawing.

This top view may seem, at first, an unusual one. But in the animal kingdom, it isn't. This motion is seen all time when an animal reaches down to graze or to nuzzle offspring.

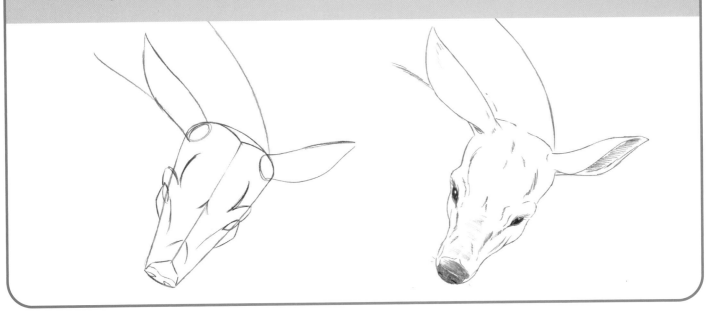

THE CURVE OF THE NECK

The deer has a very pronounced S-curve to its neck, which adds significantly to its grace and posture. Many other ungulates, including the horse, lack this feature. The deer's neck is much thicker at the base, where it connects to the chest, than it is near the head. You must show this in your drawing; othersise, your deer's neck will look skinny, making the final drawing look wrong. If you're aware of the S-curve, you'll start the deer off with an elegant posture without even trying—it'll already be built in.

VARYING THE HEAD PLACEMENT

The deer's neck is very flexible. It can move in many directions without tugging on the body or forcing the deer to adjust its footing. The neck is also useful to you as an artist, because simply altering its placement can turn a less-than-satisfying drawing into a keeper. (Altering part of the pose, rather than starting all over again, is one way to "save" a drawing from the trash.) Sometimes, repositioning the head and neck on the same body creates an entirely new feeling. Smaller, subtler changes—such as changing a standing leg to one that's bent and lifted off the ground—can also work to reinvigorate a drawing.

SIMPLIFIED BODY STRUCTURE

In the side view, three sections of the body are evident to the eye (excluding the head/neck area): the forequarters, midsection, and hindquarters. There's no need for the "layering" used to create the illusion of depth that you see in the 3/4 view. Why, then, should you bother to draw the body in sections at all? Because the body is a machine. And defining the parts of the mechanism better conveys the mastery you have over your subject matter. That mastery is, in turn, subconsciously communicated to the viewer's eye. It makes your image that much more confident and convincing because it forces the eye to suspend disbelief.

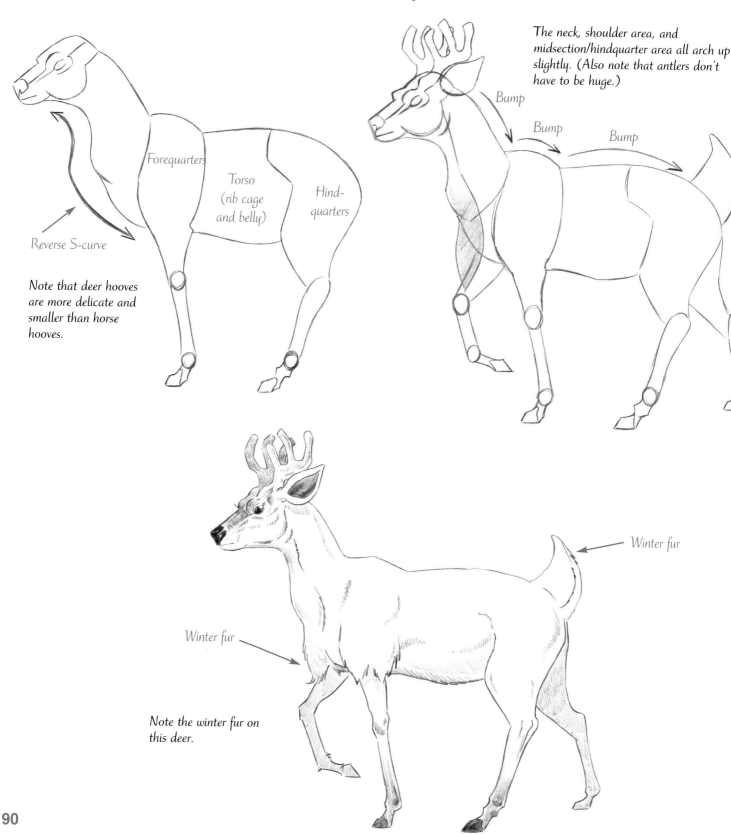

Forequarters

Torso (rib cage and belly)

Hind- quarters

Reverse S-curve

Note that deer hooves are more delicate and smaller than horse hooves.

The neck, shoulder area, and midsection/hindquarter area all arch up slightly. (Also note that antlers don't have to be huge.)

Bump

Bump

Bump

Winter fur

Winter fur

Note the winter fur on this deer.

Body Section in 3/4 View

In the 3/4 view, the deer's body is severely foreshortened. What is important to note is that without demarcating the sections of the body, the illusion of perspective would be lost. The eye needs landmarks within a large form (in the case, the torso) to trick it into thinking the shape is diminishing in size. So the best way to indicate that the torso is diminishing in size as it recedes from the chest to the tail is to break the form down into progressively smaller sections: forequarters, midsection, and hindquarters. But we're also going to include the well-muscled chest as a separate and distinct fourth section, because it is in the front and is the closest thing to the viewer. (In the side view, the chest wouldn't show.)

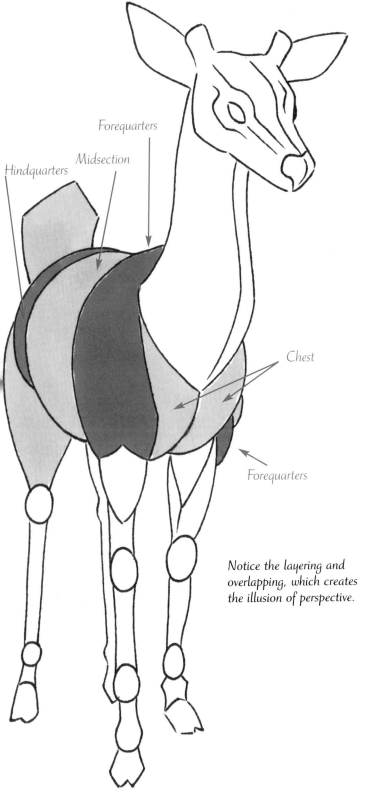

Forequarters

Midsection

Hindquarters

Chest

Forequarters

Notice the layering and overlapping, which creates the illusion of perspective.

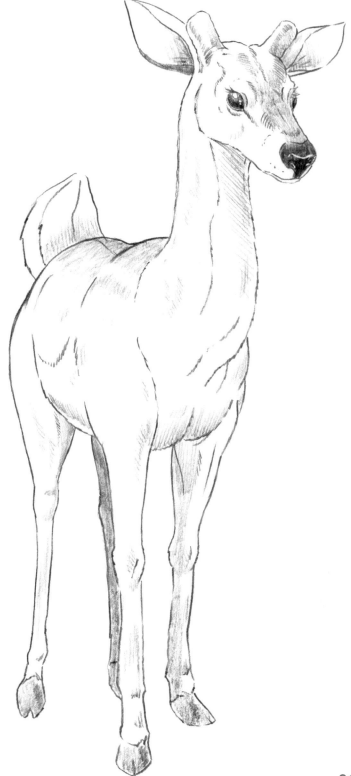

ALERTNESS

Whether walking, sitting, or standing, deer are always paying attention to the periphery of their environment. If they hear something, they don't just move an ear in the direction of the sound (like a cat); they move their entire head and neck—as one unit—toward the sound, with a big, swift motion.

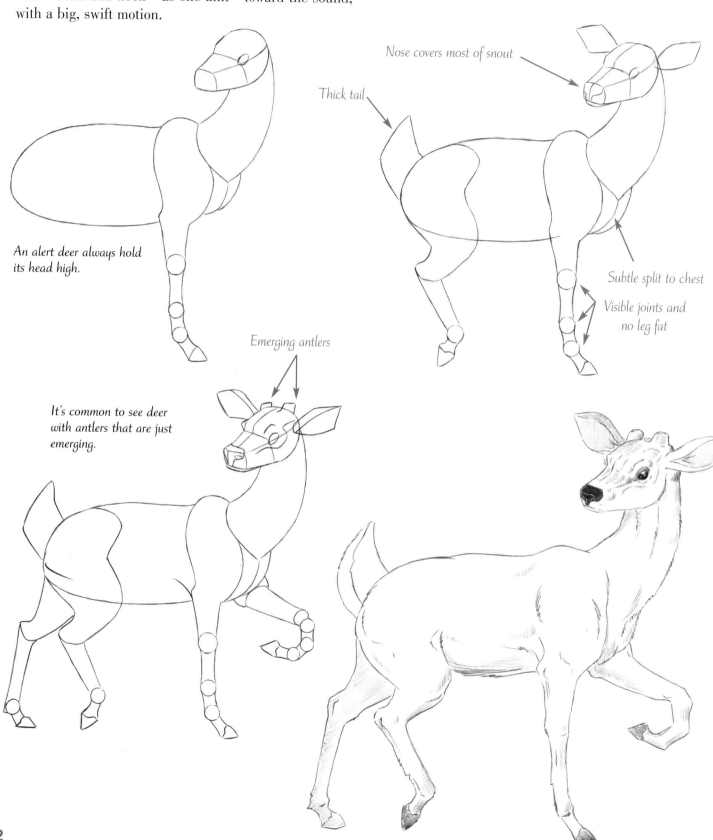

An alert deer always hold its head high.

Nose covers most of snout

Thick tail

Subtle split to chest

Visible joints and no leg fat

Emerging antlers

It's common to see deer with antlers that are just emerging.

LEAPING

The following two principles hold true for all animals, but are especially noticeable on deer: 1) when deer jump up, their heads dip down, and 2) when deer land, their heads rear back. These are the delayed reactions that follow the thrust of a motion. In the example below the reaction is jumping.

Jumping

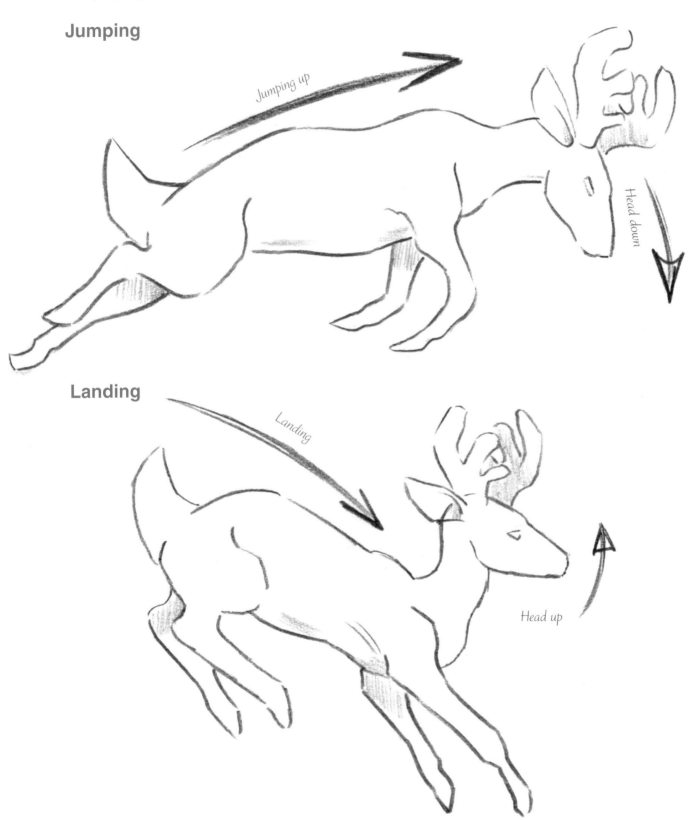

Jumping up

Head down

Landing

Landing

Head up

RUNNING

When an animal gallops, there's one main thrust, or "line of action," carrying the motion forward. But there are also other supporting forces at play that, when combined with the main thrust, give the pose a unified look. The challenge is to make all the forces blend into one another. They can't appear to be at odds.

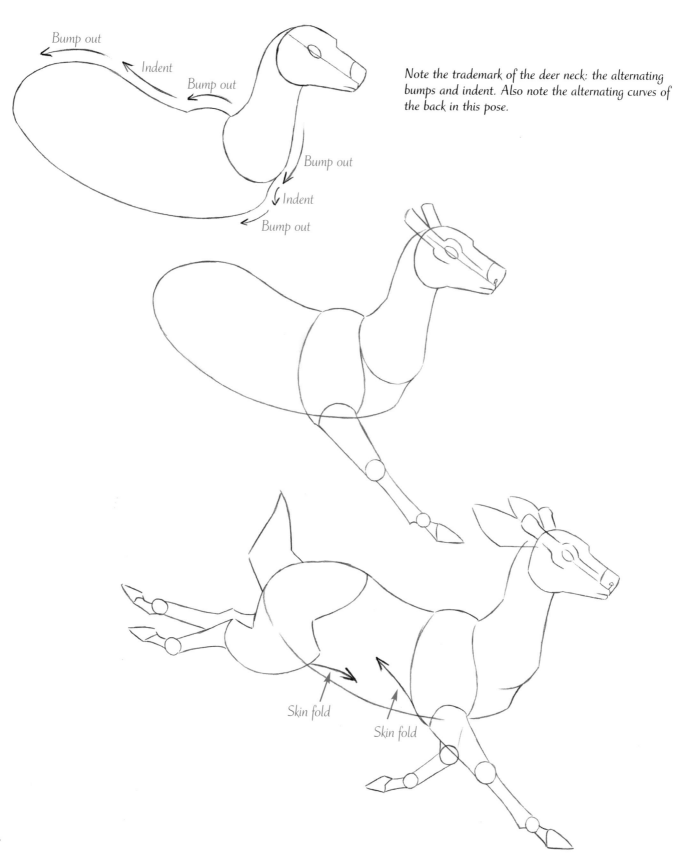

Note the trademark of the deer neck: the alternating bumps and indent. Also note the alternating curves of the back in this pose.

Bump out

Indent

Bump out

Bump out

Indent

Bump out

Skin fold

Skin fold

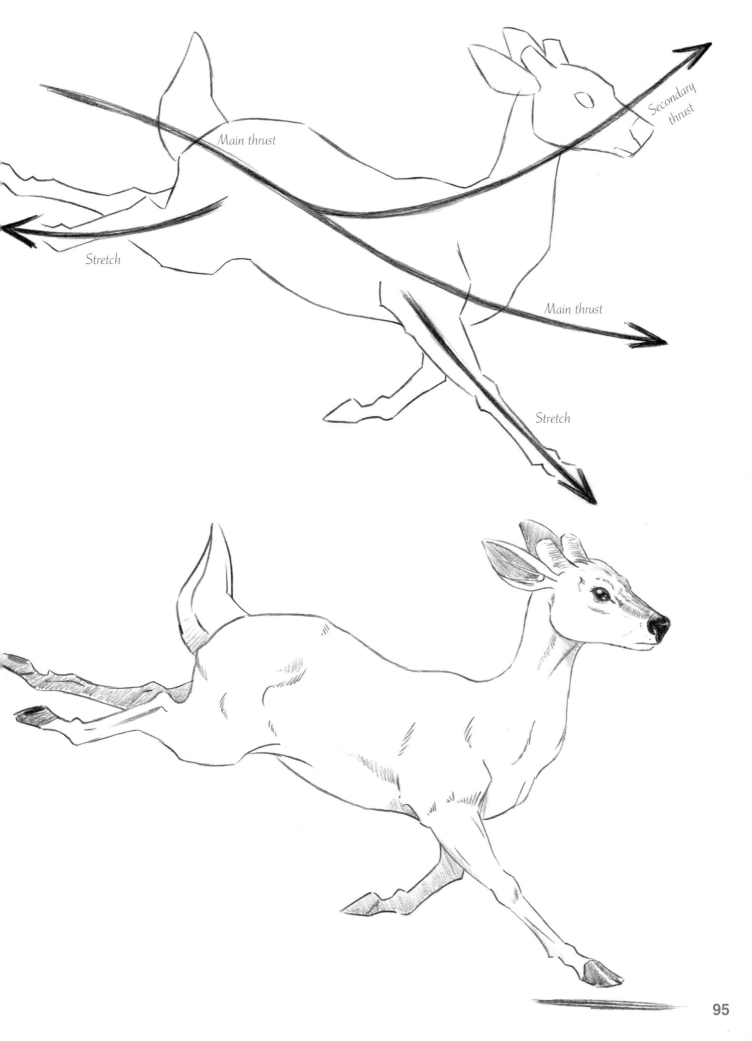

Main thrust

Secondary thrust

Stretch

Main thrust

Stretch

BEARS

Bears hold a strange fascination for people. Hikers and nature lovers like to observe them but also are, understandably, fearful of them. Bears command awe and respect. Their big, fluffy looks make them seem lovable and playful, yet the size of their claws and teeth—not to mention their sheer power and speed—remind us that they're dangerous adversaries who must be appreciated only from a distance.

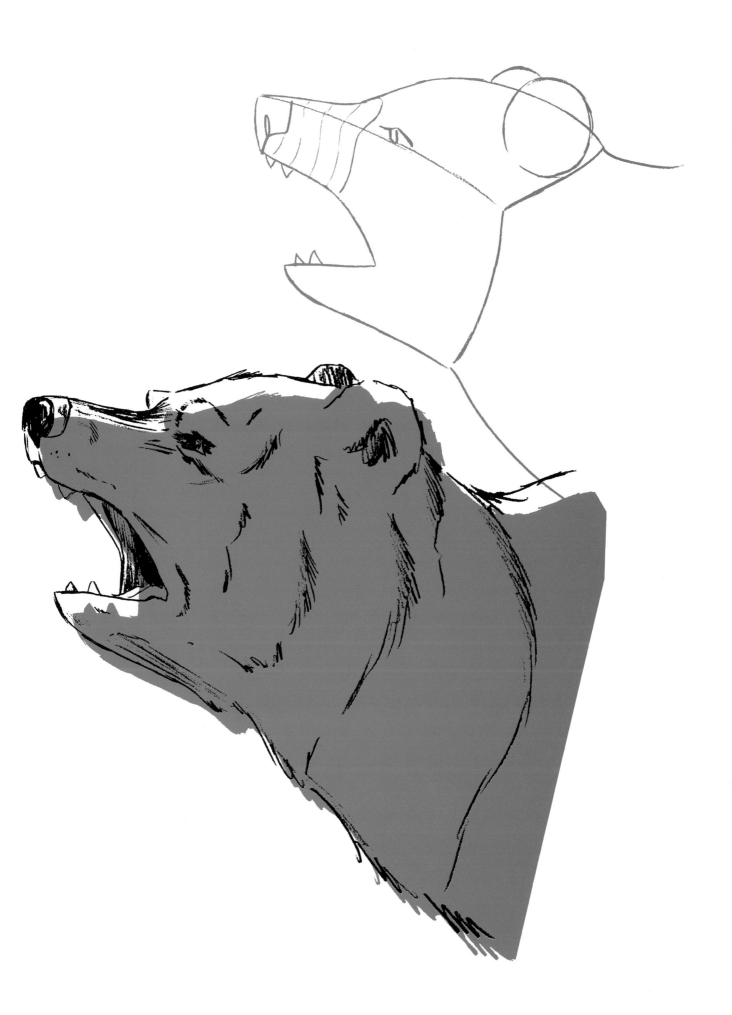

THE HEAD

As with other animals with long, pronounced muzzles, the bear is easiest to start drawing in the profile.

Profile

The bear profile is one of the easiest to draw in the animal kingdom because the head construction is so simplified in this angle, especially when there will be a prop (in this case a fish) covering some of the lower jaw/chin area in the final image. One thing to observe here as the bear reaches out to catch its lunch: Bears have really long necks—perhaps longer than you're used to drawing.

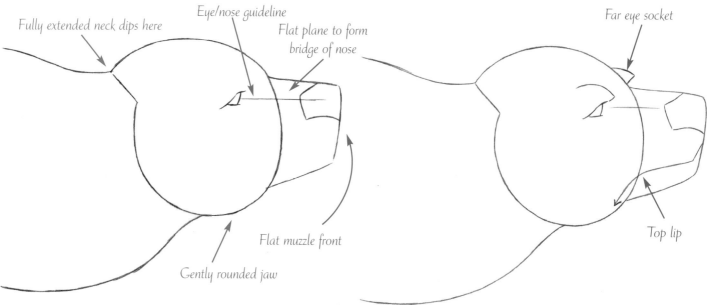

The profile head construction is pretty straightforward. The eye, which is quite small, and nose fall on the same level, and the front of the muzzle is flat.

Strictly speaking, a true profile is perfectly flat, which can be lifeless. Although it works on animals like dogs and horses, it doesn't work as well on plump, round animals like bears. So, we cheat a little by turning the bear slightly in order to see a bit of the far eye socket and the flat plane of the bridge of the nose. This softens the angle, making it more pleasing.

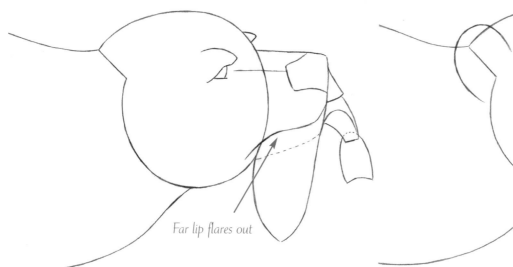

This fish in the bear's mouth pushes the far upper lip open.

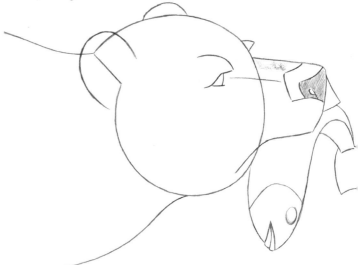

I like to add a touch of shading to the bridge of the nose. This spot is often slightly discolored, and the variety adds character.

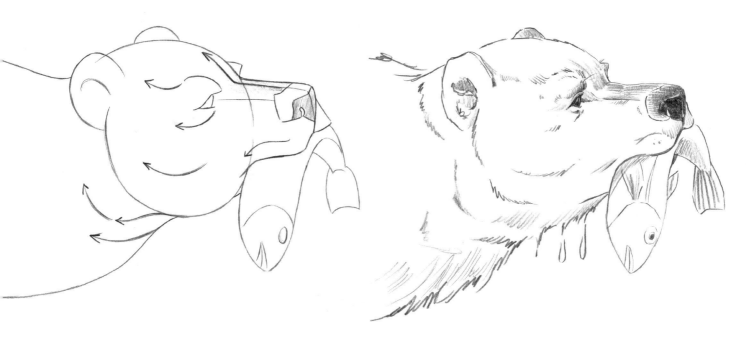

The arrows show where the final contour lines of both the face and the neck fur will be. Any bear standing in a stream is going to have dark ruffles of fur on its underside where the water splashes up. Water makes the fur appear darker and scragglier. Add a few hanging droplets to enhance the effect—just be careful not to overdo it. Great at catching fish, bears can stand in gushing streams for hours, gorging on salmon the way humans inhale pizza—except bears don't weigh themselves in the morning and feel remorse.

The Other Side

As I mentioned in the horse section, you need to be able to draw animals from all sides. So, here's the left profile of the bear. The bear, like the lion, has a very low forehead. But unlike the lion, the bear's jaw muscle doesn't appear as round or pronounced, primarily because it is masked by fur. Nor does the bear have a jutting chin or a wide muzzle. But it still cuts a striking profile.

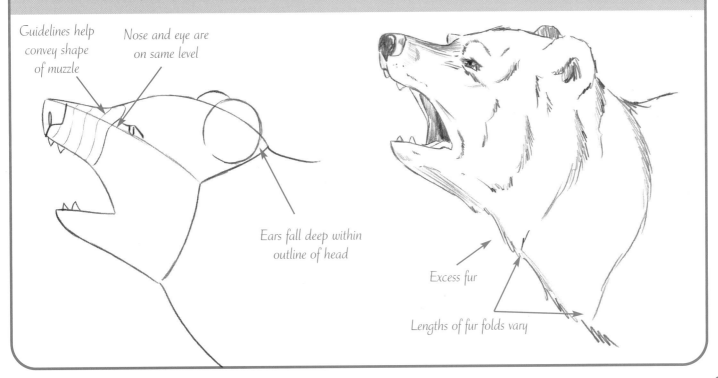

Guidelines help convey shape of muzzle

Nose and eye are on same level

Ears fall deep within outline of head

Excess fur

Lengths of fur folds vary

Front View

Bear heads are wide. You can clearly see this in the front view.

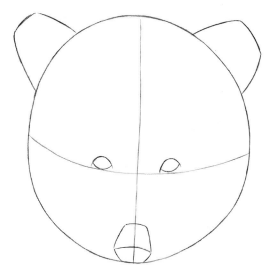

Though bear heads come in different shapes (just like human heads), you can't go wrong if you use a circle as your starting point. The bear has a sizable forehead, so place the eyes low on the circle; this automatically creates the big forehead you want. The eyes are buttonlike and face straight ahead. The eye placement is like that of humans, dogs, and cats, as compared to horses, deer, and birds, which have eyes spaced wide apart or on completely opposite sides of the head.

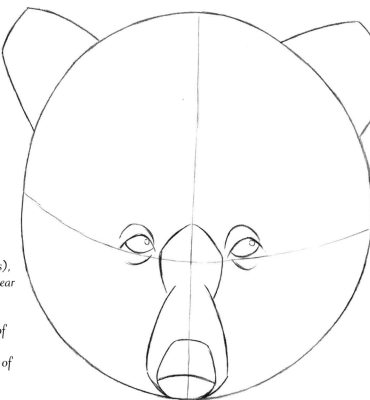

The muzzle is long and thin.

The Foreshortened Muzzle

To draw a pronounced muzzle in perspective in the front view, you need to make use of foreshortening. To get an idea of what happens when something is foreshortened and seen in perspective, hold up a pencil vertically so that you can clearly see its length. Now, angle it slightly so that the eraser is tilted toward your eye. You will see that the pencil looks shorter. This is what happens when something is viewed in perspective—it becomes foreshortened.

The same effect seen on the tilted pencil is apparent when an animal with a long muzzle faces you and tilts its head up: The muzzle becomes somewhat compressed by perspective and appears shorter. Alternately, when the animal hangs his head down so that the nose points toward the ground, the muzzle appears longer.

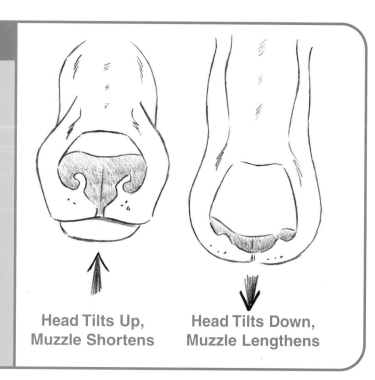

Head Tilts Up, Muzzle Shortens **Head Tilts Down, Muzzle Lengthens**

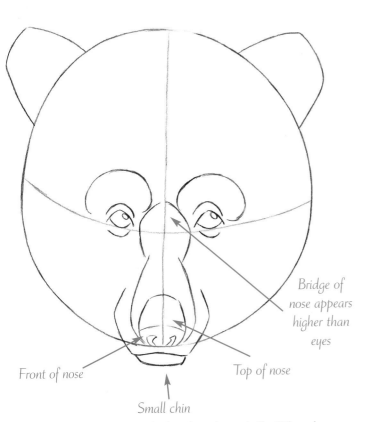

Front of nose

Top of nose

Bridge of nose appears higher than eyes

Small chin

The bridge of the nose rises higher than the eyeballs. When the head is hanging down in the front view, there is a delineation between the top of the nose and the front of it.

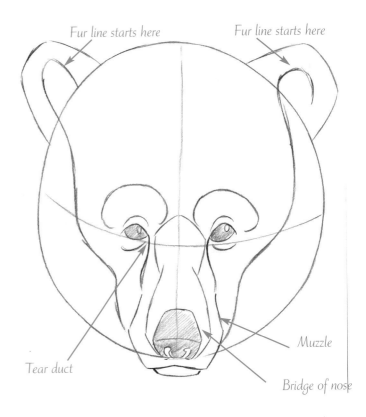

Fur line starts here

Fur line starts here

Tear duct

Muzzle

Bridge of nose

There's a long fur contour line that runs from the interior of the ear to the front of the muzzle. In addition, you must indicate the various planes of the muzzle to give the muzzle dimension.

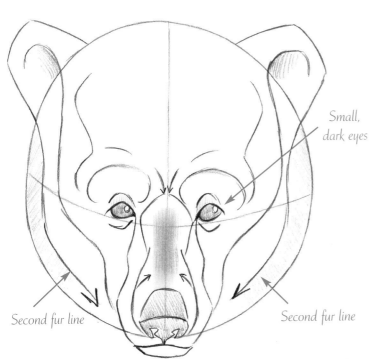

Small, dark eyes

Second fur line

Second fur line

There is a second long fur contour line that also runs from the outside of the ear toward the end of the muzzle. The eyes are small but very dark and glistening.

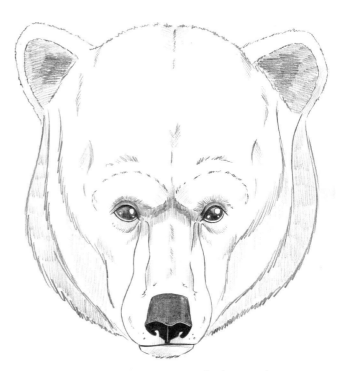

The furry outline of the head and the two fur lines inside it create the two main layers of fat and fur that frame the face in the front view. And, the innermost fur line highlights the simplified skull shape, which is somewhat camouflaged by the layers of fat and fur.

3/4 View

In the 3/4 view, draw the center line down the bridge of the nose, dividing the face in half. For most animals, everything on the far side of the center line falls off (or recedes) very quickly in the 3/4 view, but the bear, with its exceptionally wide face, doesn't fit into that category. On the far side of the center line there's still quite a lot more mass—and a lot more bear! And that's what makes this 3/4 view different from that of most other animals. The features should seem clustered in the middle of the face.

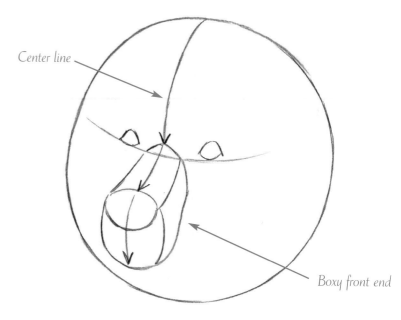

Center line

Boxy front end

The center line is useful in determining the angles as the directions change over the bridge of the nose and muzzle. The eye line (horizontal guideline) is usually placed below the middle of the bear's head. But since this bear is lifting the head to look at the viewer, we need to draw the guideline a little higher up, too, in order to accommodate the tilt in the head. Note that the muzzle is long and thin, with a flat, boxy front end.

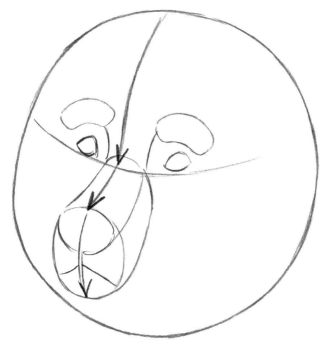

The top "lip" is split on bears, but the split is more subdued.

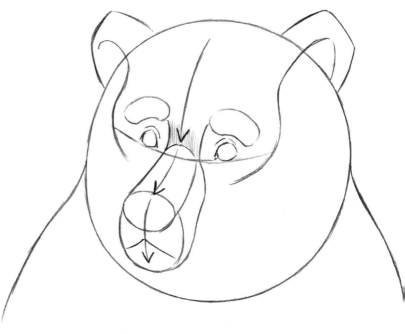

The countour lines that run from the ears and under the eyes should cradle the cheekbones of the bear.

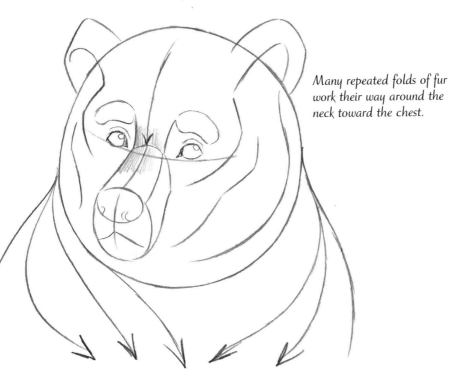

Many repeated folds of fur work their way around the neck toward the chest.

The Bear Expression

Large bears aren't afraid of you or anything else. They don't have to be—and they know it. They often sport a look that says, "Let's see, what shall I do with you?" You can see that dispassionate look in their eyes, It's not confidence, per se. When you're at the top of the food chain, you don't need confidence. It's more of an awareness that wherever they are, they own it.

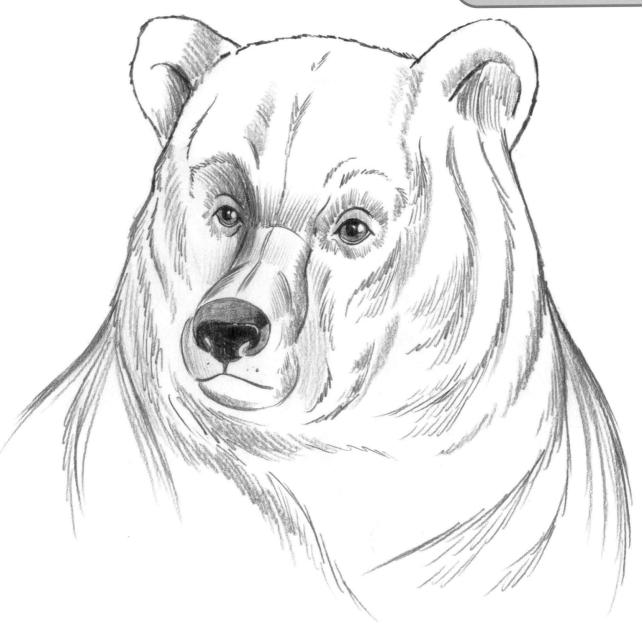

THE BODY

With respect to body construction, the bear is a bit of a departure from the animals covered in this book for two reasons: First, its rear leg position is much closer to our own; the foot rests flat on the ground, without the heel sticking up in the air as it does on a dog or horse. Second, bear anatomy is covered from top to bottom in substantial fat and fur; there's very little clearly visible definition to it. So, you have to imply it all using the overall outline of the animal and the direction of the fur. As a result, you'll need to concentrate more on the surface texture, the fur, and how it gathers than you did on the other animals you've drawn thus far.

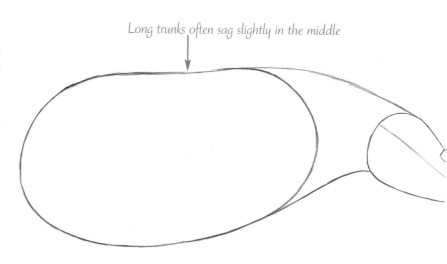

Long trunks often sag slightly in the middle

Keep the outline of the body simple, like a giant soap bubble that's being pulled in the wind. Note the length of the neck; it places the head far in front of the body.

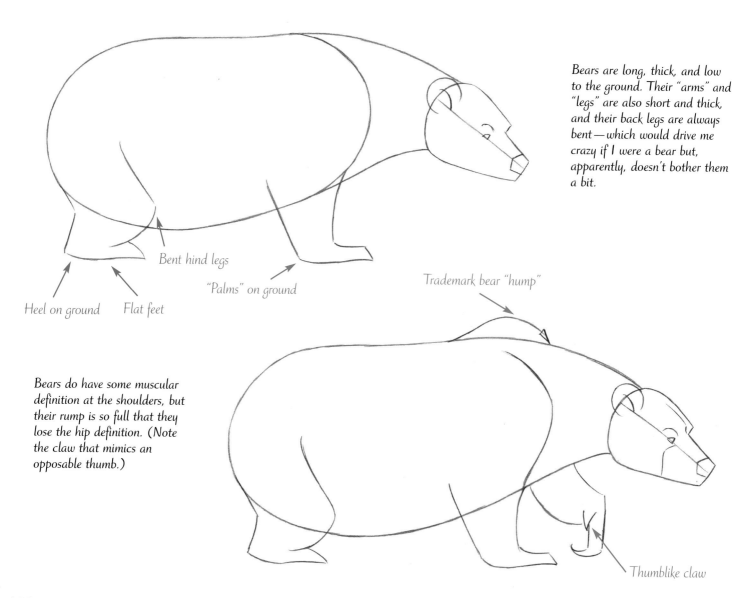

Bears are long, thick, and low to the ground. Their "arms" and "legs" are also short and thick, and their back legs are always bent—which would drive me crazy if I were a bear but, apparently, doesn't bother them a bit.

Bent hind legs

"Palms" on ground

Heel on ground *Flat feet*

Trademark bear "hump"

Bears do have some muscular definition at the shoulders, but their rump is so full that they lose the hip definition. (Note the claw that mimics an opposable thumb.)

Thumblike claw

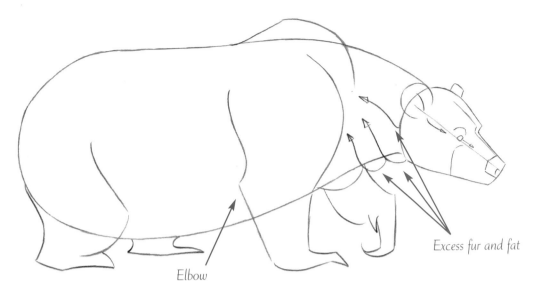

You do not need to draw the "two circle" construction of the bear in the side view since the body lacks definition. Notice how the rump is bigger than the chest.

Elbow

Excess fur and fat

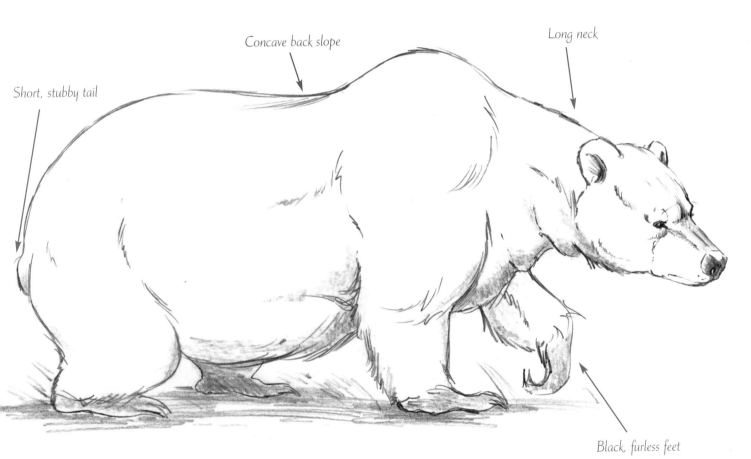

Concave back slope

Long neck

Short, stubby tail

Black, furless feet

Bears generally hold their heads low when walking.

WALKING

Instead of starting off with a layered shape in order to create a sense of perspective, we're going to add perspective to a flat shape, which will help you become a better problem solver. And problem solving is a big part of illustration. Fixing a drawing isn't just a matter of aesthetics. It's not, "How do I make this look better?" It's mostly, "Where did I go wrong?" First you build it right; then you focus on the aesthetics.

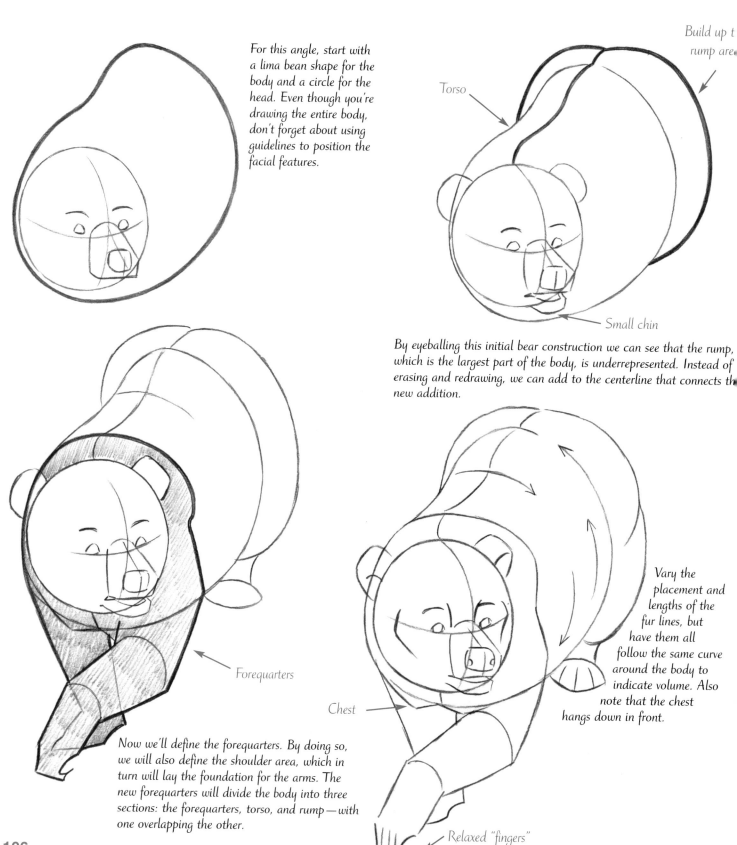

For this angle, start with a lima bean shape for the body and a circle for the head. Even though you're drawing the entire body, don't forget about using guidelines to position the facial features.

Build up t[he]
rump are[a]

Torso

Small chin

By eyeballing this initial bear construction we can see that the rump, which is the largest part of the body, is underrepresented. Instead of erasing and redrawing, we can add to the centerline that connects th[e] new addition.

Forequarters

Now we'll define the forequarters. By doing so, we will also define the shoulder area, which in turn will lay the foundation for the arms. The new forequarters will divide the body into three sections: the forequarters, torso, and rump—with one overlapping the other.

Chest

Vary the placement and lengths of the fur lines, but have them all follow the same curve around the body to indicate volume. Also note that the chest hangs down in front.

Relaxed "fingers"

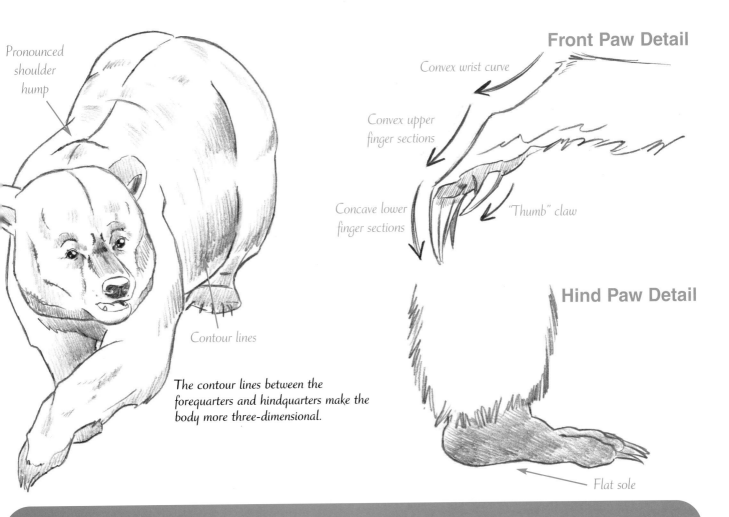

Pronounced shoulder hump

Front Paw Detail

Convex wrist curve

Convex upper finger sections

Concave lower finger sections

"Thumb" claw

Contour lines

The contour lines between the forequarters and hindquarters make the body more three-dimensional.

Hind Paw Detail

Flat sole

The Line of the Spine

Like the previous example, simply from the other side, this pose shows the "hills and valleys" of the back and how the line of the spine unifies them. I'm sure you've seen landscape paintings of rolling hills overlapping one another, with a road that disappears and reappears as it rolls over each crest. That road becomes the unifying thread that pulls those mountains together visually. So it is with the line of the spine, which unifies the curves of the bear's back.

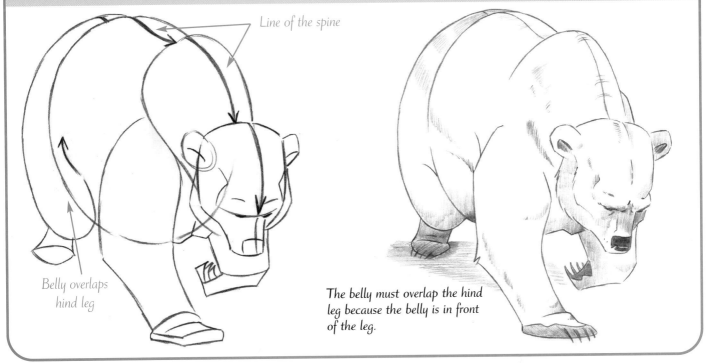

Line of the spine

Belly overlaps hind leg

The belly must overlap the hind leg because the belly is in front of the leg.

ALTERNATE BODY CONSTRUCTION: THE THREE-CIRCLE METHOD

If you have trouble with the bear body, try this easy construction method. Draw three overlapping circles: one for the head, one for the upper body, and one for the lower body. The first circle overlaps the second, and the second overlaps the third. (This is because the fist circle is infront of the second, which is, in turn, in front of the third.) You can break the body down in this kind of simplified way with animals that have lots of fat and/or fur, because those elements mask the definition of the body in the 3/4 pose.

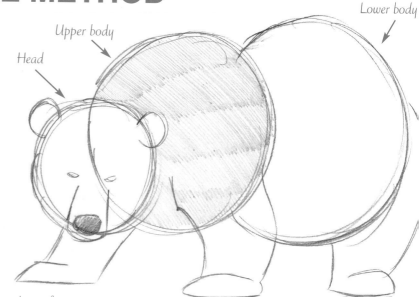

Head

Upper body

Lower body

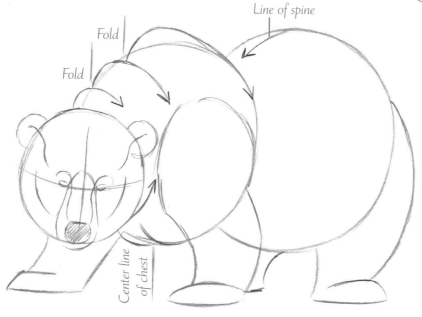

Fold

Fold

Line of spine

Center line of chest

Incorporate the neck into the circle of the upper body.

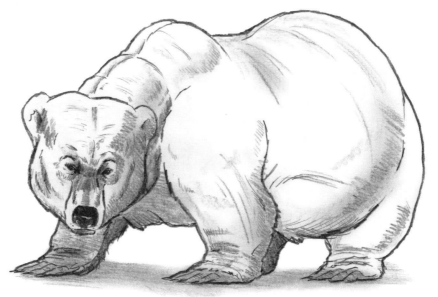

"STANDING"

When a bear "stands up," it looks immense. Due to the bear's immense weight, the body sinks down into itself in this posture, displaying accordion-like folds of fur. The head sinks into a series of furry wrinkles in the neck. This is especially noticeable on grizzly bears like the one here, because of all the bears, they have the widest, squarest head. In addition, the torso sinks into a bunch of furry wrinkles around the waist.

This posture lets us see something interesting that isn't always immediately noticeable in other poses.

While bear "arm" and "leg" gestures may sometimes mirror those of humans, there's one obvious reversal: The arms are longer than the legs. And, despite the anthropomorphism of this pose, it should look awkward, as if the bear could hold it for only a few moments. Having the bear look down is a nice touch. It highlights the creature's size, showing that in this pose the bear must look down at everything around it. If the bear looked straight ahead, it would seem to be at the same level as everything around it.

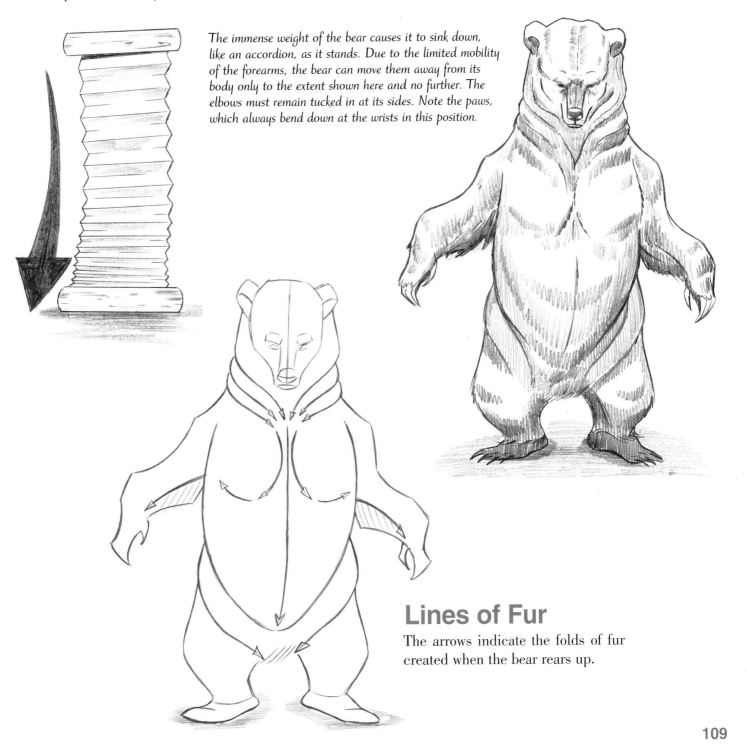

The immense weight of the bear causes it to sink down, like an accordion, as it stands. Due to the limited mobility of the forearms, the bear can move them away from its body only to the extent shown here and no further. The elbows must remain tucked in at its sides. Note the paws, which always bend down at the wrists in this position.

Lines of Fur

The arrows indicate the folds of fur created when the bear rears up.

BEAR TYPES

There's more than one type of bear. In addition to the grizzly on the previous page, there are other brown bears, polar bears, and panda bears—all of which look slightly different from one another.

Brown Bear

The brown bear is very furry. It has a compact body with hips that dive down at a sharp angle. As a result of this, the underside of the torso angles up sharply. When people think of cute bears, they are often thinking about the brown bear. When they think of majestic bears, they are most often thinking about grizzly bears. Be sure to change which species you draw according to your subject matter.

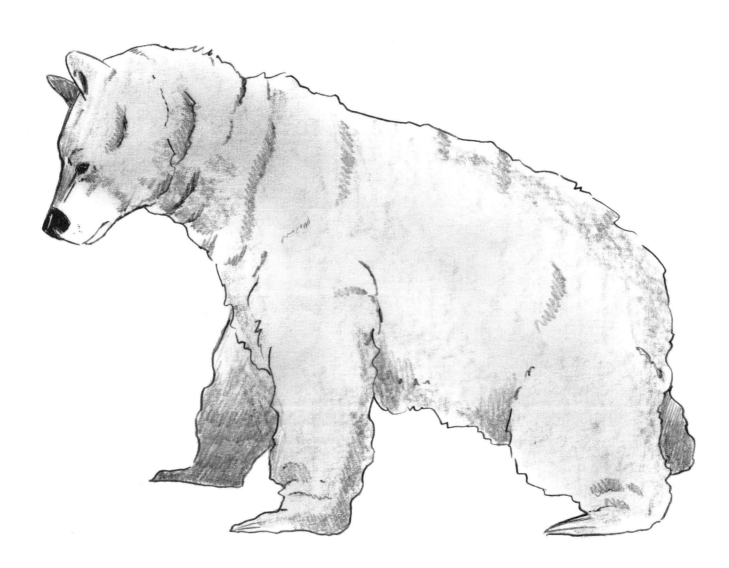

Polar Bear

The polar bear has long legs for a bear. It also has a long torso that tapers toward the head, which minimzes the resistance as it swims through the water. There is not a break where the forehead and the bridge of the nose meet, and the face comes to a point at its small nose. The polar bear also has the smallest ears of any bear.

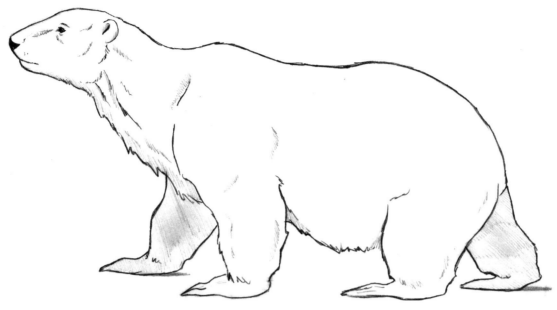

Panda Bear

Zoologists used to believe that giant pandas were related to raccoons, but now we know that they are indeed related to bears, but some other types of pandas are related to raccoons. What zoologists haven't yet been able to determine is why everyone seems to love pandas so much!

Relative to the size of its body, the giant panda has quite a large head. And note the pearlike body shape, which is very pronounced on pandas. The legs are very short. Pandas cannot walk upright on their hind legs like other bears. The panda face is very wide—but it's widest at the cheeks and not so wide at the forehead. This is unlike the grizzly, which looks much more menacing. The ears are squarish in shape, more so than on other bears. Then there are the markings. These are very important; they are what distinguish pandas. No matter how creative you are, you have to stick with what nature has dictated. The ears, eye areas, neck/shoulder area, forelegs and upper back, and hind legs are all black, while the rest of the panda is white. Note that the "eye mask" should not be too symmetrical; the shape around each eye should be a little different.

LIONS

Of all the animals I've drawn, I find the lion to be the one that makes the most anatomical "sense." The slope of the skull, the size of the shoulders, the paws, the overall skeleton, all the proportions—it just feels right. As I mentioned in the cat section, don't make the mistake of thinking of lions (and tigers, for that matter) simply as large house cats. There really are a lot of differences. After all, no fireman has ever received a call to get a tiger out of a tree!

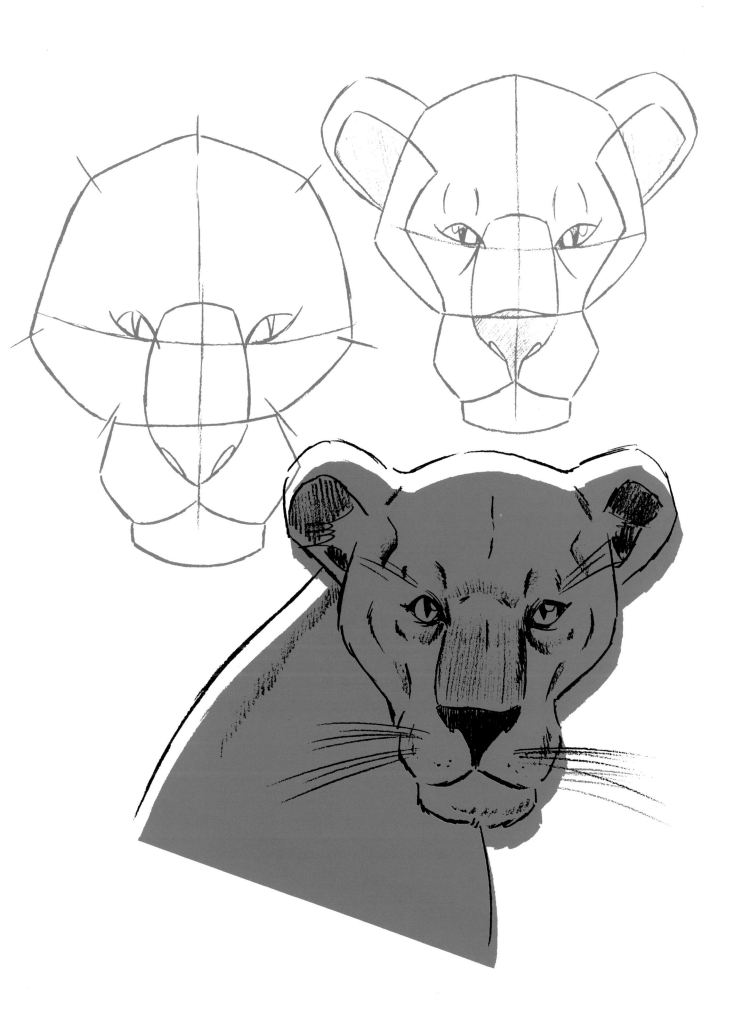

THE LIONESS HEAD

It's better to start with a lioness, rather than a lion, because there's no mane blocking our view of the head structure. And the major characteristics are the same for both lions and lionesses.

I've always been fond of drawing the lioness. Her construction is simple and unassuming, yet her look strikes fear in almost every animal she encounters. She is a contradiction of brute power and feminine slinkiness. She is the hunter of the pride. The male? A typical freeloader.

Profile

Unlike the house cat, the lion and lioness have longer muzzles, so it makes more sense to begin with the profile, rather than the front view.

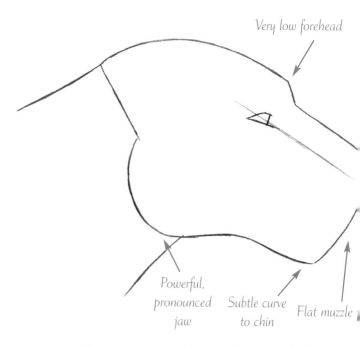

Very low forehead

Powerful, pronounced jaw

Subtle curve to chin

Flat muzzle

The most important things to keep in mind when constructing the lion and lioness's head are that both have extremely low foreheads and large snouts that curve slightly downward.

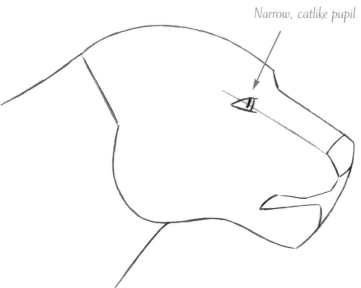

Narrow, catlike pupil

As with many other animals with pronounced muzzles, the eye and nose fall on the same level. And as you did with the horse, "carve" a large masseter (or jaw muscle) into the lioness.

Add a shine to the pupil in order to give this big cat that piercing stare of a predator.

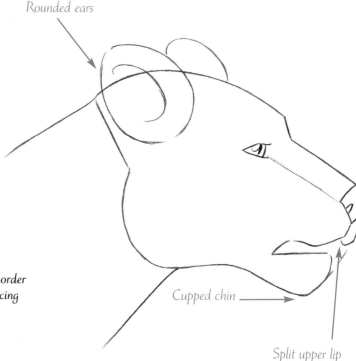

Rounded ears

Cupped chin

Split upper lip

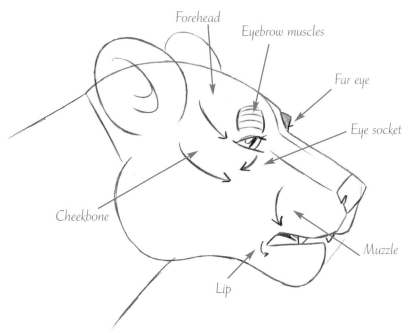

Forehead

Eyebrow muscles

Far eye

Eye socket

Cheekbone

Muzzle

Lip

Note the facial contours, indicated by arrows here. In a relaxed pose, the lioness's mouth hangs slightly open and reveals part of her fangs. The back of her mouth dips down. This isn't an expression, but rather the way the mouth is formed.

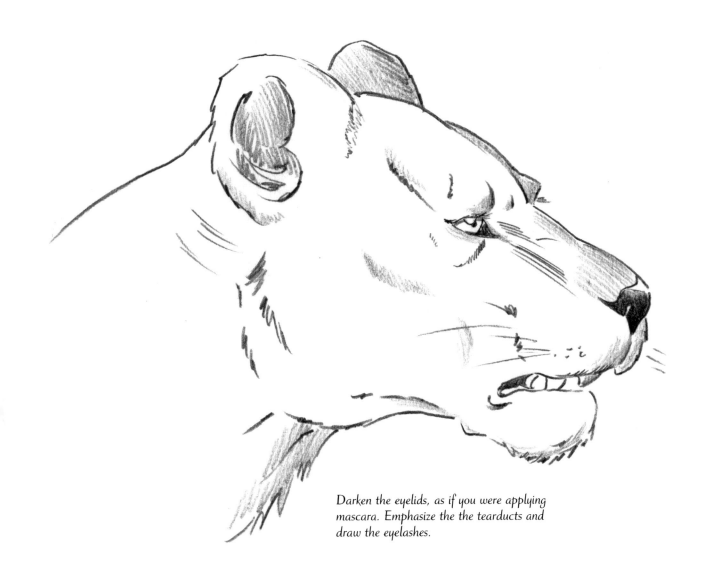

Darken the eyelids, as if you were applying mascara. Emphasize the the tearducts and draw the eyelashes.

115

Front View

In the front view, the outline of the head is rounded but is not a true circle. And again, all the information here applies to lions, as well. (We'll get to the lion's mane on page 125.)

Top right

Top left

Left side

Right side

Bottom left

Bottom right

Note the angular shape of the head, with many planes. The muzzle elongates the face. The upper lip is puffed out and clearly split. The chin is squared off—more so than on any of the other animals in this book.

Narrowest part of muzzle

Widest part of muzzle

The bridge of the nose is wide, filling up the entire space between the eyes. Both the eyes and the nostrils tilt up at a 45-degree angle.

Ears at 45-degree angle

The pupils have thickness to them, but are drawn as slits. Make sure you always make the pupils bleed into the upper eyelids.

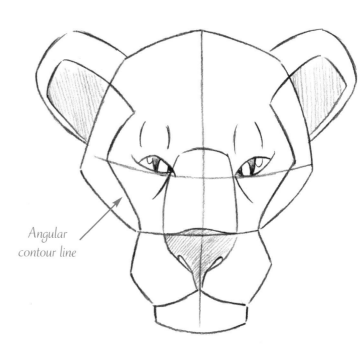

Angular contour line

There is a distinct contour line that starts at the inner ears, continues to the cheekbones, and then into the muzzle.

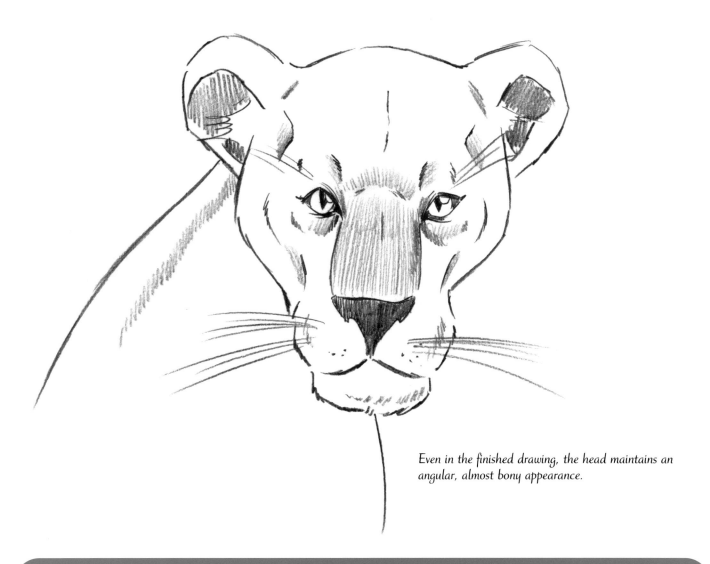

Even in the finished drawing, the head maintains an angular, almost bony appearance.

Lion Eye vs. Human Eye

Compared to the human eye, the lion eye has a dark, superextended eyelid, as if someone went crazy with the liquid eyeliner. This results in a pronounced contrast between the light eyelid and the dark eyelid, making the eyelid seem sharp as a razor. The pupil is narrow and catlike, as opposed to the human pupil, which is round.

Regardless of what animal you're drawing, the eye shine is most effective when it overlaps the pupil.

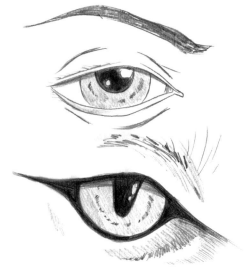

If you look at the shapes of the muscles around the eye to the right, the eye contours in the finished drawing to the left make more sense.

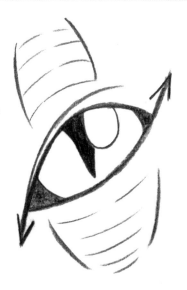

3/4 View

The skull maintains its angularity in the 3/4 view. It has a rhythm to it: Thick, thin, thick. Thick skull, thinner bridge of nose, and thick muzzle.

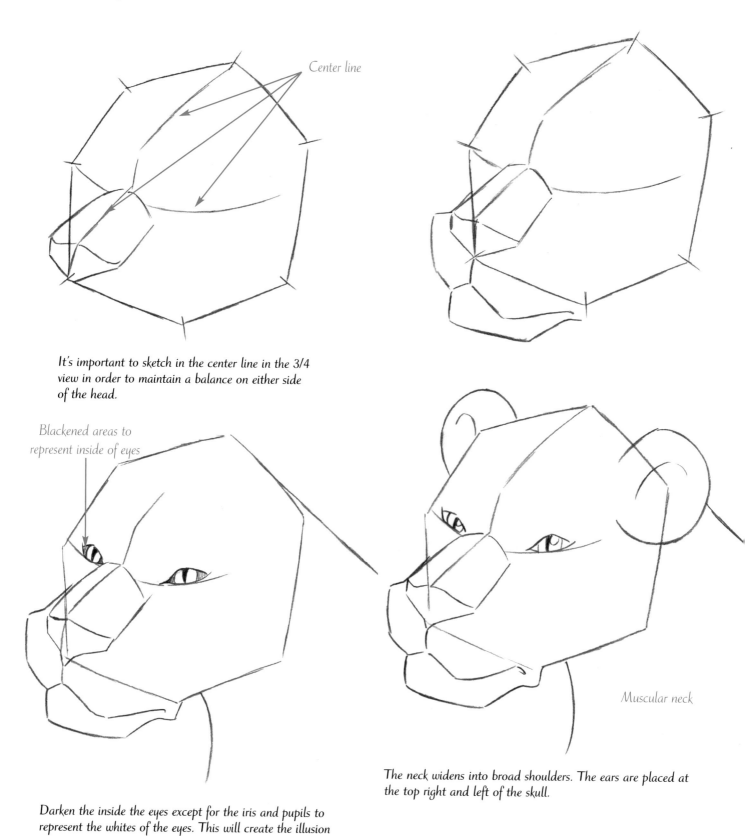

Center line

It's important to sketch in the center line in the 3/4 view in order to maintain a balance on either side of the head.

Blackened areas to represent inside of eyes

Muscular neck

The neck widens into broad shoulders. The ears are placed at the top right and left of the skull.

Darken the inside the eyes except for the iris and pupils to represent the whites of the eyes. This will create the illusion of an intense stare.

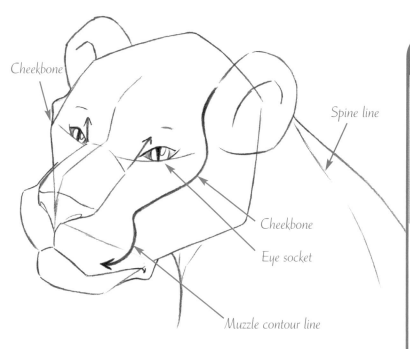

Cheekbone

Spine line

Cheekbone

Eye socket

Muzzle contour line

Note that the face immediately gets wider above the bridge of the nose. And, the contour line that runs from the ear down to the muzzle evident in the front view is still visible in the 3/4 view.

Avoiding a Common Muzzle Pitfall

The key to the lion and lioness muzzle is the length of the split in the front lip. It's very easy to make a lion look goofy if this split is not long enough, but it's only a tiny error that is easily remedied. So if your drawing isn't looking right, before you crumple up your page and try to make a bank shot into the circular file, make sure you haven't made this common error.

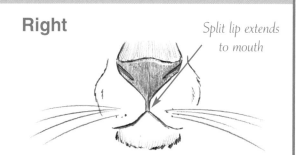

Right

Split lip extends to mouth

Wrong

Split lip is too long

Nose Detail

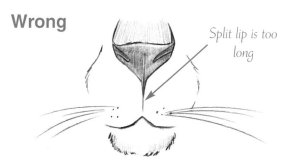

Wrong Right

The top edge of the nose curves up at the outer sides. Instead of dipping down in the center, it rises up slightly.

SIMPLIFIED ANATOMY

The lioness's build is more fluid, with less definition between the body sections (the forequarters, midsection, and hindquarters). That's not to say that these sections shouldn't be defined; they should. But the skin is quite loose.

The shoulder blades are massive. The space between the rib cage and pelvic area is long, making room for a big belly so that the animal can eat large enough amounts of food to carry itself through lean days when food is not available. The rib cage and chest area is actually narrower near the upper chest and wider near the stomach. The tail is quite long and always hovers above the ground, if only by a few inches. (Compare to the tail position of the house cat on page 55.)

In addition, the overall body structure is rather horizontal, with a long torso carried low to the ground. The "arms" and "legs" are thick and somewhat stubby. The head is also often held low, with the nose pointed toward the ground, when the animal walks—a sign of a predator. A deer, for example, cannot afford to take its eyes off the horizon. One cannot help but get a sense of immense power when watching this animal in motion. Even a slow-moving lion or lioness exudes a feeling of primitive strength.

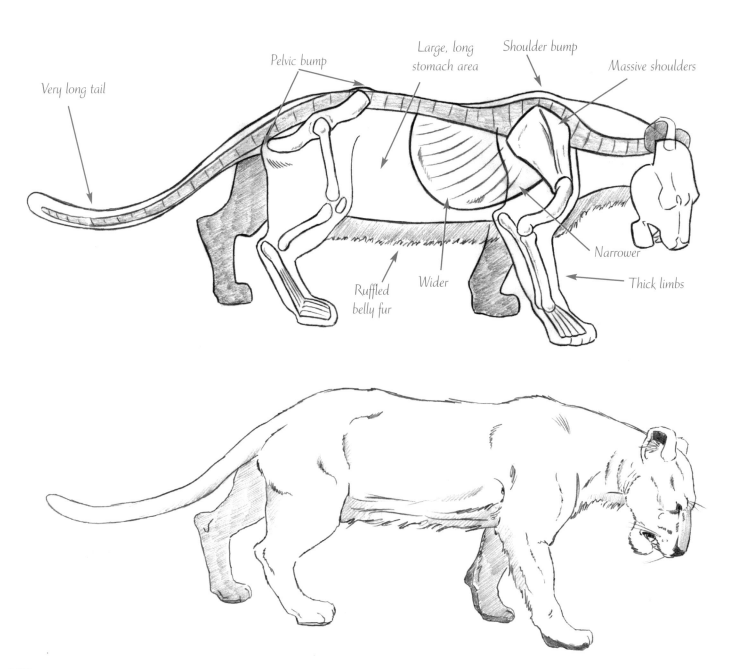

Very long tail

Pelvic bump

Large, long stomach area

Shoulder bump

Massive shoulders

Narrower

Thick limbs

Ruffled belly fur

Wider

RELAXED TORSO

When the lion or lioness relaxes in a reclining posture, its hindquarters typically twist so that both legs are on the same side of the body. You can see the torso twist by following the line of the spine from the base of the neck down to the tail. Make sure that the shoulders are thicker than the hindquarters in this position.

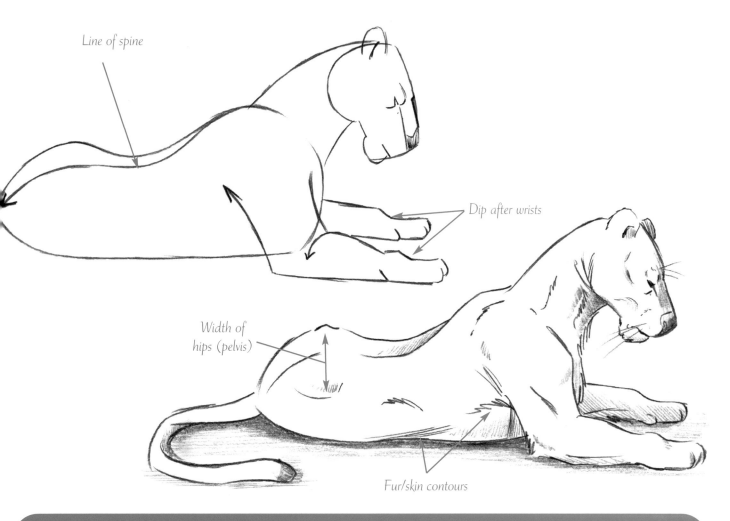

Line of spine

Dip after wrists

Width of hips (pelvis)

Fur/skin contours

The Stripes Make the Tiger

Tigers are similar in body structure to lions, only bigger. By making your lioness a bit larger and adding stripes, you can create a tiger. The stripes are not solid; they break apart and come together again. They also don't appear with the same density over the entire body but sort of peter out as they travel from the back down the sides toward the belly. They also cluster around the cheek area on the face.

In this alternate view of the relaxed torso, the sections of the body overlap one another to create a feeling of depth and three-dimensionality. The line of the spine winds its way over each body section, like a string falling over a ball, and linking them together. It rises and falls with the natural curve of each section, neck, shoulders/forequarters, midsection, hindquarters, and tail.

DETAILS OF THE WALK

Both the lion and lioness move gracefully, but they are also sturdy predators, moving slowly and keeping low to the ground—except when making lightning-quick strikes during an attack.

Shoulder Placement

When one foreleg lifts off the ground, the shoulder on that same side has no support, so it sags. The shoulder on the other side, though, remains propped up by the other foreleg. As a result, the shoulder blades are at two different levels. (You should be able to draw a diagonal line across the two of them.) This is a dramatic look. But more important, it's anatomically correct; conversely, it's anatomically incorrect to draw the shoulders at the same level during the walk. The same principle applies to all four-legged mammals, but is pronounced on animals with large, muscular shoulder blades with good definition, which the lioness possesses.

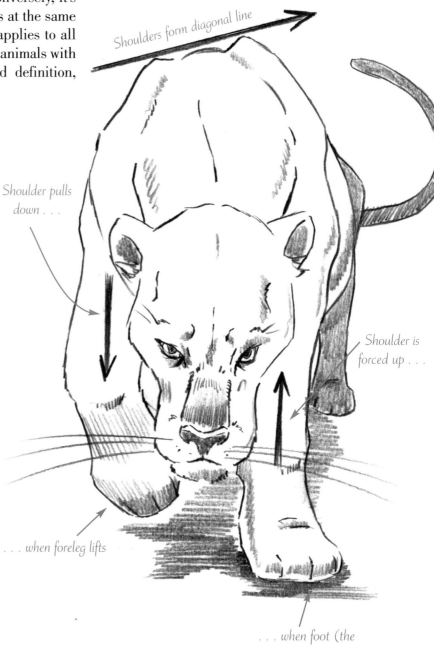

Shoulders form diagonal line

Shoulder pulls down . . .

Shoulder is forced up . . .

. . . when foreleg lifts

. . . when foot (the foundation) remains in place

When the support is removed, the slab slants downward.

The Line of the Spine

From a high angle, or bird's-eye view, most or all of the line of the spine is evident. Try to show the natural S-curve of the spine in the walk. Doing so will accentuate the slinkiness of the lion and create a fluid pose. In addition to being pleasing to the eye, it's also anatomically accurate: When the lion walks, the shoulders tilt in one direction (to one side) while the hips tilt in the opposite direction (to the other side).

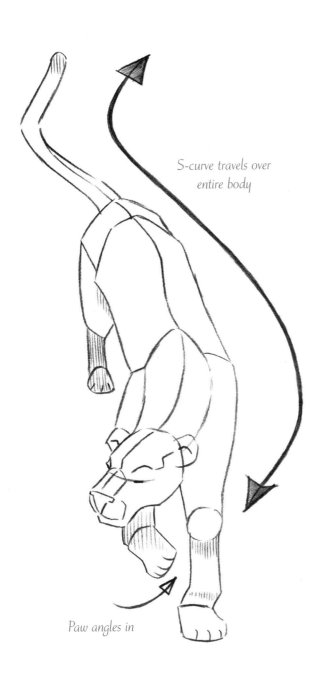

S-curve travels over entire body

Paw angles in

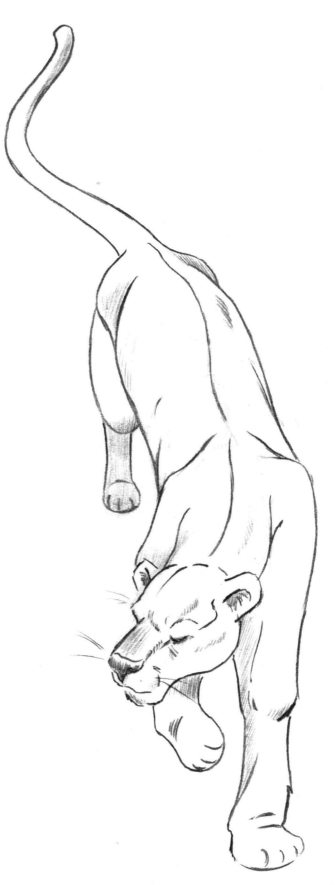

RUNNING

There is a point in the stride when all the legs are off the ground. Since no weight is on the paws in this moment, the shoulder blades and pelvis are not pushed up. As a result, they don't make pronounced contours or bumps in the outline of the back as they would if the paws were on the ground. So, you can draw the body as a simple sausage shape, loose and relaxed. (The big cat is never tense, even on the hunt.)

The darkened lines on the neck, shoulder, legs, and hip highlight the contours that show through to the surface. The tail dips in the middle and then rises near the tip, like a delayed reaction, as the lioness runs.

Minimal pelvis bump

Minimal shoulder bump

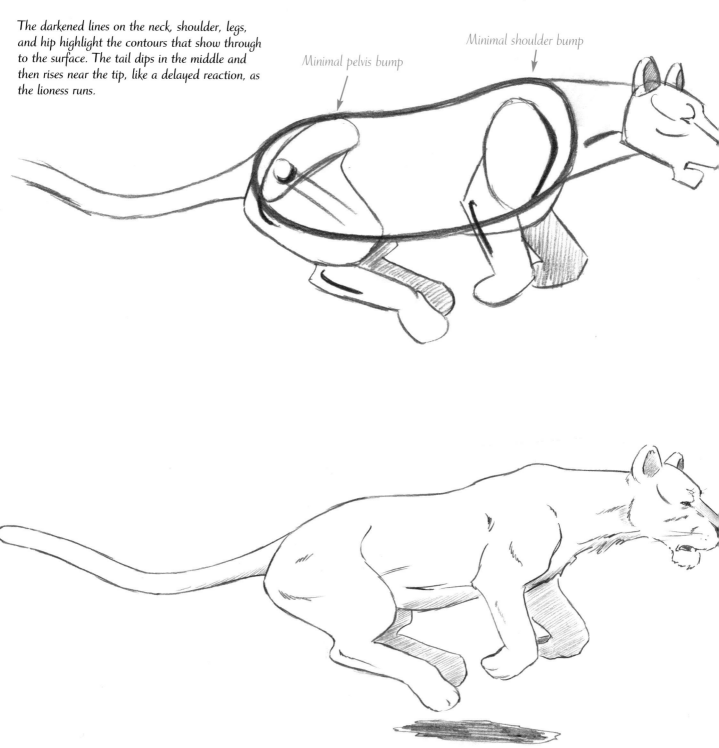

THE MANE

The male lion's face is a little bigger that of the lioness. And then there's the mane. The mane has three sections: the part on the forehead, the part over the back of the head, and the part that frames the face (this is the longest part).

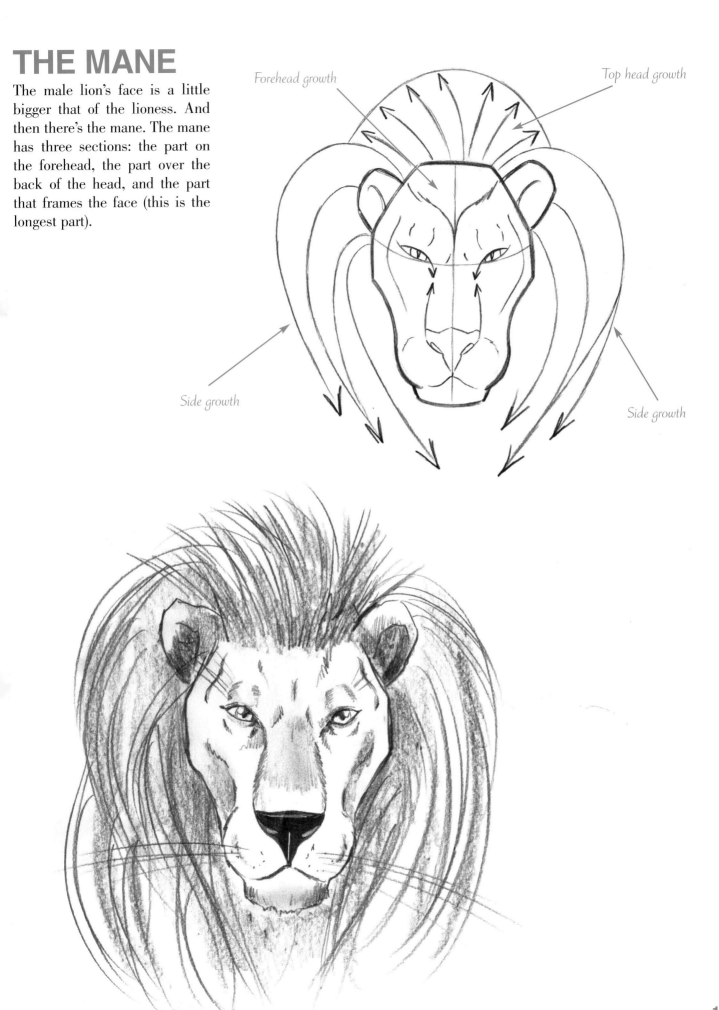

Forehead growth

Top head growth

Side growth

Side growth

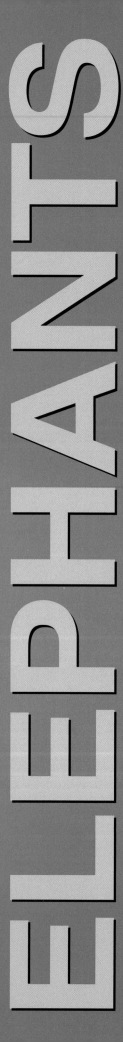

ELEPHANTS

Elephants are wonderful animals, aren't they? Giant, lumbering, gentle creatures, they are loving parents to their young, kind and nurturing with a true sense of community. They also have some unique qualities. For example, they can't run. When they go on a rampage, the most they can do is walk very fast. And, they can't turn their heads, because they have no necks! To turn to look at something, they must move their entire bodies, which is cumbersome. But, that puts them at no disadvantage. They're never in a rush to move, because they have no natural predators—except, of course, men without conscience and an appetite for ivory.

Perhaps the most wonderful things about elephants are the unexpected details, which we'll uncover in this chapter. So, throw away all your preconceived ideas about elephants, because those can get you into trouble. Get ready to learn the elephant characteristics that might be at odds with what you thought you knew. You're in for a pleasant surprise.

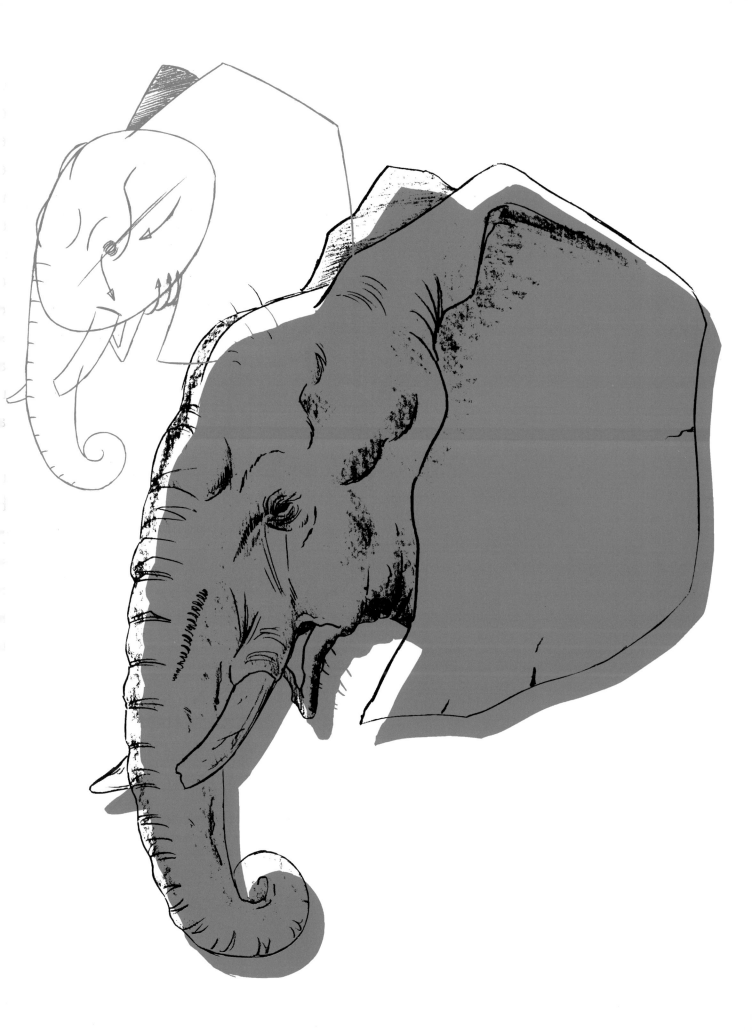

AFRICAN ELEPHANTS VS. ASIAN ELEPHANTS

There are two types of elephants: African and Asian (sometimes referred to as Indian). Before we get to the details, let's compare the two. The African elephant is, by far, the more popular elephant with artists. It is the larger of the two types, making it more awesome and powerful looking. However, the Asian or Indian elephant can seem more people-friendly. Many charming illustrated children's books feature human characters who befriend elephants (and vice versa), and they, by and large, are Asian or Indian elephants. Compare these drawings to get a feel for all the differences between the two.

African

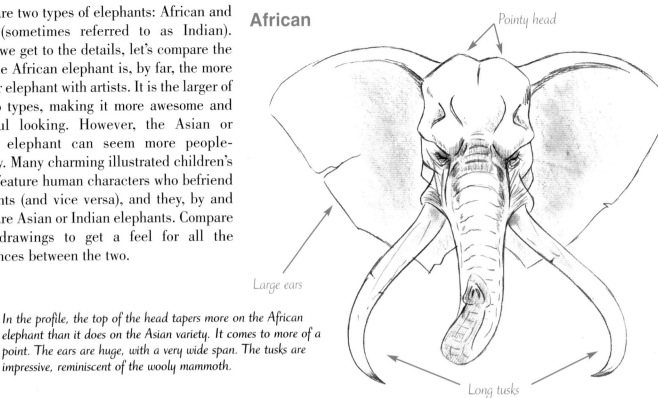

Pointy head

Large ears

Long tusks

In the profile, the top of the head tapers more on the African elephant than it does on the Asian variety. It comes to more of a point. The ears are huge, with a very wide span. The tusks are impressive, reminiscent of the wooly mammoth.

The African elephant has a more complex back arch than the Asian elephant. On the African elephant, the arch actually changes direction. The African elephant is also significantly bigger and more massive than its Asian counterpart.

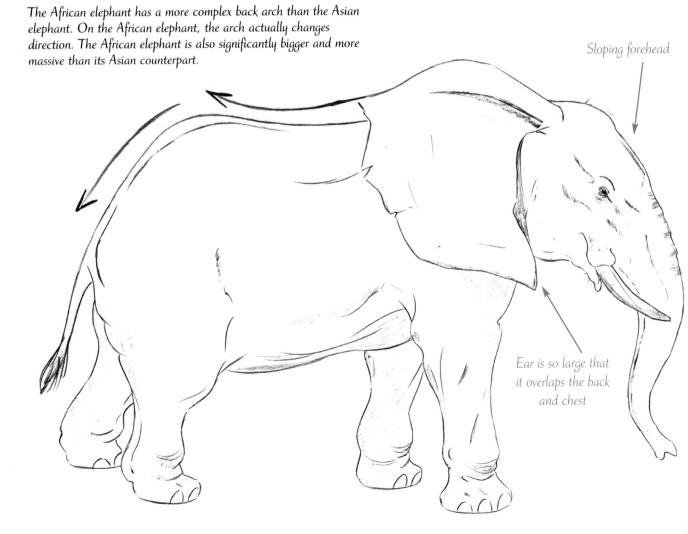

Sloping forehead

Ear is so large that it overlaps the back and chest

Asian or Indian

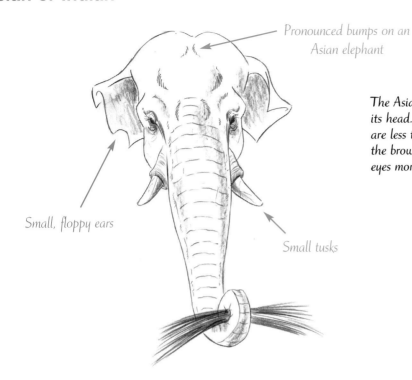

Pronounced bumps on an Asian elephant

Small, floppy ears

Small tusks

The Asian elephant has two rounded bumps at the top of its head. The ears are smaller and floppier, and the tusks are less threatening. Also note the subtle difference around the brow area. The brow is not thick and heavy, leaving the eyes more open—giving a slightly friendlier look.

The back arch is one, simple convex curve. The forehead is more pronounced here than on the African variety.

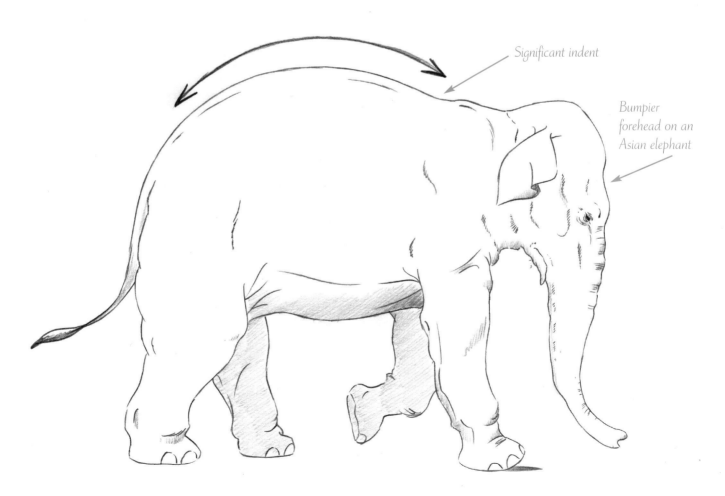

Significant indent

Bumpier forehead on an Asian elephant

THE HEAD IN PROFILE

Now, on to drawing elephants. Let's start with the side view of an African elephant, as it give us the clearest view of the trunk and a chance to draw those incredible ears. In this angle, you can see clearly how the trunk originates from the top of the forehead. The other benefit of this pose is that the trunk doesn't hide the mouth, as it does in the front view. And, you can see the exact spot at which the ear attaches to the head.

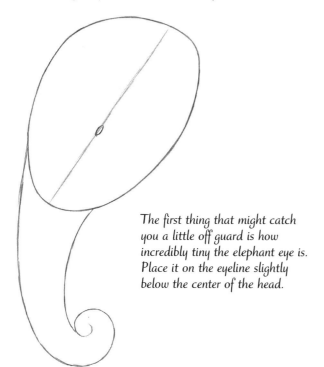

The first thing that might catch you a little off guard is how incredibly tiny the elephant eye is. Place it on the eyeline slightly below the center of the head.

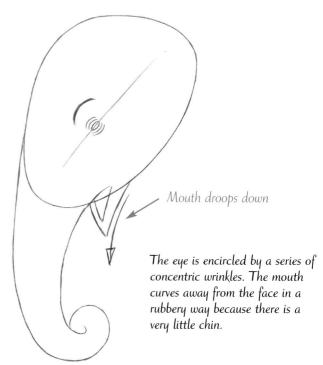

Mouth droops down

The eye is encircled by a series of concentric wrinkles. The mouth curves away from the face in a rubbery way because there is a very little chin.

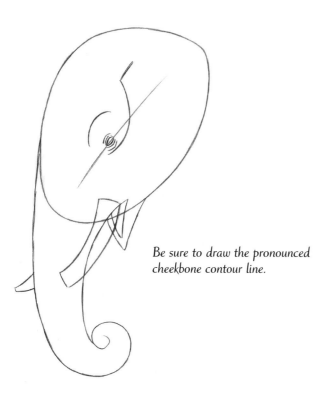

Be sure to draw the pronounced cheekbone contour line.

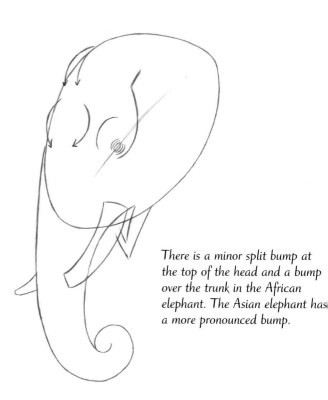

There is a minor split bump at the top of the head and a bump over the trunk in the African elephant. The Asian elephant has a more pronounced bump.

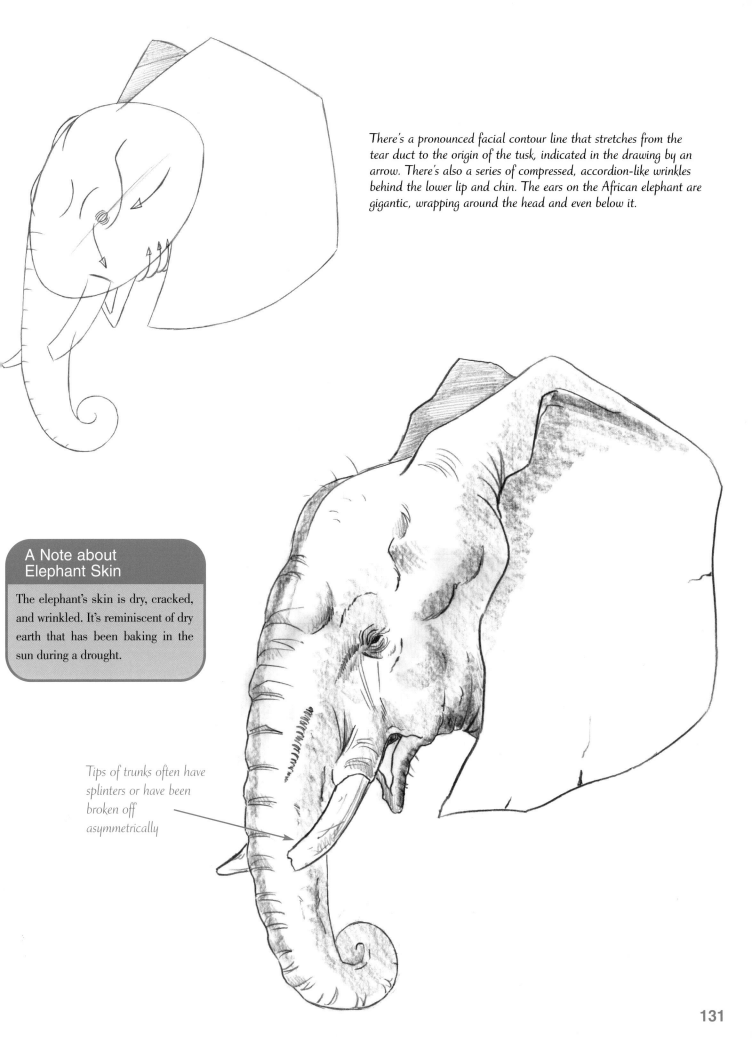

There's a pronounced facial contour line that stretches from the tear duct to the origin of the tusk, indicated in the drawing by an arrow. There's also a series of compressed, accordion-like wrinkles behind the lower lip and chin. The ears on the African elephant are gigantic, wrapping around the head and even below it.

A Note about Elephant Skin

The elephant's skin is dry, cracked, and wrinkled. It's reminiscent of dry earth that has been baking in the sun during a drought.

Tips of trunks often have splinters or have been broken off asymmetrically

THE BODY IN PROFILE

This is a good pose from which to view the compete outline of the elephant. Note that, due to the stretching posture with the head held high, the torso takes on a kidney-bean shape.

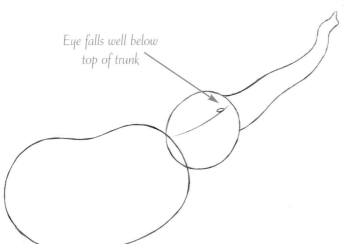

Eye falls well below top of trunk

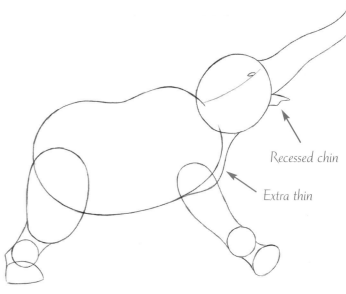

Recessed chin

Extra thin

Notice how the head overlaps the body, because there's no neck to connect them. The trunk itself is a long muscle. Without any bones in it, it can't be held perfectly straight like a human arm. So, when the elephant extends its trunk up and out, the trunk curves and bends—even at its straightest.

Note how the muscle and fat on the chest hangs due to the effects of gravity.

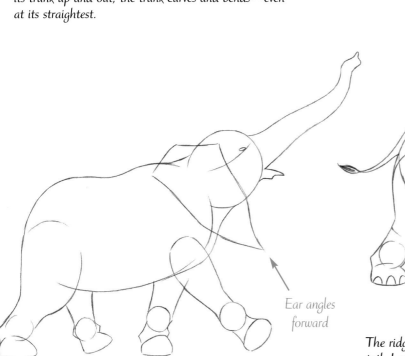

Ear angles forward

Since this is an African elephant, the ears are substantial.

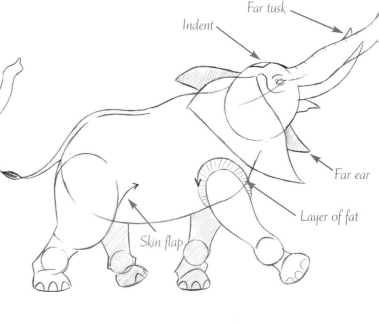

Far tusk

Indent

Far ear

Layer of fat

Skin flap

The ridge of the spine shows all the way down the back to the tail. Layers of fat and skin flaps encircle the tops of the legs. And, don't forget the details on the far side of the body; a bit of the far ear and the far tusk should be visible.

When the elephant's foreleg is extended in front and the hind leg is all the way back, draw a good amount of stretch lines on the underside of the belly, where the loose skin is pulled tighter.

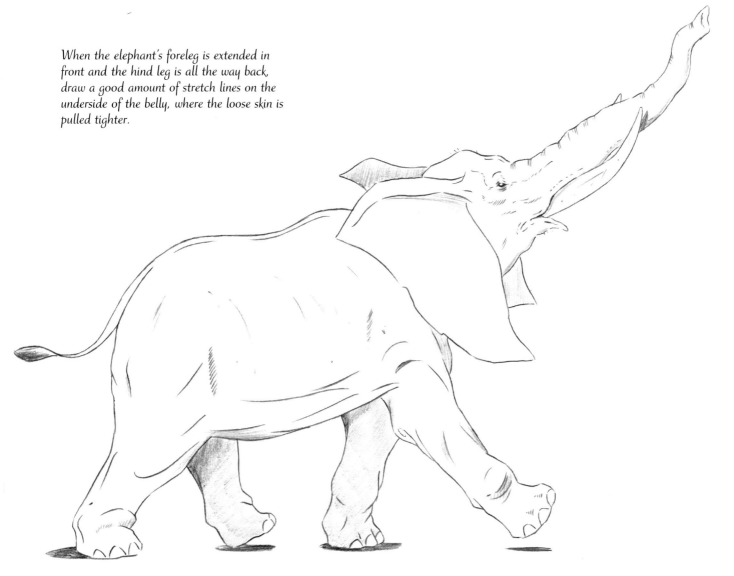

Hind Leg Comparison

The mechanics of different mammals are basically the same. However, the joints may be in higher or lower spots, and the angles of some of the limbs may be greater or smaller. Take a look at the deer and elephant hind legs.

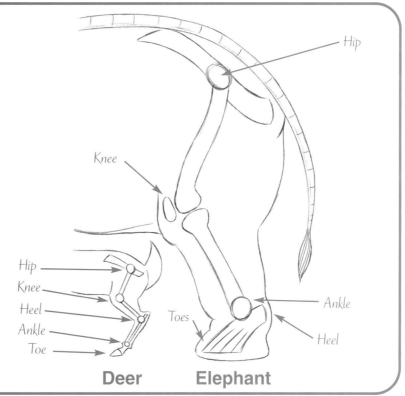

Hip

Knee

Hip
Knee
Heel
Ankle
Toe

Toes

Ankle

Heel

Deer **Elephant**

THE BODY HEAD-ON

The front view is a dramatic angle from which to draw the elephant. We don't often think of elephants this way, but it's effective to portray this giant creature coming right at you. This example shows the Asian elephant.

Back rises above head

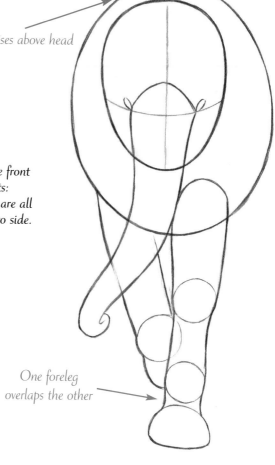

Note that the back rises above the head. Also, the foreleg that steps out in the front overlaps the other foreleg. This brings us to another secret of drawing elephants: They have very long, thin legs, epecially at this angle. Moreover, the rear legs are all but hidden from view. As the elephant walks, there is a slight sway from side to side. The trunk lags behind a beat, swaying in the opposite direction of the body's momentum.

Contour of skull indents

One foreleg overlaps the other

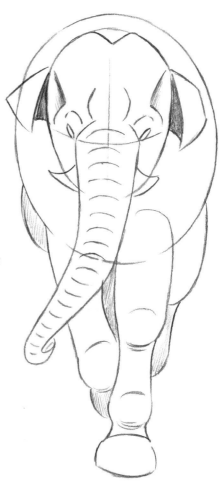

If you were drawing the African elephant, the ears would be very dramatic in this angle, like the outstretched wings of an eagle. Since this is the Asian elephant, however, the ears are smaller.

An Asian elephant's eyes appear to look up at the viewer whereas an African elephant's eyes look from an angle.

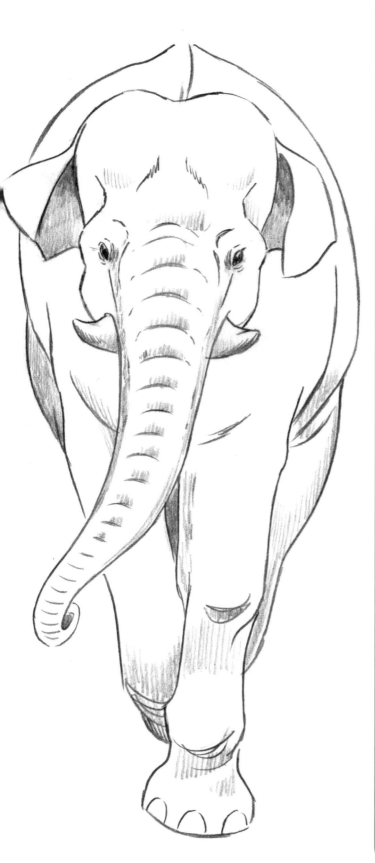

The Trunk

At the point midway down the trunk, the curves of trunk contour lines break in the opposite direction. Due to perspective, this can be a subtle effect, or it can be more pronounced.

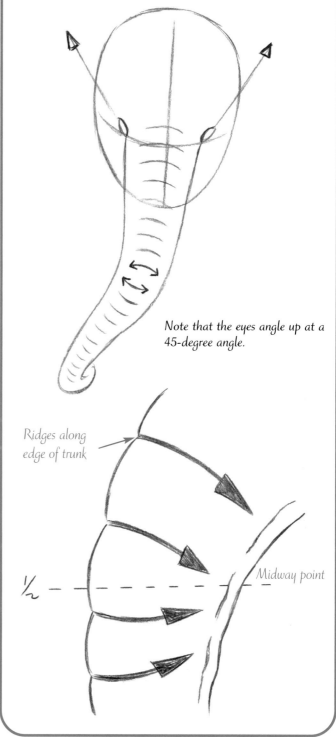

Note that the eyes angle up at a 45-degree angle.

Ridges along edge of trunk

Midway point

½

THE BODY IN 3/4 VIEW

The key to drawing an elephant's frame in any view is simplicity. Keep it bold and simple.

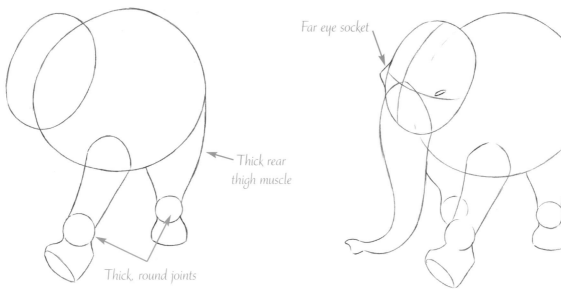

Thick rear thigh muscle

Thick, round joints

Far eye socket

The head is an elongated oval in the 3/4 view. Don't forget to omit any sign of a neck connecting the head to the body. Even though elephants have long legs, the joints are big and round, which make them stand out in the outline. In order to sustain such immense weight, their feet are wide pads, like giant cushions.

Lots of overlapping on a large scale does the trick in this step. The head, body, trunk, and legs are all composed of overlapping lines.

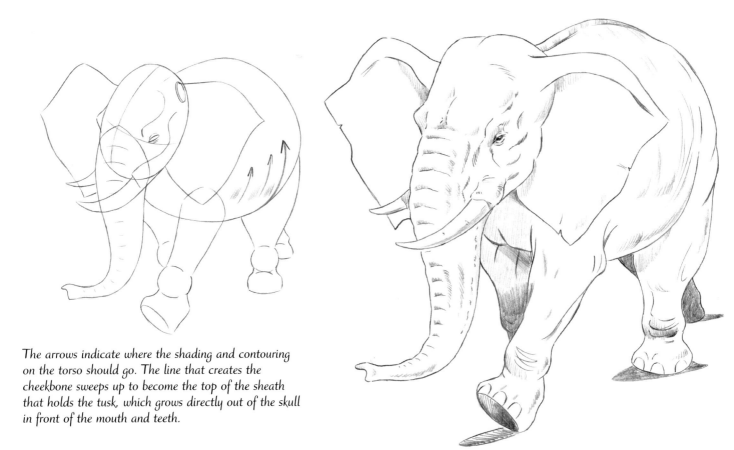

The arrows indicate where the shading and contouring on the torso should go. The line that creates the cheekbone sweeps up to become the top of the sheath that holds the tusk, which grows directly out of the skull in front of the mouth and teeth.

A Note about Shading

Shading shouldn't always be an afterthought, something you add after you've completed a drawing as the finishing touch to "spruce it up." Yes, shading is certainly useful as an accent. But often, it's an essential tool—one of the main elements of a drawing. Without it, large areas would look empty and hollow, which is deadly for a drawing.

Without shading, the ball to the right isn't a ball but a circle—a flat, two-dimensional object. With shading, the circle suddenly becomes a sphere, round and solid. Why is this important? Because the elephant torso is huge. There's simply no way to avoid the need to shade it. How do you do this? By creating sketch marks that follow the contours of the body. This reinforces that the body is round.

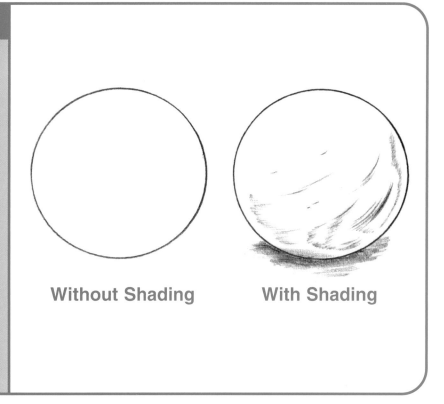

Without Shading **With Shading**

Use shading to "flatten" underside of trunk

Spine becomes visible

Spine ridge becomes tail

Sheathlike skin at base of trunk

Contour indicates overlapping and creates dimension

Bump

Wrinkles

Wispy, whiplike tail

Bump

The Dirt Bath

Elephants love to throw their heads back and let some dirt fly. I suppose it's their idea of "freshening up." As long as it works for them, who am I to argue? Like the example below, this is also a 3/4 view—just from the other end. Regardless of direction, the 3/4 view adds depth and interest to a drawing. Even though the effects of perspective are only slight here, some foreshortening is required. Due to the angle, the back end of the animal is like a hill, partially cutting off most of the "valley" of the back from view. You lose sight of the spine temporarily, until it reappears near the shoulders. Some overlapping of the sections of the body occurs, which makes the torso look more three-dimensional than it otherwise would.

137

THE BABY ELEPHANT

Name me one person who doesn't have a soft spot for baby elephants. What is it that makes them so cute? Big eyes? No, they have tiny eyes. Short, chubby legs? Nope, their legs are long in proportion to their body size. You're thinking about the proportions of a puppy or a bear cub. Let's find out what makes a baby elephant such a cutie. It has a large head, compared to the body size, and its ears, legs, and trunk are too big, since it hasn't grown into its adult proportions yet. It also has a confused, unassuming expression.

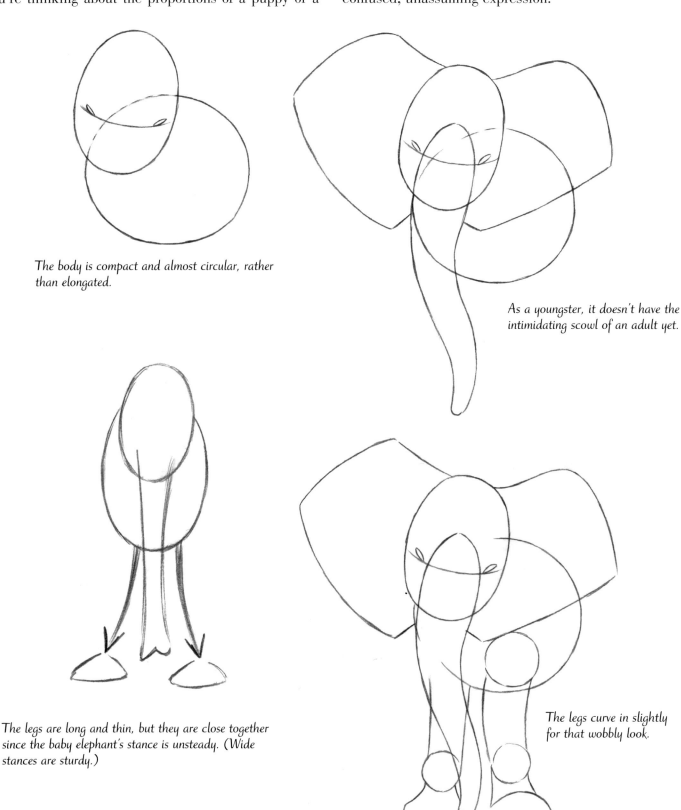

The body is compact and almost circular, rather than elongated.

As a youngster, it doesn't have the intimidating scowl of an adult yet.

The legs are long and thin, but they are close together since the baby elephant's stance is unsteady. (Wide stances are sturdy.)

The legs curve in slightly for that wobbly look.

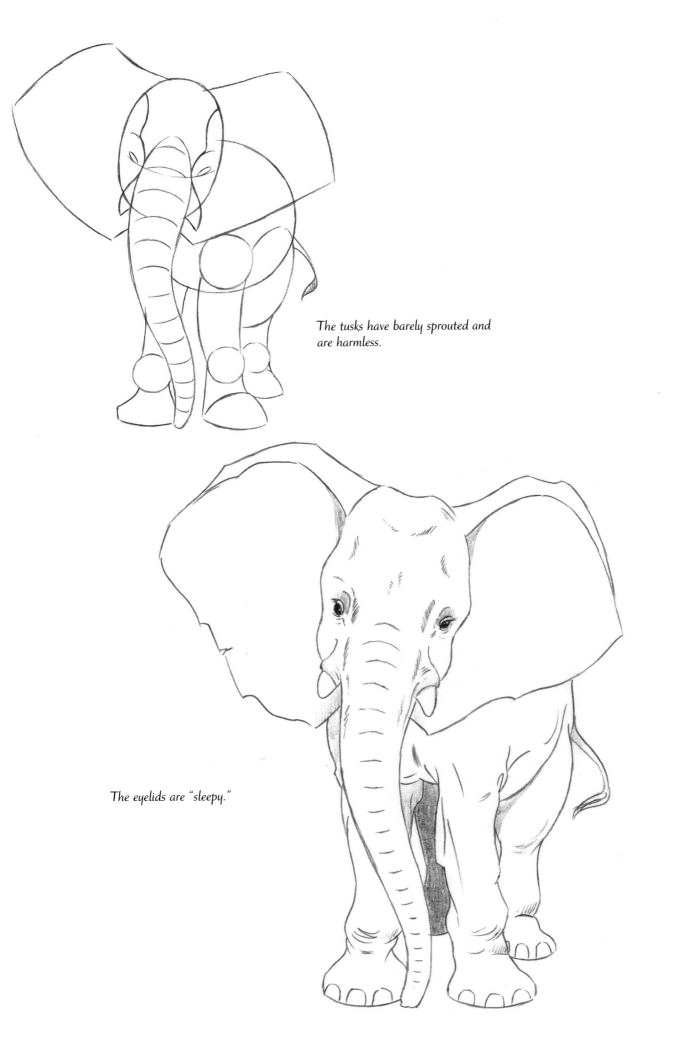

The tusks have barely sprouted and are harmless.

The eyelids are "sleepy."

139

OTHER ANIMALS

O f course, a book on how to draw every animal out there would be endless, so I've included the most popular species, as well as some less common subjects. For example, chimpanzees and monkeys have an interesting effect on people. Many of us find them mysterious and captivating. Others find them odd and creepy. In any case, the chimp and monkey exhibits remain among the most popular at zoos around the world. Perhaps that's because it's like looking into a distant mirror. Or at a snapshot of your Uncle Phil.

Certain birds are also favorites: penguins, eagles, and ducks, for instance. You can hardly find an animated movie these days that doesn't feature a wacky avian character in a lead role. Pigs are another favorite, and there are many more.

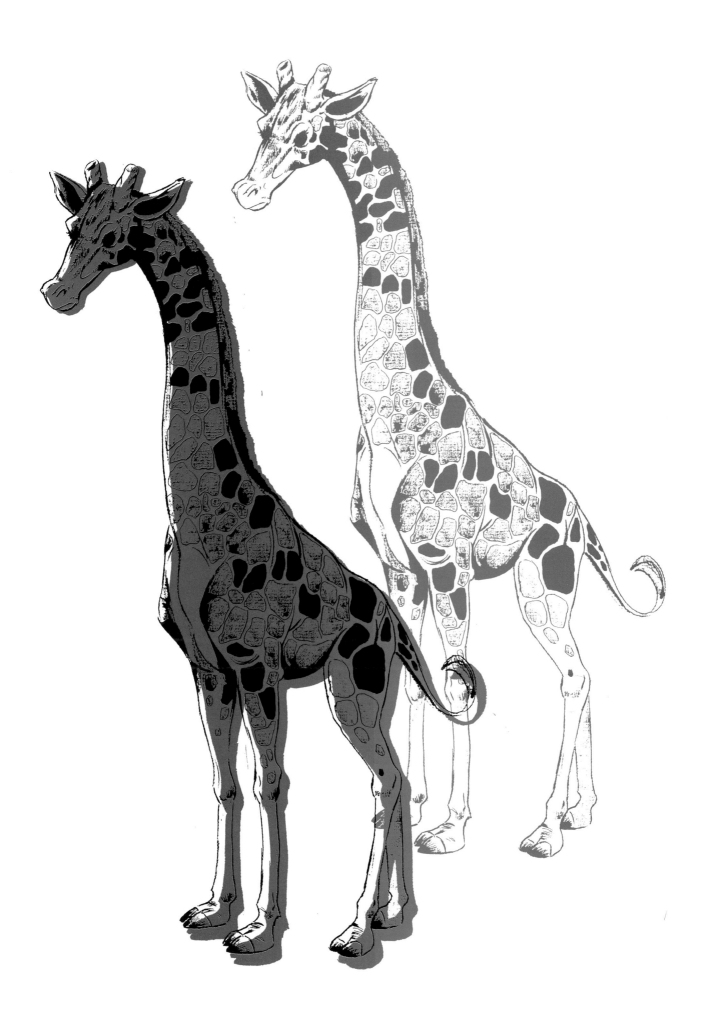

CHIMPANZEE

I've always felt that gorillas looked the most like humans. But, scientists now tell us that chimpanzees share more genetic material with humans, making them our closest living relatives. Even though the posture is similar to ours, the chimpanzee proportions are different: Their arms are much longer than their legs, their foreheads are smaller than ours, and the space between the nose and upper lip is much longer.

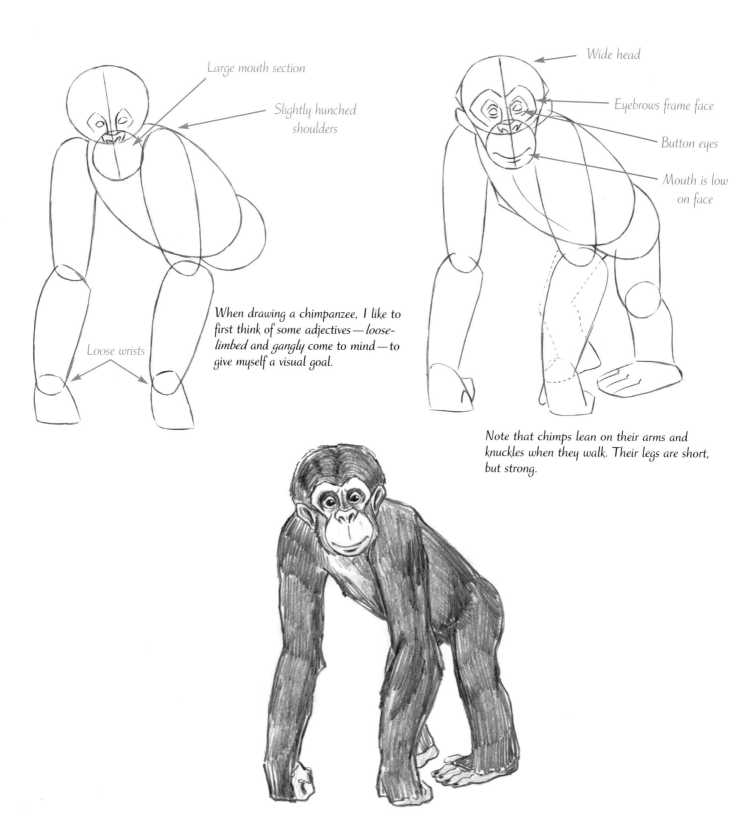

Large mouth section

Slightly hunched shoulders

Loose wrists

When drawing a chimpanzee, I like to first think of some adjectives—loose-limbed and gangly come to mind—to give myself a visual goal.

Wide head

Eyebrows frame face

Button eyes

Mouth is low on face

Note that chimps lean on their arms and knuckles when they walk. Their legs are short, but strong.

Walking Upright

Walking upright, like a human, is a real a balancing act for a chimp. There's just a whole lot of upper-body teetering on not a whole lot of legs. This pose gives you a clear view of just how short a chimpanzee's legs really are compared to its arms.

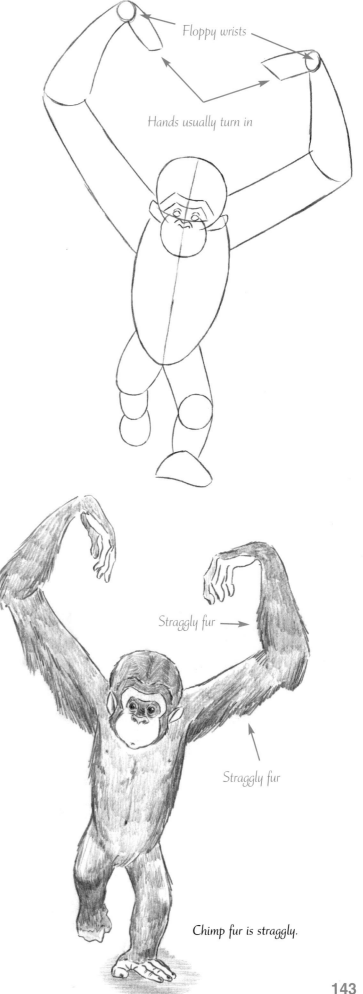

Floppy wrists

Hands usually turn in

Straggly fur

Straggly fur

Chimp fur is straggly.

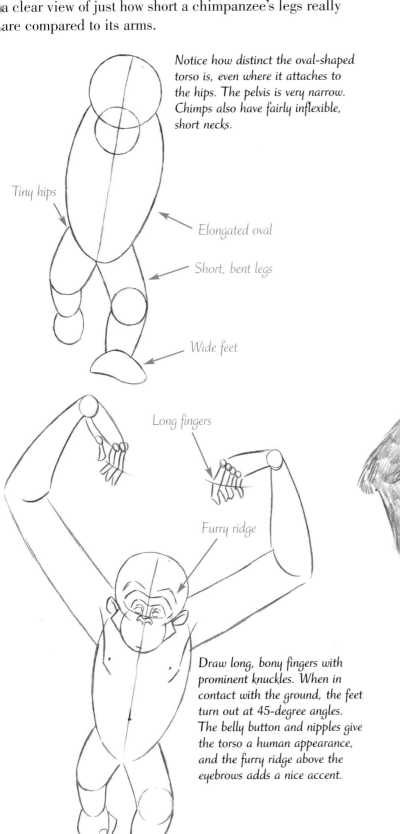

Notice how distinct the oval-shaped torso is, even where it attaches to the hips. The pelvis is very narrow. Chimps also have fairly inflexible, short necks.

Tiny hips

Elongated oval

Short, bent legs

Wide feet

Long fingers

Furry ridge

Draw long, bony fingers with prominent knuckles. When in contact with the ground, the feet turn out at 45-degree angles. The belly button and nipples give the torso a human appearance, and the furry ridge above the eyebrows adds a nice accent.

Gripping

The knuckle on the base of the thumb on the chimp hand is located farther down the wrist than it is on humans. This leaves a bigger "pocket," or space, between the index finger and the thumb, and between the "toe-thumb" (our big toe) and the "second toe." The hair doesn't fully cover the hands and feet. Also, to help you visualize its feet better, it may help to think of the chimp as having four hands.

Hand

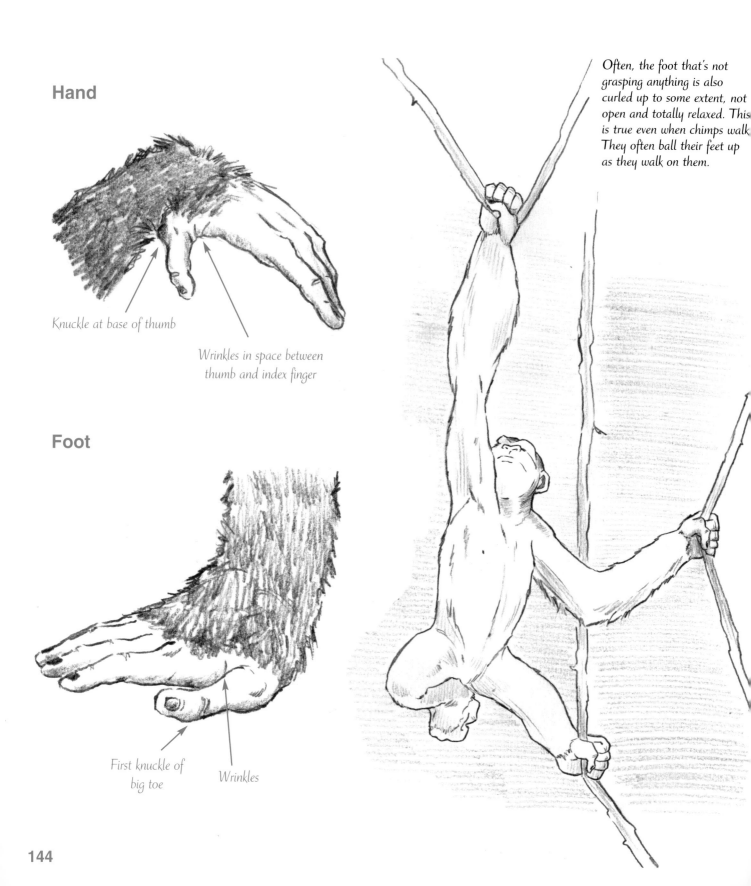

Knuckle at base of thumb

Wrinkles in space between thumb and index finger

Foot

First knuckle of big toe

Wrinkles

Often, the foot that's not grasping anything is also curled up to some extent, not open and totally relaxed. This is true even when chimps walk. They often ball their feet up as they walk on them.

The chimp's arms are incredibly strong. They can hold
all their weight on one arm and carry about their
business, without feeling any strain whatsoever.

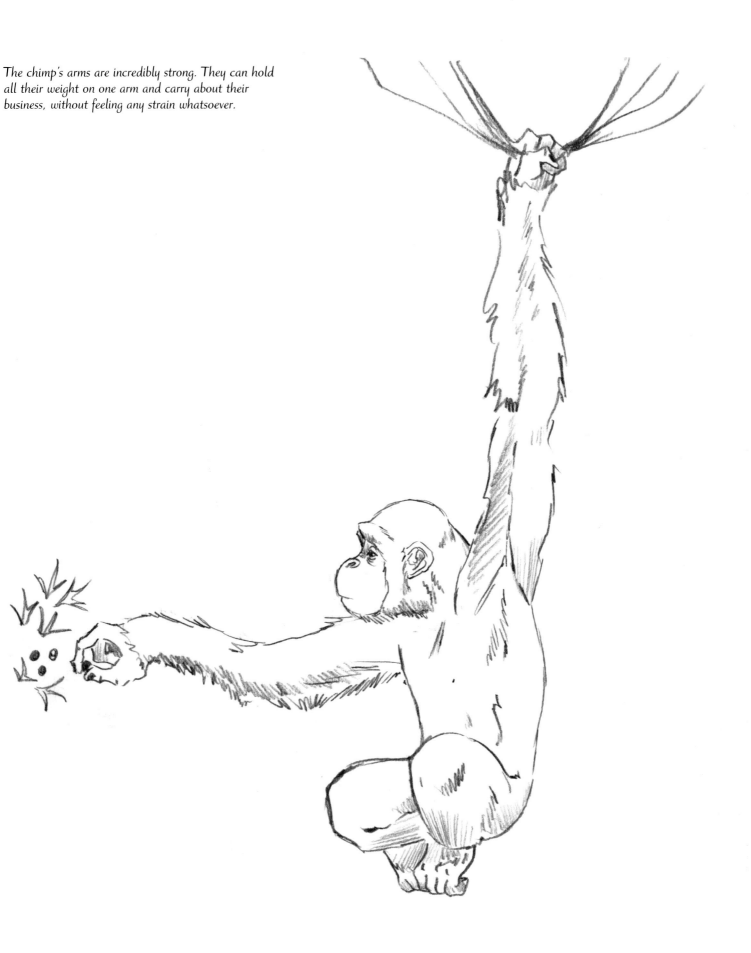

BALD EAGLE

Many books on drawing animals omit birds altogether. But birds are useful subjects for artists. We use them often. They add life to scenes. The bald eagle, for example, is one proud-looking bird: majestic, bold, powerful, and graceful. It has an impressive wingspan, sharp beak, and fierce talons. And then there's that piercing eye. The term *eagle eye* wasn't coined for nothing. It's a heroic animal, the rock star of birds.

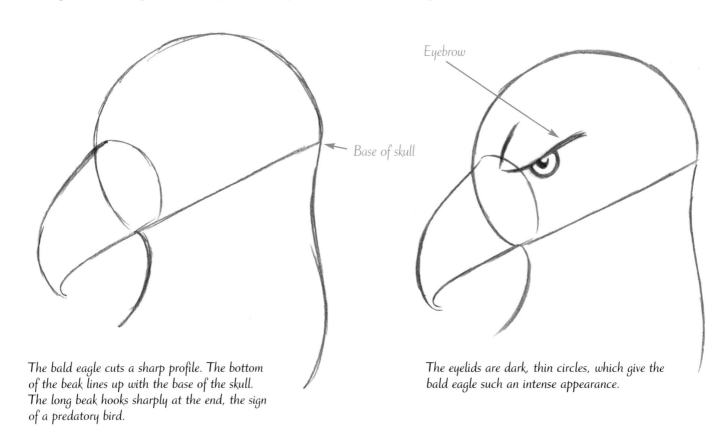

Base of skull

The bald eagle cuts a sharp profile. The bottom of the beak lines up with the base of the skull. The long beak hooks sharply at the end, the sign of a predatory bird.

Eyebrow

The eyelids are dark, thin circles, which give the bald eagle such an intense appearance.

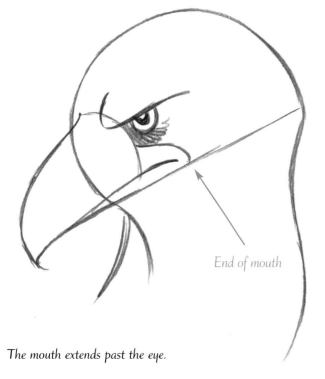

End of mouth

The mouth extends past the eye.

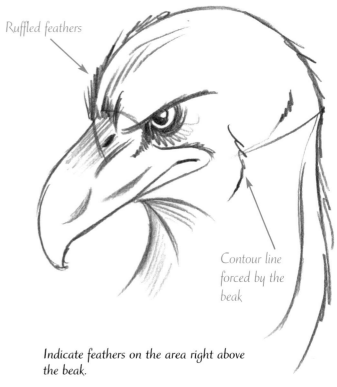

Ruffled feathers

Contour line forced by the beak

Indicate feathers on the area right above the beak.

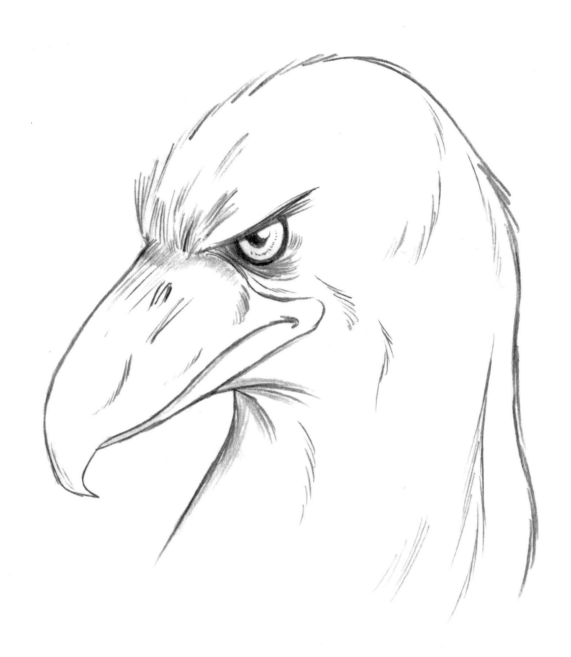

The Eagle Eye

The arrows in the drawing at the right indicate the direction of the black streaks around the eyes. Notice how dark and thick the eyebrow is above the eyeball. The shine in the pupil is left open, which gives the bald eagle its steely stare.

The Eagle Body

The eagle has a sizable body with significant leg strength. Like most birds that fly, the eagle holds its body at a 45-degree angle when it stands. The chest area is large and tapers toward the tail. The neck is clearly visible and can turn almost 360 degrees—a chiropractor's dream.

Beak hooks

Long, oval body

Some things to note: Again, the beak hooks sharply under at the tip. When the eagle turns its head, there's a contour line that stretches from the underside of the beak to the torso.

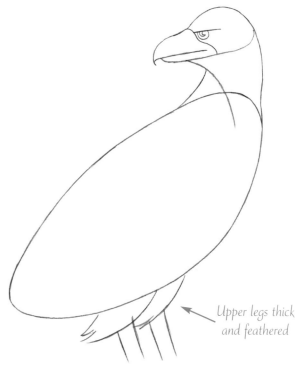

Upper legs thick and feathered

You'll never see the tops of the legs bare; they are always covered with feathers.

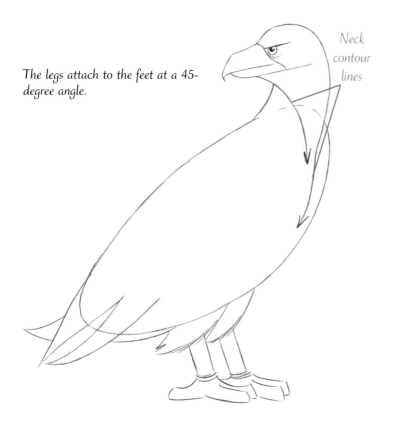

The legs attach to the feet at a 45-degree angle.

Neck contour lines

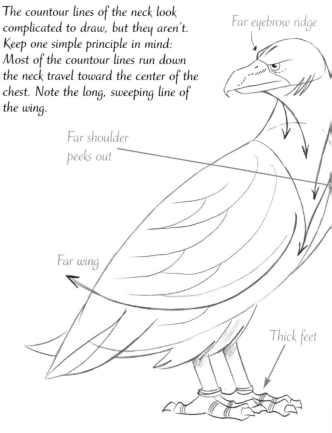

The countour lines of the neck look complicated to draw, but they aren't. Keep one simple principle in mind: Most of the countour lines run down the neck travel toward the center of the chest. Note the long, sweeping line of the wing.

Far eyebrow ridge

Far shoulder peeks out

Far wing

Thick feet

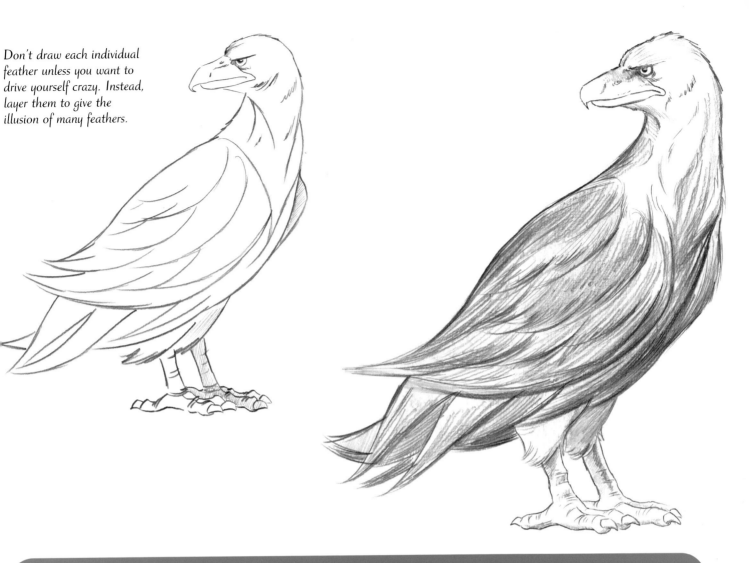

Don't draw each individual feather unless you want to drive yourself crazy. Instead, layer them to give the illusion of many feathers.

When Eagles Attack

When an eagle attacks, it dives talons first toward its prey. The head and legs stretch forward, forcing the body into an arc. The bird keeps its eyes trained on its prey at all times and flaps its wings furiously, continuously modulating its velocity.

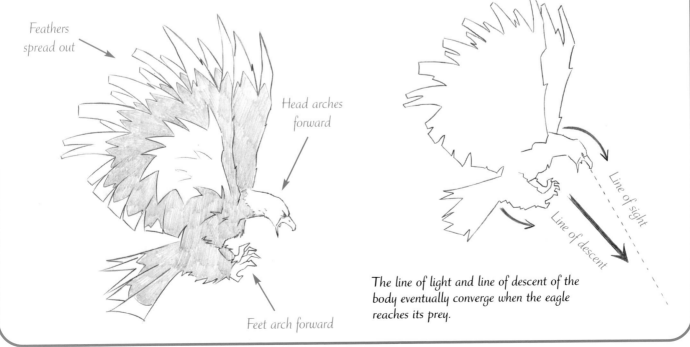

Feathers spread out

Head arches forward

Feet arch forward

Line of sight

Line of descent

The line of light and line of descent of the body eventually converge when the eagle reaches its prey.

PENGUIN

Everyone loves penguins. With their formal attire (their little "tuxedos") and irresistible waddle, they melt hearts as they skate along the ice and jump into the frigid water. Penguins are great swimmers but are totally lacking in agility on land, which is what makes them so endearing—they're practically immobile. One feels that they might as well fall down and roll, which might get them where they're going faster than walking. But, we all like to see penguins walk. And, they seem to like to do it, too.

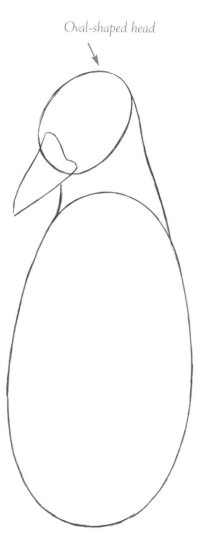

Oval-shaped head

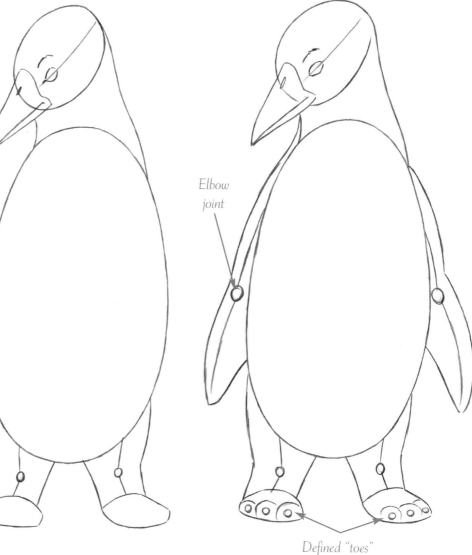

Elbow joint

Defined "toes"

The penguin's body should look completely "porked-out" and impossible to maneuver, much the way Charlie Brown does in an oversized winter jacket. The head of the penguin is quite small compared to its body and somewhat narrow, as well, like a stretched oval.

The legs are short and covered with feathers.

The penguin's long, padded wings always bend at the elbow, even when totally relaxed. They are, for all intents and purposes, useless on land. Penguins can't even flap a "hello" at one another. The feet have individually defined "toes." They're not large webbed pads, like duck feet. You've been watching too many penguin cartoons!

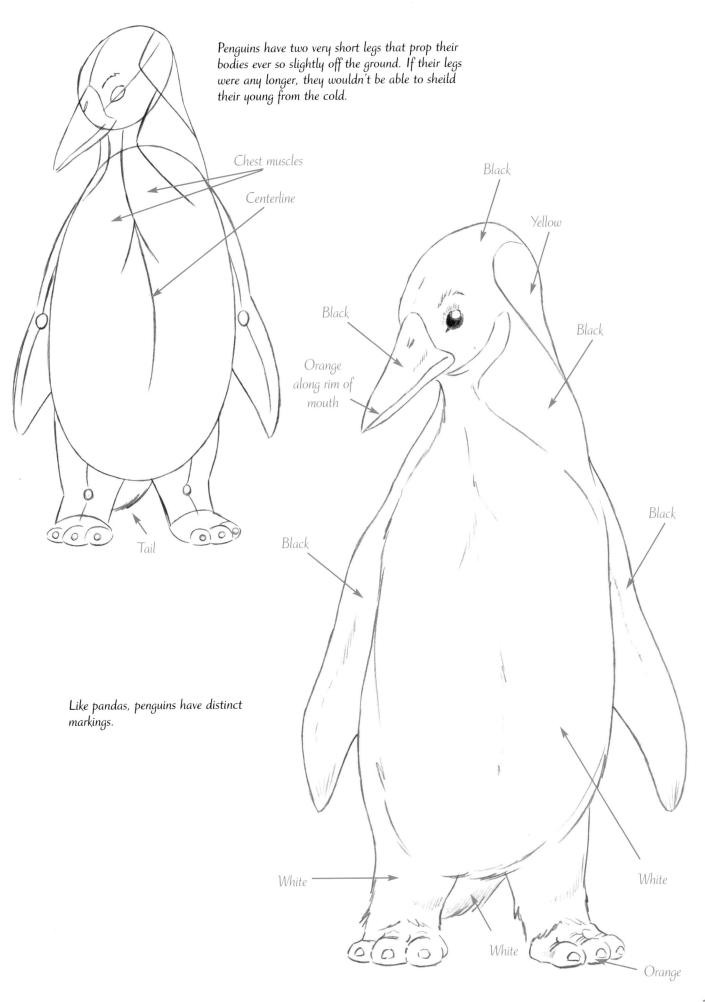

Penguins have two very short legs that prop their
bodies ever so slightly off the ground. If their legs
were any longer, they wouldn't be able to sheild
their young from the cold.

Chest muscles

Centerline

Tail

Like pandas, penguins have distinct
markings.

Black

Yellow

Black

Black

Orange
along rim of
mouth

Black

Black

White

White

White

Orange

151

PIG

I don't know why the term "pig" became one of disparagement. Pigs are gregarious, sociable, and, arguably, more intelligent than dogs. Some people even keep them as pets. Pigs come in every size and shape—overweight and trim, large and small. They have keen noses, much like dogs, and are used, in Europe, to ferret out truffles from the ground. The construction of the pig holds no dramatic surprises, except that the ears are quite long—and not at all floppy, as you might expect from reading children's picture books.

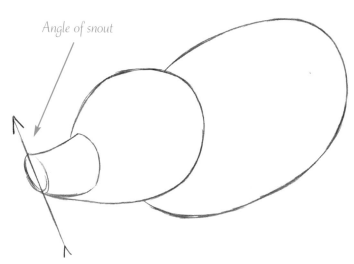

Angle of snout

Not all pigs are obese looking. In fact, most are on the athletic side. The front of the snout falls at an angle, not perfectly straight up and down.

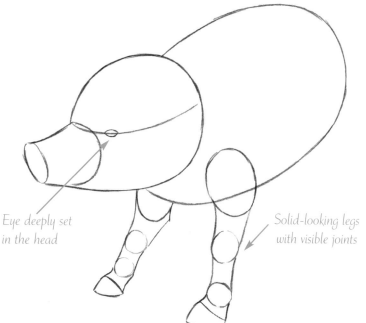

Eye deeply set in the head

Solid-looking legs with visible joints

There are a few farm pigs that are bred to be hugely overweight, with their bellies barely an inch off the ground. But in the majority of pigs, the torso is a good height from the ground, on sturdy legs with cloven hooves.

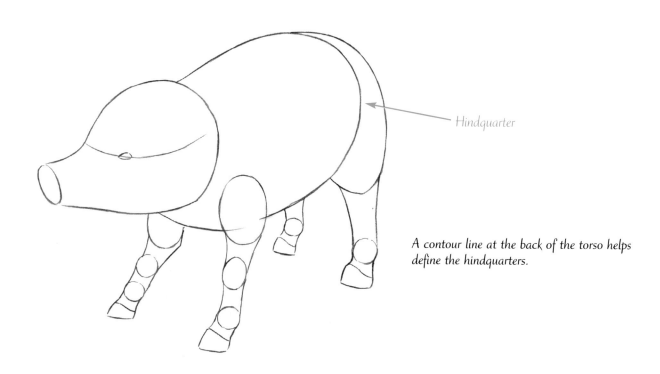

Hindquarter

A contour line at the back of the torso helps define the hindquarters.

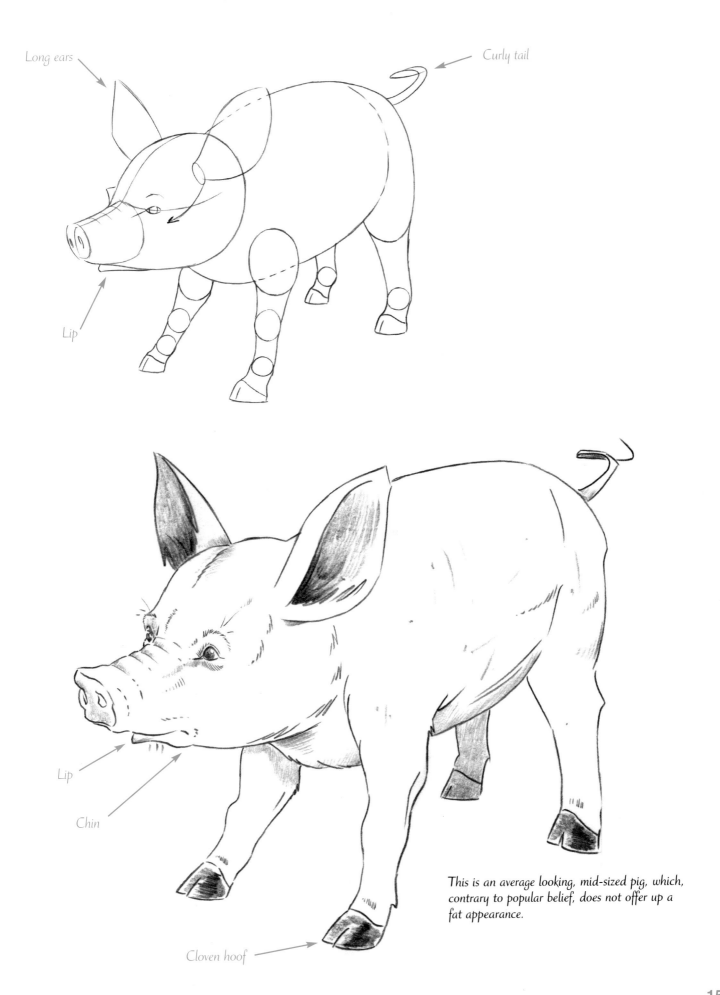

Long ears

Curly tail

Lip

Lip

Chin

Cloven hoof

This is an average looking, mid-sized pig, which, contrary to popular belief, does not offer up a fat appearance.

153

GOAT

Goats have always interested me from a drawing point of view because their heads have a similarity to the horse's. As a young teen, goats were one of my favorite animals to draw. I particularly liked the shaggy coat. It was like drawing a horse with a carpet over its back. A tough and sturdy climber, the goat has a compact build and rugged quality that shouldn't be lost under its shaggy camouflage.

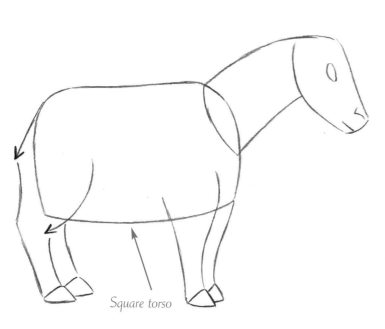

Square torso

There's a square shape to the goat body.

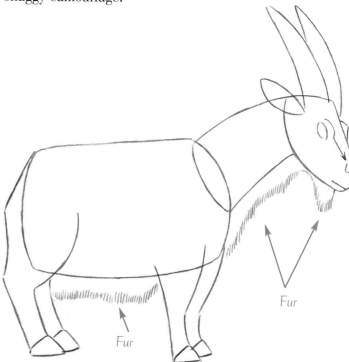

Fur

Fur

There's also lots of hanging fur. The horns have a very slight curve to them. They almost extend straight back from the forehead.

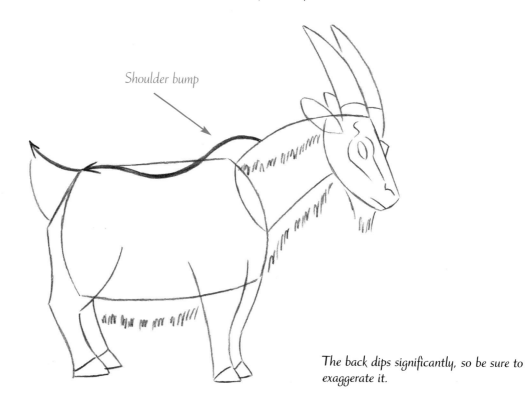

Shoulder bump

The back dips significantly, so be sure to exaggerate it.

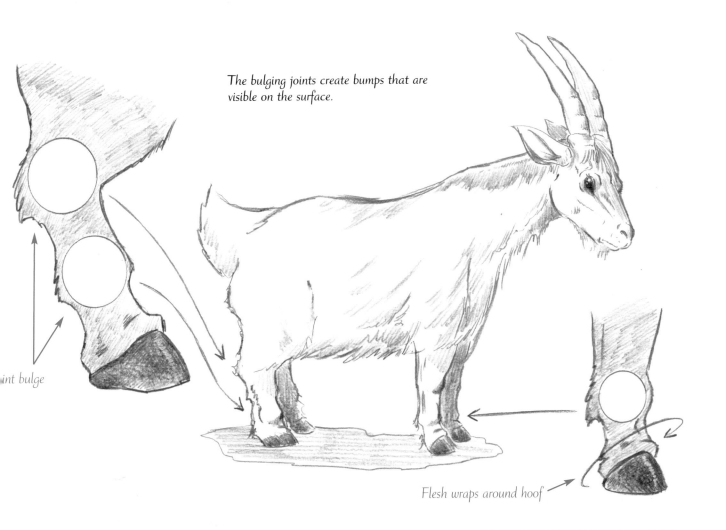

The bulging joints create bumps that are visible on the surface.

int bulge

Flesh wraps around hoof

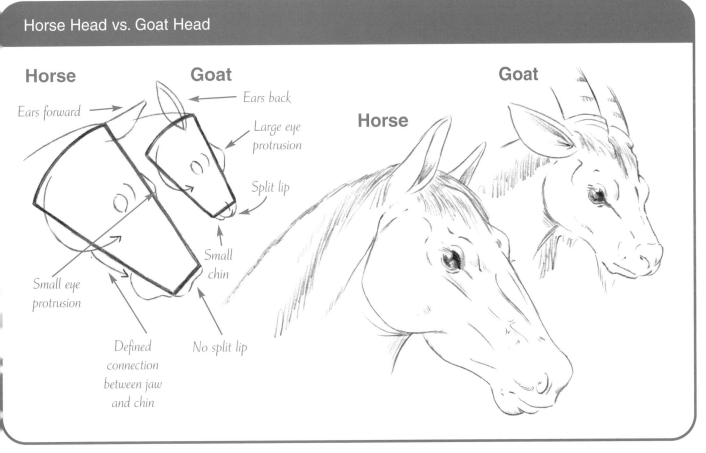

Horse Head vs. Goat Head

Horse

Goat

Ears forward

Ears back

Large eye protrusion

Split lip

Small eye protrusion

Small chin

Defined connection between jaw and chin

No split lip

Horse

Goat

KANGAROO

Kangaroos are odd-looking creatures, yet who can resist them? Isn't there something inherently compelling about them? Maybe it's the desire to jump and hop everywhere, which we all had when we were children, or maybe we're jealous of kangaroos because we see them as animals that never have to grow up?

Regardless of the reason, being a kangaroo looks like a lot of fun. When I draw an unusual animal, I find it helpful to liken its appearance to a more familiar animal, since that gives me a springboard from which to work. I find the kangaroo's face reminiscent of a deer, except at the nose.

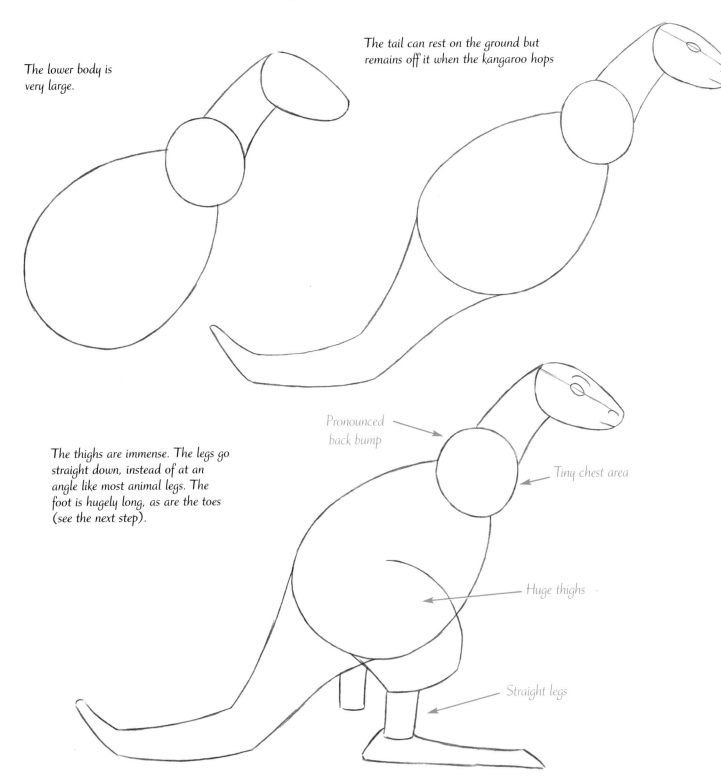

The lower body is very large.

The tail can rest on the ground but remains off it when the kangaroo hops

The thighs are immense. The legs go straight down, instead of at an angle like most animal legs. The foot is hugely long, as are the toes (see the next step).

Pronounced back bump

Tiny chest area

Huge thighs

Straight legs

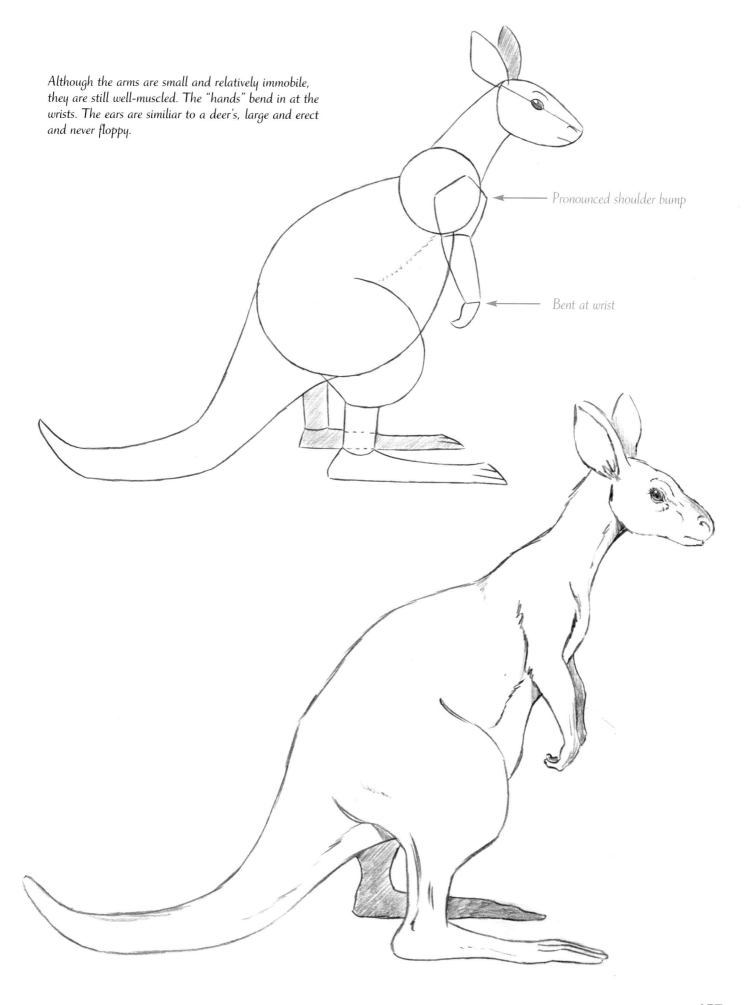

Although the arms are small and relatively immobile, they are still well-muscled. The "hands" bend in at the wrists. The ears are similiar to a deer's, large and erect and never floppy.

Pronounced shoulder bump

Bent at wrist

GIRAFFE

They say that the camel is a horse that was created by a committee. I believe that the people who said that never saw a giraffe. The neck and head of a giraffe seem logical enough, but the body is positively bizarre.

Before you start, make sure you turn your paper to the vertical orientation to give yourself enough room. The neck takes up a lot of room. The chest is large, but the body suddenly stops short at the rear, as if it forgot to continue growing at the rump, which is unreasonably tiny. But, you can't argue with success. And, the giraffe does what it does well.

The legs are very long, just like the neck. The giraffe's entire mechanics are built to give it height. The leg joints should be large, as they bulge on this animal. And, the feet are cloven, oversized, big, and floppy-looking— almost goofy.

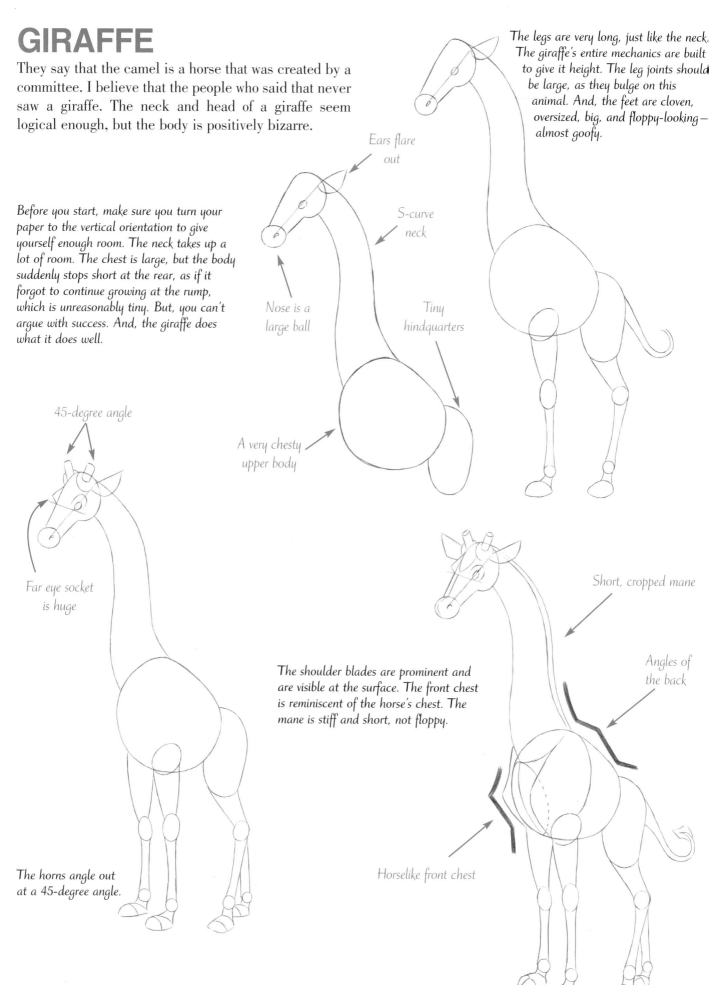

Ears flare out

Nose is a large ball

S-curve neck

Tiny hindquarters

A very chesty upper body

45-degree angle

Far eye socket is huge

The horns angle out at a 45-degree angle.

The shoulder blades are prominent and are visible at the surface. The front chest is reminiscent of the horse's chest. The mane is stiff and short, not floppy.

Short, cropped mane

Angles of the back

Horselike front chest

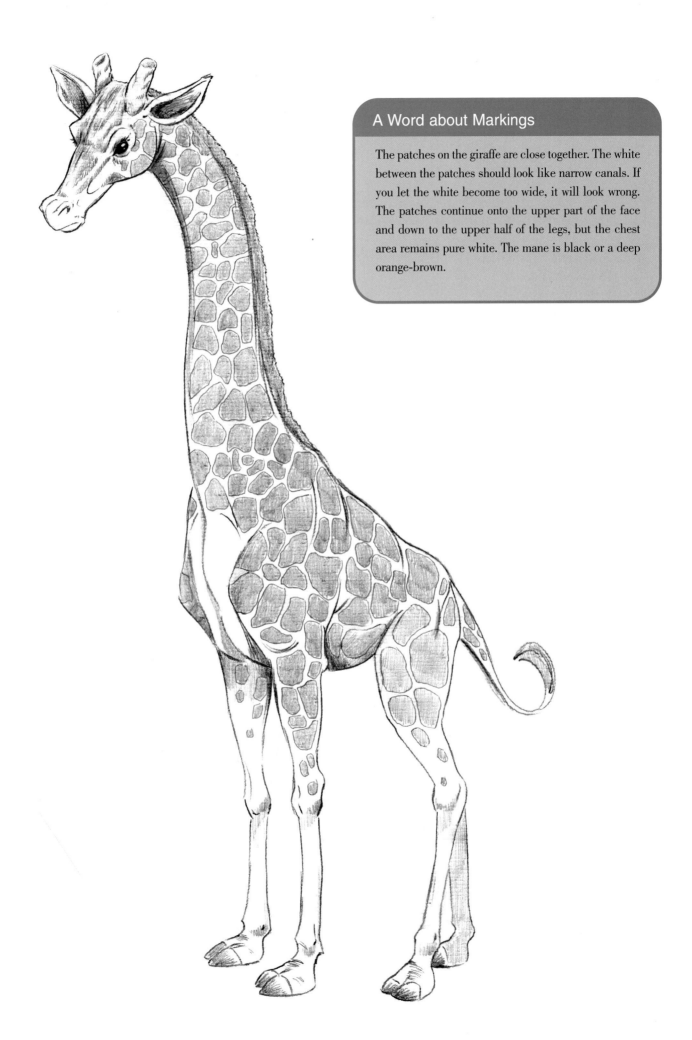

A Word about Markings

The patches on the giraffe are close together. The white between the patches should look like narrow canals. If you let the white become too wide, it will look wrong. The patches continue onto the upper part of the face and down to the upper half of the legs, but the chest area remains pure white. The mane is black or a deep orange-brown.

INDEX

Anatomy, of animals, 7
 deer, 90–91
 dogs, 20, 26
 horses, 70
 human anatomy and, 10–11
 lions, 120
 paws and feet, 36–37
 paws and hands, 34–35
Animals, seeing as human, 10–11
Bald eagles, 146–149
Bears, 96–111
 body contours, 104–105
 brown bear, 110
 expressions, 103
 fur lines, 109
 head, 98–103
 line of spine, 107
 overview, 96
 panda bear, 111
 polar bear, 111
 standing, 109
 three-circle construction method, 108
 types of, 110–111
 walking, 106–107
Birds, 140
 bald eagles, 146–149
 penguins, 150–151
Body parts.
See Anatomy, of animals;
Eyes; Heads; specific animals
Brown bear, 110. See also Bears
Cats, 8, 44–61. See also Lions
 arched back, 58
 concentrating, 61
 contour lines, 52
 eyes, 46, 47, 51
 facial details, 52–53
 head, 46–53
 line quality for, 53
 overview, 44
 reclining/relaxing, 60
 sitting, 56–59
 standing, 54–55
 whisker placement, 53
Chimpanzee, 142–145
Contours, 52, 71, 73, 102, 104–105
Deer, 8, 80–95
 alertness, 92
 curve of neck, 88
 does, 87
 fur and texture, 83
 head, 82–87, 89
 leaping, 93
 overview, 80
 running, 94–95
 simplified body structure, 90–91
 varying head placement, 89
Directional flow, 28
Dogs, 8–43
 anatomy of, 20, 26
 barks, 19

body-type variations, 32–33
conveying volume, 38
curling up, 30
eyes, 12, 13
floppy ears, 30
fur on head, 18
gravity effects on, 41
head, 12–18, 30, 43
knees, 22
legs, 20, 21, 22, 31, 34–37
overlapping lines, 39
paws and feet, 36–37
paws and hands, 34–35
perspective and, 40
playful pose, 28–29
running, 31
seeing as human, 10–11
simplified body structure, 20–23
sitting, 26–27
"smiles," 19
standing, 24–25
torso, 23
walking, 21, 36
wolf and, 42–43
Drawing animals, overview, 7
Eagles, bald, 146–149
Elephants, 8, 126–139
 African vs. Asian, 128–129
 baby, 138–139
 body head-on, 134–135
 body profile, 132–133
 body 3/4 view, 136–137
 dirt bath, 137
 eyes, 130, 139
 heads, 128–131
 hind leg comparison, 133
 overview, 126
 skin, 131
 trunk, 135
Eyes. See also Heads
 cats, 46, 47, 51
 dogs, 12, 13
 eagle, 147
 elephants, 130, 139
 head, 85
 horses, 66, 67
 lions, 116, 117
Foreshortening, 15, 100
Fur
 on dog head, 18
 lines, on bear, 109
 texture and, on deer, 83
Giraffes, 158–159
Goats, 154–155
Gravity effects, 41
Gripping, 144–145
Heads
 antlers, 85
 cats, 46–53
 deer, 82–87, 89
 dogs, 12–18, 30, 43

elephants, 128–131
eyes, 85
front views, 14–15, 46–47, 65–66, 84–85,
 100–101, 116–117
goat, 155
horses, 64–69, 155
lions, 114–119, 125
profile views, 12–13, 50, 64–65, 82–83, 98–99,
 114–115, 130–131
3/4 views, 16–17, 48–49, 68–69, 86–87, 102–103,
 118–119
Horses, 8, 62–79
 body contours, 71, 73
 eyes, 66, 67
 galloping, 78–79
 goat vs., 155
 head, 64–69, 155
 heels, 75
 hooves, 75
 legs, 74–79
 neck and chest muscles, 72–73
 overview, 62
 simplified anatomy, 70
 walking, 76–77
Humans, seeing animals as, 10–11
Kangaroos, 156–157
Line quality, 53
Lions, 8, 112–125
 avoiding muzzle pitfall, 119
 eyes, 116, 117
 head (lion), 125
 head (lioness), 114–119
 line of spine, 123
 mane, 125
 overview, 112
 relaxed torso, 121
 running, 124
 shoulder placement, 122
 simplified anatomy, 120
 tigers compared to, 121
 walking, 122–123
Muzzles. See Heads
Overlapping lines, 39
Panda bear, 111. See also Bears
Penguins, 150–151
Perspective, 40
Pigs, 8, 152–153
Polar bear, 111. See also Bears
Shading, 137
Tigers, 121. See also Lions
Volume, conveying, 38, 73
Wolf, 31, 42–43. See also Dogs